目 錄 Contents

10　推薦序 Preface

12　前言 Forward

14　專文 Special Article

23　金工 Metalwork（按藝術家姓氏首字母排序）

24　張珈釟 Chia-Fan, Chang
《未知的內在》《Unknown inside》
《饕食》《Nibble》
《福壽》《Fu shou》

25　張建瑋 Chien-Wei, Chang
《接連不斷 No.3》《One after another no.3》
《懷舊誘人》《Nostalgia is a bitch》
《我打碎掉的湯匙》《My broken spoon》

26　張惠竹 Hui-Chu, Chang
《自我消弭》《Dissociative disorder》
《多我狀態》《Manic episode》
《集合體》《Personas》

27　張柔婕 / 李馨彣 / 金凡淇
Rou-Jie, Chang / Ching-Wen, Li / Fan-Chi, Chin
《幕後英雄 - 化妝間》《Heroes behind the scenes - makeup room》
《幕後英雄 - 攝影棚》《Heroes behind the scenes - photostudio》
《幕後英雄 - 音樂廳》《Heroes behind the scenes - concert hall》

28　張益弘 / 宋沛緼 / 李弦庭 / 錢薇
Yi-Hung, Chang / Pei-Yun, Sung / Shian-Ting, Li / Wei, Chien
《未來盛市》《Future city》

29　張佑群 Yu-Chun, Chang
《兩杯 - 茶壺》《Zwei tasse - teekanne》
《相框》《Rahmen im rahmen》
《無題》《Untitled》

30　趙丹綺 Tan-Chi, Chao
《鎏金歲月 - 季系列》《The golden times - season series》
《鎏金歲月 - 木系列》《The golden times - trunk series》
《鎏金歲月 - 盛系列》《The golden times - ladle series》

31　陳柏宇 Bo-Yu, Chen
《未經省視的過往 - 方》《Heretofore - square》
《未經省視的過往 - 圓》《Heretofore - around》
《未經省視的過往 - 溢》《Heretofore - overflow》

32　陳志揚 Chih-Yang, Chen
《旅的記憶》《Memory of trip》
《旅的記憶 _ 山》《Memory of trip, the mountains》
《秀外慧中》《Vase》

33　陳綉怡 Hsiu-Yi, Chen
《津津》《Marvelous feast》
《異界居所》《Whose house? - have a look!》
《甜蜜守護者》《Sweet guard》

34　陳立輝 Li-Huei, Chen
《迎春花》《Winter jasmine》
《台灣百合》《Taiwan lily》
《山芙蓉》《Taiwan hibiscus》

35　陳彥如 Yan-Ru, Chen
《每日小紅花》《Daily life of little red flower》
《茶花園》《Camellia garden》

36　陳逸 Yi, Chen
《不對稱形‧瓶子 II》《Asymmetrical‧vase II》
《不對稱形‧瓶子 III》《Asymmetrical‧vase III》
《渴望》《Thirsty》

37　陳怡汶 Yi-Wen, Chen
《次方 II #25‧7、#26‧3》《The power series II #25‧7, #26‧3》
《藻‧數列》《Algae . sequence》
《次方 I #25、#26》《The power series I #25, #26》

38　鄭亞平 Ya-Ping, Cheng
《收縮體 - O》《Contraction - O》
《收縮體 - II》《Contraction - II》
《收縮體 - V》《Contraction - V》

39　鄭瑜婷 Yu-Ting, Cheng
《美好的旅程》《Wonderful journey》

40　姜秀傑 Hsiu-Jye, Chiang
《核》《Core》
《佇離之間 - 皮帶扣》《In between - belt buckle》
《綻放 - 咖啡濾杯》《Blossom - coffee dripper》

41　江郁航 Yu-Hang, Chiang
《身體與容器：殼》《Body and container : shell》
《身體與容器：摺》《Body and container : fold》
《BM015》

42　簡辰峰 Chen-Feng, Chien
《束腹》《Constraint》
《慾見、擇中、抑慾 - 釋放系列》《Desire, compromise, constrain - a series of release》
《施放》《Release and pressure》

43　簡正鎮 Cheng-Chen, Chien
《紅運當頭 - 香盒》《Good luck - incense ware》
《水舞 - 香則》《Water study - incense ware》
《流動‧留白 - 品茶道具組》《Time still - tea utensils》

44　朱彥瑞 Yen-Jui, Chu
《永發 - 充電座》《Yongfa - charging dock》
《永發 - 揚聲器》《Yongfa - horn》

45　闕承慧 Cheng-Hui, Chueh
《岩途風景 III - V》《The scenery on the way, III - V》
《山海微觀》《The extend of mind - V》
《山海微觀系列 - 純銀酒器 VII》《The extend of mind - VII》

46　董承濂 Nick, Dong
《若水》《Becoming horizon》
《沉 - 浸》《Immersion》
《復圓計劃》《Mendsmith project》

47　何堂立 Tang-Li, Ho
《初夏 - 茶倉》《Early summer》
《生命之葉》《Leaves of life》
《綠工藝 - 毛筆飾品》《Green craft - writing brush jewelry》

48　洪寶國 Bao-Guo, Hong
《Prometheus - M & B》
《保存記憶的三種方式 - Nikon COOLPIX 3700》
《Three methods to preserve memory - Nikon COOLPIX 3700》
《Love it？- housefly 2.0》

49　蕭明瑜 / 陳煜權 Ming-Yu, Hsiao/ Yu-Chuan, Chen
《擁抱幸福》《Embracing happiness》
《想像之海》《The sea of imagination》
《海洋上的花》《Flowers on the sea》

50　謝旻玲 Min-Ling, Hsieh
《不虛 No.1》《Intangible reality no.1》
《不虛 No.2》《Intangible reality no.2》
《不虛 No.3》《Intangible reality no.3》

51　謝毅弘 Yi-Hung, Hsieh
《這樣會被人類發現嗎？》《Will we be found？》
《流線型 I》《Streamline I》
《筆跡》《Handwriting》

52　許溙秦 Chen-Chin, Hsu
《悠緩》《Peeling calmly》
《混 I》《Mix I》
《槁木》《Dead - alive》

53　黃淑蘭 Su-Lan, Huang
《錫雕 我的父親》《Tin carving my father》
《遙望台中公園湖心亭》《Looking at lake heart pavilion in Taichung park》
《富貴牛》《Rich cow》

54　鄭芝琳 Jhih-Lin, Jheng
《茶鑲 - 1》《Tea setting - 1》
《茶鑲 - 2》《Tea setting - 2》
《茶鑲 - 3》《Tea setting - 3》

55　周立倫 Lih-Luen, Jou
《新星系列 - 1》《Nova series - 1》
《新星系列 - 2》《Nova series - 2》
《新星系列 - 3》《Nova series - 3》

56　康嘉文 Chia-Wen, Kang
《逐光 I》《Chasing the light I》
《逐光 II》《Chasing the light II》

57　康立穎 Lih-Ying, Kang
《童言無忌》《Innocence》
《旋轉軸》《Rotation axis》
《我祇是安靜地擺置》《I just place quietly》

58　郭晉楓 Chin-Feng, Kuo
《浯島》《Kinmen》
《城隍》《City god》

59　郭宜瑄 I-Hsuan, Kuo
《心象風景》《Mental image》
《愛的讚歌》《The hymn of love》
《圓舞曲》《Waltz》

60　賴芃羽 Peng-Yu, Lai
《口日皿品 - 秋》《Kou ri min pin- autumn》

61　賴維政 / 蔡祐瑄 Wei-Zheng, Lai / Yu-Hsuan, Tsai
《蜂居》《Bee a home》

62　賴維治 Wei-Zhi, Lai
《蝗禍》《Locust plague》

63　李敏惠 Min-Hui, Lee
《曲折 2016》《Shape 2016》
《曲折 : 荷器》《Blossom》

64　李婉瑜 Wan-Yu, Lee
《月間飛行 - 月亮巨蟹》《Sail to the moon - moon in cancer》
《月間飛行 - 月亮天蠍》《Sail to the moon - moon in scorpio》
《月間飛行 - 月亮魔羯》《Sail to the moon - moon in capricorn》

65　李依軒 Yi-Hsuan, Li
《狗狗的旅途因為我們而完整 - 歸宿》《A dog's journey - destination》
《狗狗的旅途因為我們而完整 - 陪伴》《A dog's journey - accompany》
《狗狗的旅途因為我們而完整 - 初次相遇》《A dog's journey - first meet》

66　廖建清 Chien-Ching, Liao
《擬真似幻 I》《Floral simulation I》
《擬真似幻 II》《Floral simulation II》
《花序 I》《The sequence of bloom I》

67　廖婉純 Wan-Chun, Liao
《光景》《Scene》
《痕》《Traces》
《恍惚》《Dimly》

68　廖偉淇 Wei-Chi, Liao
《雲氣我執》《Clouds of hear》
《拙納自在》《Simple of heart》
《無際之際》《The eye and mind》

69　林國信 A-Shinn, Lin
《樹 - 口打出銀壺》《Pavilion - punch out a silver teapot》
《樹 II - 口打出銀壺》《Pavilion II - punch out a silver teapot》
《澐 - 側把銀壺》《Yun - side handle silver teapot》

70　林秀姿 Hsiu-Tzu, Lin
《哺系列》《Breast。feed》
《臍 - 系列》《Navel》
《璇》《Whirlpool》

71　林凱媚 Kai-Mei, Lin
《脈動 - 蝗蟲》《Pulsation - locust》
《脈動 - 蝴蝶》《Pulsation - butterfly》
《脈動 - 蟬》《Pulsation - cicada》

72　林耕弘 Keng-Hung, Lin
《蕨角三葉蟲》《The trilobite with ferning horned》
《延展》《Fold ferning》
《石炭紀公園》《Carboniferous park》

73　林麗娟 Li-Chuan, Lin
《夢行者》《Dream yogi》
《如此，如匙》《Such as spoons》
《願愛輕盈》《Pray for a lithe love》

74　林子翔 Tzu-Hsiang, Lin
《生生》《Growing》
《曦和》《Soleil》
《望舒》《Luna》

75　林昱廷 Yu-Ting, Lin
《無題》《Untitled》

76　劉宜婷 Yi-Ting, Liou
《失語症》《Aphasia》
《群體之外》《Outsider》
《規格化》《Standardisation》

77　劉冠伶 Kuan-Lin, Liu
《印象·花開》《Impression blossom》
《日冕》《Corona》

78　劉書佑 Shu-Yu, Liu
《大地之母 - 冬季》《We only have two seasons left》
《大地之母 - 夏季》《We only have two seasons left》

79　劉紋安 Wen-An, Liu
《量米杯》《Rice measure》
《自體分娩 2》《Fission 2》

80　劉宜欣 Yi-Shin, Liu
《記憶風景 _ 雪日暖光》《Memorable scenes - snow days and warm light》
《記憶風景 _ 雪日小森》《Memorable scenes - snow days and little forest》

81　呂涵育 Han-Yu, Lu
《日常存有》《Daily being》
《伴》《Accompany》
《四季映像》《Four seasons impression》

82　呂燕華 Yen-Hwa, Lu
《山倒影》《Reflection of mountain》
《春之雨》《Spring rain》
《金色月光》《Golden moonlight》

83　南宇陽 Yu-Yang, Nan
《觀風 - 花器創作》《The floating spirit - vase creation》
《白墨 - 盤型創作》《White ink - tea plate creation》
《品山 - 茶倉創作》《Taste mountains - tea caddy creation》

84　歐軍佑 Jiun-You, Ou
《個體神話 - 暗色 #1》《Individual mythology - dark #1》
《個體神話 - 暗色 #2》《Individual mythology - dark #2》
《個體神話 - 暗色 #3》《Individual mythology - dark #3》

85　歐立婷 Li-Ting, Ou
《之間 V》《Between V》
《徑 V》《Path V》
《佇 V》《Stand V》

86　許美嘉 Mei-Jia, Syu
《悸動之隅》《Enchanting corner》
《器·非器》《Vase in another universe》
《悄然》《Gently and quietly》

87　蔡佳雯 Chia-Wen, Tsai
《慢。生活》《Slow and simple living》

88　蔡亞潔 Ya-Jie, Tsai
《翻翻燈》《Fan - fan - light》
《翻翻花》《Fan - fan - flower》

89　蔡宜蓁 Yi-Chen, Tsai
《親愛的內臟 - 腎》《Dear organs - kidneys》
《親愛的內臟 - 肝》《Dear organs - liver》
《親愛的內臟 - 心》《Dear organs - heart》

90　曾莉婷 Li-Ting, Tseng
《花時·緣 I》《The destiny I》
《花時·緣 II》《The destiny II》
《花時·緣 III》《The destiny III》

91　曾永玲 Yung-Ling, Tseng
《蒔時 - 一花一世界之 01》《In the world - 01》
《蒔時 - 一花一世界之 05》《In the world - 05》
《蒔時 - 一花一世界之 06》《In the world - 06》

92　杜嘉琪 Chia-Chi, Tu
《秋景》《Autumn scenery》
《疏影斜月》《Sparse shadow with slanting moon》
《台灣萍蓬草》《Taiwan yellow water lily》

93　王安琪 An-Chi, Wang
《不入耳》《Silent sound source》
《那些討厭的時刻》《Unresolved moment》

94　王夏滿 Hsia-Man, Wang
《藝想自然系列一》《Art with nature Series 1》
《藝想自然系列二》《Art with nature Series 2》
《藝想自然系列三》《Art with nature Series 3》

95　王以安 I-An, Wang
《沒有焦距的文字系列 - 友、好、心、多、呢》
《Out of focus letter - yu, hao, hsin, duo, ne》

96 王意婷 I-Ting, Wang
《佇足 #1、2》《Stay #1, 2》
《佇足 #3、4》《Stay #3, 4》

97 吳竟銍 Ching-Chih, Wu
《海底印象》《The impression of ocean》
《火珊瑚》《The fire coral》
《末冬》《The end of winter》

98 姚怡欣 Yi-Hsin, Yao
《錫光茶倉組》《Tin luster / pu'er tea cake box set》
《印象台東》《Impression of Taitung》
《生命之舞》《The dance with life》

99 易佑安 Yu-An, Yi
《追尋》《Seek》
《追尋 II》《Seek II》
《追尋 III》《Seek III》

100 余孟儒 Meng-Ju, Yu
《癭 II》《Insect galls II》
《癭 IV》《Insect galls IV》
《蔓生》《Growing》

101 游雅帆 Ya-Fan, Yu
《夢‧蝶 - 青眼蛺蝶》《Dream‧butterfly - junonia orithya》
《夢‧蝶 - 艷粉蝶》《Dream‧butterfly - delias pasithoe》
《夢‧蝶 - 大絹斑蝶》《Dream‧butterfly - chestnut tiger》

102 游奕晴 Yi-Ching, Yu
《山嵐水色》《Mountain lake》

105 首飾 Jewelery（按藝術家姓氏首字母排序）

106 白瓊如 Chiung-Ru, Bai
《摺 I 頸圈》《Fold I choker necklace》
《摺 II 頸圈》《Fold II choker necklace》
《摺 III 手環》《Fold III bangle》

107 詹心慈 / 原劭英 Hsin-Tzu, Chan / Shao-Ying, Yuan
《自漫 - 霞》《Self - random》
《自漫 - 映》《Self - random》

108 張筑雅 / 魏玉函 / 方茹萱
Chu-Yia, Chang / Yu-Han, Wei / Ru-Xuan, Fang
《冥‧誕》《The birth from the nether》

109 陳婕薇 Chieh-Wei, Chen
《繡外慧中 - 平板手拿包》《Embroider and intelligent - ipad handbag》
《繡外慧中 - 手機手拿包》《Embroider and intelligent - mobile phone handbag》
《繡外慧中 - 耳機包》《Embroider and intelligent - earphone bag》

110 陳若馨 Ju-Hsin, Chen
《界線 - 容貌》《Limit - golden mask》
《界線 - 唇》《Limit - perfect lip》
《界線 - 脊椎》《Limit - vertebral》

111 陳愷靜 Kai-Jing, Chen
《粼粼 III》《Wave light III》

112 陳高登 Kao-Teng, Chen
《守在季節的輪迴裡》《Stay in the cycle of seasons》
《掌握心方向》《Grasp the direction of the heart》
《美麗的蛻變》《Beautiful transformation》

113 陳國珍 Kuo-Jen, Chen
《生如夏花 / 項鍊》《Life is like summer flowers / necklace》
《生如夏花 / 胸針》《Life is like summer flowers / brooches》
《蕨醒系列 - 雙扇蕨》《Consciousness - coupled dipteris》

114 陳姵蓉 PJ, Chen
《層》《Layer》
《籠》《Cage》
《積》《Accumulation》

115 陳聖鈞 Sheng-Chun, Chen
《卑南神話》《Pinuyumayan myth》

116 陳亭君 Ting-Chun, Chen
《扭態 I》《Twist I》
《扭態 II》《Twist II》
《扭態 III》《Twist III》

117 陳韋廷 Wei-Ting, Chen
《川芎 - 青春永駐》《Chuanxiong - eternal youth》
《中藥系列 - 川芎》《Traditional chinese medicine》
《中藥系列 - 木瓜》《Traditional chinese medicine》

118　陳奕中 Yi-Chung, Chen
《共生之島 頸飾》《Symbiosis island neckpiece》
《共生之島 胸針》《Symbiosis island brooch》
《流體意識系列 戒指》《Consciousness is fluid collection ring》

119　陳臆文 Yi-Wen, Chen
《蜜源 1》《With a butterfly 1》
《蜜源 2》《With a butterfly 2》

120　陳映秀 Ying-Hsiu, Chen
《凝視 I》《Gaze I》
《寫生系列》《Sketch series》

121　陳韋伶 / 湛佩璇 Wei-Ling, Chen / Pei-Hsuan, Chan
《童樂 - 套鍊》《Child joy - collar necklace》
《童樂 - 肩飾》《Child joy - shoulder ornament》

122　鄭巧明 Chiao-Ming, Cheng
《九個女子 #3》《Nine women III》
《九個女子 #9》《Nine women IX》
《穿越雲朵》《Through the clouds》

123　鄭聿婷 Yu-Ting, Cheng
《伎樂飛天》《Musical fairy》
《散花飛天》《Flowing petals》

124　鄭元怡 Yuan-Yi, Cheng
《夜鶯之歌》《The song of the nightingale》
《無法實現的舞會》《The impossible dance》
《關於愛情》《About love》

125　江怡瑩 I-Ying, Chiang
《靜好系列》《Tranquility》
《旋進系列》《Precession》
《俯拾系列》《Picking》

126　江曼荷 Man-Her, Chiang
《春花囍 - 鳳求凰》
《Twined flower wedding high - heeled shoes》

127　簡嬿庭 Yen-Ting, Chien
《微風。牡丹》《The breeze . peony》
《流動。荷花》《The flow . lotus》
《梅花》《The plum blossom》

128　周仕敏 Shih-Min, Chou
《無限循環 I》《Infinity I》
《生命之旅 V》《Journey V》
《內外之間 I》《Between I》

129　周育慈 Yu-Tzu, Chou
《是結束也是開始》《It is the end, also the beginning》
《選一個喜歡的，帶走吧！》《Pick one that you like and take it!》
《生活窺視》《Peeping at life》

130　莊舒凱 Su-Kai, Chuang
《矯正器 I》《Corrector I》
《矯正器 IV》《Corrector IV》
《矯正器 V》《Corrector V》

131　鍾欣瑜 Hsin-Yu, Chung
《信福時光》《Best friend series》
《Pei 的瑜珈課》《Pei's yoga class》
《一切都會變好的》《Everything will be ok》

132　柯啟慧 Shirley Ke, Geiger
《颺》《Floating》
《升》《Ascent》
《側風》《Cross wind》

133　何家穎 Chia-Ying, Ho
《心之塚》《The grave of the heart》
《記憶的載體 II》《Medium of memories II》
《生長》《Grow up》

134　何紹慈 / 蔡宜潔 / 陳筱婷 Shao-Tzu, Ho / Yi-Jie, Tsai / Xiao-Ting, Chen
《懸案之枷項》《Who is murderer? - pillory》
《懸案之束縛》《Who is murderer? - restrain》
《懸案之桎梏》《Who is murderer? - shackles》

135　侯其伶 Chi-Ling, Hou
《蝶嬉 #6》《Butterfly #6》
《花舞 #9》《Blossom #9》
《花嬉 #11》《Blossom #11》

136　侯千珈 Angela Chien-Chia, Hou
《眼淚生態 - 針雨》《Tear ecology - needle rain》
《眼淚生態 - 柔軟如葉》《Tear ecology - as soft as tender leaves》
《眼淚生態 - 惠斯德哥爾摩症候群的珍珠》《Tear ecology - pearl with stockholm syndrome》

137　侯靖 / 邱家榆 / 黃俞熏 / 楊旻馨
Ching, Hou / Chai-Yu, Chiu / Yu-Xun, Huang / Min-Hsin, Yang
《萬生 _ 平原 _ 套鍊 & 頭飾》《Nature rebuild project_enar_necklace & crown》
《萬生 _ 山 _ 套鍊 & 頭飾》《Nature rebuild project_lutuk_shoulder & crown》
《萬生 _ 森林 _ 套鍊》《Nature rebuild project_kilakilangan_necklace》
《萬生 _ 海洋 _ 套鍊 & 頭飾》《Nature rebuild project_liyal_necklace & crown》

138　謝宜庭 I-Ting, Hsieh
《氣度》《Magnanimity》
《無所畏懼》《Fearless》
《生命之美》《The beauty of life》

139　謝佾勳 Yi-Shun, Hsieh
《光的元素》《The elements of light》
《繁光》《The complexity of light》
《表象》《Appearance》

140　許舒媛 Su-Yuan, Hsu
《龍韻 頸飾》《New dragon necklace》
《龍韻 肩飾》《New dragon shoulder-wear》
《龍韻 手鍊》《New dragon bracelet》

141　許元馨 Yuan-Hsin, Hsu
《台灣蝴蝶戲珠花》《Tomentose japanese snowbell》
《玉山薄雪草》《Small leaf edelweiss》
《台灣火刺木》《Taitung firethorn》

142　黃薰慧 Hsun-Hui, Huang
《星際旅行》《Space traveling》
《窗景》《Window》
《歲月》《Time passing by》

143　黃亦捷 I-Chieh, Huang
《心禮 - 鳳凰于飛》《Hearty gift - always be in love》
《心禮 - 連年有餘》《Hearty gift - surplus every year》
《心禮 - 九如之頌》《Hearty gift - blessing on longevity》

144　黃照津 Jaw-Jin, Huang
《蓋置「暗香」「深深」「月光」「月之森」》
《Lid rest - hidden fragrance, deep snow, moonlight, moon forest》
《花器「月」》《Single flower vase - moon》
《象嵌筆座「百花」》《Pen holder - blooming》

145　黃琳真 Ling-Chen, Huang
《湖光瀲瀲》《Leaf over the sparkling lake》
《採集記憶》《Collection of memories》
《掠影》《Sparkling shadow》

146　黃淑萍 Shu-Ping, Huang
《微風景》《The scenery》
《韶光流轉》《Flow》

147　黃以筑 Yi-Jhu, Huang
《反差 - 1》《Contrast - 1》
《反差 - 2》《Contrast - 2》
《反差 - 3》《Contrast - 3》

148　洪慈君 Tzu-Chun, Hung
《記憶殘骸 - 66》《Remnants of memory #66》
《記憶殘骸 - 70》《Remnants of memory #70》
《記憶殘骸 - 55》《Remnants of memory #55》

149　洪子筠 Tzu-Yun, Hung
《身份認同 02》《Identity 02》
《身份認同 05》《Identity 05》
《身份認同 06》《Identity 06》

150　洪雅芬 / 鍾潔妮 Ya-Fen, Hung / Chieh-Ni, Chung
《Zemadrezadrezadr - 如光一般的愛》
《Zemadrezadrezadr - love that shine as light》

151　張皓涵 Hao-Han, Jhang
《Hoe we dei I, II》
《C3H6N6》
《C2Cl4 V》

152　柯婷婷 Ting-Ting, Ko
《澀‧摺》《The faded youth》
《堆漬》《Deposition of the time》
《視 XI XII XIII XIV》《Sight XI XII XIII XIV》

153　郭昭賢 Chao-Hsien, Kuo
《銀色的風，陽光 / 手環》《Silver wind, sunshine / bracelet》
《銀色的風，金心 / 項飾》《Silver wind with golden hearts / neckpiece》
《銀色的風 / 頭飾 No.2》《Silver wind / tiara no.2》

154　郭胤誥 Yin-Gao, Kuo
《龍鳳》《Dragon and phoenixes》

155　賴佳慧 Chia-Hui, Lai
《淌 IV》《Dripping IV》
《容納 I》《Accommodating I》
《賦予 III》《Endowing III》

156　賴得詒 / 陳奕含 / 蔡宜庭 / 蔡昕玶
Te-Yi, Lai / Yi-Han, Chen / I-Ting, Tsai / Hsin-Yi, Tsai
《TO - NIGHT - 崑山夜光》《To - night - peony》
《TO - NIGHT - 夜皇后》《To - night - queen of the night》
《TO - NIGHT - 路燈草》《To - night - juncus》
《TO - NIGHT - 不夜城》《To - night - aloe perfoliate》

157　李恒 Heng, Lee
《樹葉裡有光之一》《Light enter through leaves I》
《樹葉裡有光之二》《Light enter through leaves II》

158　李冠儀 Kuan-Yi, Lee
《容納系列 - 契合 #2》《Inclusion series - agree #2》
《破曉系列 - 分解 #1》《Dawning series - disintegration #1》
《疊加系列 - 滲透 #5》《Superimposition series - penetration #5》

159　李梅華 Mei, Lee
《原礦》《Raw ore》
《張力》《Tension》
《裡外》《Inside and outside》

160　李玫儒 Mei-Ju, Lee
《生命的盡頭是進入新的開始》《The next section of death》
《智慧的結晶就在累世的輪迴中》《Wisdom converge the wheel of karma》
《記憶在下一次輪迴前流逝》《Momeries will fade away before the next reincarnation》

161　李奕芃 Yi-Peng, Lee
《水管珠寶 1》《Water pipe jewellery 1》
《水管珠寶 2》《Water pipe jewellery 2》
《水管珠寶 3》《Water pipe jewellery 3》

162　李豫芬 Yu-Fen, Lee
《時間的痕跡》《Trace of time》
《優雅女士》《Elegant lady》
《外星人》《ET》

163　李岱容 Dai-Rong, Li
《情說書愛》《Written in love》

164　梁淑堯 Shu-Yao, Liang
《繁花叢中 III》《Blossom III》
《凝聚體》《Scene in the city》

165　梁紫祺 Zih-Ci, Liang
《思絮 I》《Fiber of thoughts I》
《思絮 II》《Fiber of thoughts II》
《思絮 III》《Fiber of thoughts III》

166　廖珮君 Pei-Jun, Liao
　　《荒漠花園 - 成長》《Desert garden - grow》
　　《荒漠花園 - 茁壯》《Desert garden - thrive》
　　《荒漠花園 - 綻放》《Desert garden - bloom》

167　廖珮婷 Pei-Ting, Liao
　　《展翅之前 I》《Before blooming I》
　　《展翅之前 II》《Before blooming II》
　　《展翅之前 III》《Before blooming III》

168　廖偉忖 Wei-Tsun, Liao
　　《新生》《New born》
　　《摺玉》《Folding》
　　《日常景色》《Daily scenery》

169　連若均 / 李雅媛 / 程蘭淇
　　Ruo-Chun, Lien / Ya-Yuan, Li / Lan-Chi, Cheng
　　《織竹》《Weaving nature》

170　連時維 Shih-Wei, Lien
　　《倒水》《Pour clean water into a bowl》
　　《植栽與石》《A plant and two stones》
　　《供水》《Offering clean water》

171　林貝郁 Rita Bey Yu, Lin
　　《夏時瑞虎》《Summer guardian tiger》
　　《冬時瑞虎》《Winter guardian tiger》
　　《夏時與冬時瑞虎》《Summer and winter guardian tigers》

172　林佳靜 Chia-Ching, Lin
　　《自然析數一》《Nature and architecture 1》
　　《自然析數二》《Nature and architecture 2》
　　《自然析數三》《Nature and architecture 3》

173　林秀蘋 Hsiu-Ping, Lin
　　《未曾擁抱,那黑｜漩之黑》《Darkness un-embraced｜brooch series｜the spiral of black》
　　《未曾擁抱,那黑｜看見那黑》《Darkness un-embarced｜brooch series｜the glimpse of black》
　　《未曾擁抱,那黑｜光影》《Darkness un-embarced｜brooch series｜light and shadow》

174　林蒼玄 Tsang-Hsuan, Lin
　　《位移 I》《Shifting I》
　　《位移 II》《Shifting II》
　　《位移 III》《Shifting III》

175　林奕彣 Yi-Wen, Lin
　　《以花會友 - 濱菊》《Best friend rings for 2 - shasta daisy》
　　《以花會友 - 黃色鬱金香》《Best friend rings for 3 - yellow tulips》
　　《以花會友 - 虞美人》《Best friend rings for 4 - corn poppy》

176　林盈君 Ying-Chun, Ling
　　《瞬間的永恆 結婚對戒》《Sunrise & sunset》
　　《宇宙邀遊 求婚戒》《Fly into universe》
　　《國王先生與皇后小姐的海上探險》《Mr. king & Mrs. queen wedding rings》

177　劉芳慈 Fang-Tzu, Liu
　　《新丁板》《Rice cakes for newborns》
　　《炒茄子》《Basil eggplant》
　　《高麗菜封》《Stuffed cabbage》

178　劉淑玲 Noelle, Liu
　　《出發》《Departure》
　　《星空一隅》《Scene of outer space》
　　《即將…到達》《Almost …achieved》

179　劉子幼 Tzu-Yu, Liu
　　《雀躍》《Cheer》
　　《喜悅》《Joy》
　　《寶藏》《Treasure》

180　劉瑋珊 Wei-Shan, Liu
　　《妳好‧自在 - 包包掛飾》《Sunny days - bag hanging》
　　《妳好‧自在 - 項鍊》《Sunny days - necklace》
　　《妳好‧自在 - 手環》《Sunny days - bangle》

181　呂佳靜 Chia-Ching, Lu
　　《痕跡》《Trace》
　　《靈肉對立》《Spirit wander》
　　《有好事會發生》《Soft shield》

182　羅硯澤 Yan-Ze, Luo
　　《共生 - 漫 I》《Mutualism - wave I》
　　《共生 - 漫 II》《Mutualism - wave II》
　　《共生 - 漫 III》《Mutualism - wave III》

183　兵春滿 Chin-Man, Ping
　　《境 - 洋汗系列 項鍊》《Real / place - boundless necklace》
　　《境 - 洋汗系列 手環》《Real / place - boundless bracelet》
　　《境 - 洋汗系列 戒指》《Real / place - boundless ring》

184　阮文盟 Weng-Mong, Ruan
　　《人形》《People in movement》
　　《熱帶迴響》《Tropic echo》
　　《檳榔神靈》《Spirit of betelnuts》

185　沙之芊 / 方芊文 / 王祈玉 / 鍾嬡
　　Chih-Chien, Sha / Chien-Wen, Fang / Chi-Yu, Wang / Ai, Chung
　　《金蒔紅樓 薛寶釵》《The dream of the red chamber - Bao Chai Xue》
　　《金蒔紅樓 林黛玉》《The dream of the red chamber - Dai Yu Lin》
　　《金蒔紅樓 王熙鳳》《The dream of the red chamber - Shi Fung Wang》
　　《金蒔紅樓 賈迎春》《The dream of the red chamber - Ying Chun Jia》

186　蘇宸緯 / 陳重楠 / 鮑亨艾
　　Chen-Wei, Su / Chung-Nan, Chen / Heng-Ai, Pao
　　《餘生 2050》《Cyrvive2050》

187　蘇健霖 Chien-Lin, Su
　　《揭墨之捌》《Uncovering ink VIII》
　　《揭墨 - 山岩、薄霧、浮冰》《Uncovering ink - mountain rock, mist, floating ice》
　　《揭墨 - 雙生》《Uncovering ink - twins》

188　蘇小夢 Hsiao-Meng, Su
　　《包容》《Capacity》
　　《瓔珞 - 1》《Yingluo necklace - 1》
　　《時間型態》《Time form》

189　蘇筱婷 Hsiao-Ting, Su
　　《轉化 I》《Transformation I》
　　《轉化 II》《Transformation II》
　　《轉化 III》《Transformation III》

190 蔡沛珍 Pie-Chen, Tsai
《視‧知覺 I》《The perception by seeing I》
《視‧知覺 II》《The perception by seeing II》
《視‧知覺 III》《The perception by seeing III》

191 蔡依珊 Yi-Shan, Tsai
《芳蹤精靈 1(瑟西亞)》《Flower genius 1》
《芳蹤精靈 2(迪米亞)》《Flower genius 2》
《食心人》《Someone who eat heart》

192 曾敬之 Ching-Chih, Tseng
《Zazazoo》
《永痕對戒》《Scratch / wedding bands》
《穗對戒》《Tassel / wedding bands》

193 曾翊捷 Yi-Jie, Tseng
《修復》《Repair》

194 林玉萍 Yu-Ping, Lin(Rainey Walsh)
《萬花朵記之 2》《The journey of dazzle 2》
《萬花朵記之 10》《The journey of dazzle 10》
《萬花朵記之 6》《The journey of dazzle 6》

195 王奕傑 Yi-Chieh, Wang
《漸》《Gradually》
《構》《Structure》
《消失的存在》《Disappearing from existence》

196 王御茗 Yu-Ming, Wang
《Householic 頸飾》《Householic neckwear》
《Householic 耳飾》《Householic earcuff》
《Householic 耳飾》《The eye and mind》

197 溫政傑 Cheng-Chieh, Wen
《沈懿》《Shen Yi》
《循環生機 II》《Circulation#2》
《旅程。記憶》《Journey memory》

198 翁子軒 Tzu-Hsuan, Wong
《花間夢‧鳳冠》《The phoenix coronet of dreaming in the flowers》
《花間夢‧霞帔》《The xiapei of dreaming in the flowers》
《花間夢‧耳環》《The earings of dreaming in the flowers》

199 吳禮竹 Li-Chu, Wu
《山景系列》《Mountain collection》
《城市系列 I》《City I》
《植之生 II - 作品 1》《Plants life II - work 1》

200 吳孟儒 Meng-Ju, Wu
《重生》《Rebirth》
《現代遺物》《Modern relics》
《精神遺跡》《Spiritual relic》

201 吳沛 Pei, Wu
《孝》《Xiao》
《我是壞小孩嗎？》《Am I bad kid?》

202 吳淑麟 Shu-Lin, Wu
《Re - 木目 #1》《Re - mokume #1》
《季節的回憶 - 橄欖》《Seasonal memory - olive》
《穿戴陶 GCC #1》《GCC #1》

203 許淳瑜 Ivy, Xu
《蔓延 II》《Spread II》
《覆蓋》《Covering》
《簇擁 II》《Crowd II》

204 楊彩玲 Tsai-Lin, Yang
《木 - 蕪盡》《Wood - barren》
《土 - 菱花》《Earth - rhombus flower》
《火 - 未燼》《Fire - unburnt》

205 楊炘彪 Xin-Biao, Yang
《宇宙之秩序》《Cosmos》
《寰宇》《Universe》
《世界》《The world》

206 楊雅如 Yu-Ju, Yang
《末路青春 系列一》《Last blossom #1》

207 葉方瑾 Fang-Jin, Yeh
《浸泡在海裡的家鄉印象》《Homeward impressions pickled in the sea》
《閑靜的海》《The sea》
《藏》《Hide and seek》

208 葉璇 Hsuan, Yeh
《花非花 - 髮飾系列 I、II、III、IV》《Flower in the haze - hairpin series I, II, III, IV》

209 葉旻宣 Min-Hsuan, Yeh
《袖珍記憶》《Pocket memories》

210 葉玟妙 Wen-Miao, Yeh
《空間盒子系列 - 生生不息》《The space - circle of life》
《空間盒子》《The space》

211 顏亮中 Liaung-Chung, Yen
《漫步在石頭路上 - 手環》《Stone pathway I - bracelet》
《悸動 - 胸針》《In the mood for love - brooch》
《兔子般的關係 / 美麗的關係 - 胸針》《Bunny(bonnie)kind of relationship - brooch》

212 余純綠 Chun-Yuan, Yu
《山水墨 #1 - #3》《Films of landscapes #1 - #3》
《日常風景》《Daily scenery》
《飄渺》《Ethereal》

213 余啟菁 Mimi, Yu
《光》《Light》
《齊心》《Hand in hand》
《太極》《Tai chi》

214 俞溫馨 / 楊修 Wen-Shin, Yu / Shiu, Yang
《烏托邦項頸飾 / 胸針》《Utopia neckwear / brooch》
《烏托邦項鍊》《Utopia necklace》

推薦序

國立臺灣工藝研究發展中心 張仁吉主任

金屬工藝的發展由來已久，歷史上銅器時代、鐵器時代等人類文明演進階段也以之為標識劃分，顯見其地位與關鍵性。時至今日，金工仍以器物、首飾、藝術創作等諸多形態，在生活之中閃耀著熠熠光華。

用於金工的材料有數十種，常見者如金、銀、銅、鐵、錫，隨著時代與趨勢發展，新媒材與複合媒材的使用催化了金工更加多元奔放的樣貌；就技法來說，舉凡鋸切、燒焊、退火、燒珠、蠟雕、鑲嵌、拋光、蝕刻、沖壓、纏繞、銼削、鍛敲、鑄造，基本的金工技法至少上百種，組合搭配又能產生多樣變化；至於金工的用途，從古至今除了製造生活器物、生產工具，也可用於機器甚至武器，目前則以首飾創作最為常見，其他尚有大型裝置藝術等。

原本便具有極高可塑性與變化性的金工創作，於近代結合新興科技如電腦輔助設計、3D 列印等，使其在材料、技法以及應用上均開展出更多可能性，而呼應當代生活美學發展與時代趨勢，亦融入更多對藝術性、精神性的探求，不斷地創新價值，彷彿有著無限可能。對於金工創作者而言，其魅力如同古代的煉金術（Alchemy）般，創作所隱含著亦是人類的無窮想像與內心真實的想望。

「一鑫一藝 - 臺灣當代金工與首飾藝術聯展」以展覽結合學術論壇，匯集了 200 位金工首飾藝術家，以多元跨域開啟對生活與當代社會環境反思的創作實驗，跳脫單一特定的材料、技法與形式，採用木竹、玉石、漆、纖維、種子，甚至人造樹脂、昆蟲標本、廢棄魚網、瀝青混凝土等，在視覺上以現實、寫意，更多的是抽象的表現方式，所見紋理、色彩、形象展現更多元的、現代的、前衛的金工創作，也演繹個別創作者對世界的認識、自身生命經驗與思考，以及自我表現的藝術語彙。

本展呈現多元跨域概念，結合當代藝術思潮，探討傳統工藝與當代科技的關係，發掘突破與創新的無限可能，進而串連形成臺灣當代金工首飾藝術的思潮脈動。至盼透過本展，能引領觀者認識當代金工與首飾藝術的豐富樣貌，感受蘊含其中的創新態度與思惟，亦能深入體會這些作品所形塑的—屬於臺灣的當代工藝美學。

Preface

Director Ren-Ji, Chang of NTCRI

The development of metalwork has a long history, and the evolution of human civilization, from the Bronze Age and the Iron Age, has also been marked by its indelible presence, showing its status and criticality. Today, metalwork still shines in many forms throughout our lives, including as objects, ornaments, and artistic creations.

There are dozens of materials used in metalwork, including gold, silver, bronze, iron, and tin, and with the evolution of the times and emerging trends, the use of new and mixed media has catalyzed even more diversified and unrestrained appearance in metalwork. In terms of techniques, there are sawing, welding, annealing, bead-granulation, wax carving, inlaying, polishing, etching, stamping, winding, filing, forging, and casting. There are no less than hundreds of basic metalwork techniques, which can be combined and matched to produce tremendously diverse variations. As for the uses of metalwork, it has been deployed since ancient times for producing not only household objects and production tools, but also machines and even weapons, and nowadays it is most commonly used in the creation of ornaments and massive installation art.

In recent times, the combination of emerging technologies with computer-aided design and 3D printing has opened up more possibilities in terms of materials, techniques and applications, and in response to the development of contemporary aesthetics and evolving trends, it has also incorporated more artistic and spiritual exploration, constantly creating new values with seemingly infinite possibilities. For the creators, the charm of Dazzling Metal reveals an ancient alchemy, through creations presenting infinite human imagination amid the true desire of their hearts.

"Dazzling Metal - Taiwan Contemporary Metalwork and Jewelry Art Exhibition" is an exhibition combined with an academic forum, bringing together 200 metalwork and jewelry artists to unleash creative experiments on life and contemporary society. The artists deftly employ wood, bamboo, jade, lacquer, fiber, seeds, and even artificial resin, insect specimens, discarded fishnets, asphalt and concrete. The visual expressions are realistic, freehand, and more abstract. The textures, colors, and images seen present a more diversified, modern, and avant-garde artwork, as well as the individual creators' understanding of the world, their personal life experiences and reflections, and their self-expressive artistic vocabulary.

This exhibition presents a multi-dimensional concept combining contemporary art trends, exploring the relationship between traditional craftsmanship and contemporary technology, and pursuing the infinite possibilities for disruptive breakthroughs and innovations, thus linking them to form the pulse of contemporary metalwork arts in Taiwan. Through this exhibition, we hope to lead visitors to appreciate the richness of contemporary metalwork and jewelry, to engage their innovative attitudes and ideas, and gain deep appreciation for the contemporary art aesthetics of Taiwan shaped by these works.

前 言

策展人 陳國珍 博士

首先我以一鑫一藝策展人的身分，由衷感謝參與此次展覽的 200 位金工與首飾藝術家；經由他們的精彩作品，我們得以一窺臺灣當代金工與首飾藝術的多元樣貌；參展藝術家中有人已是國際知名的藝術家，也有人是年輕而勇於創新的新血，有人則是長期在大專院校培育人才的教授，也有人是建立自有品牌的創業者，而更多人則是胼手胝足努力經營工作室的專職創作者等，無論大家選擇的形態如何，共通之處是藉由創作傳達他們對藝術的熱愛與執著。

當代金工與首飾突破固有的傳統印象，著重在藝術性的表現與自我感知與概念思維的傳遞，不僅具備對材質與技法的掌控，更多經由材質技法實驗而創造出獨特的造形形態，就如同新素材與新科技來打造視覺經驗的突破，從而建構雕琢出專屬於個人特質的藝術語彙。

金工與首飾的造物成形，經由實踐操作的步驟，形成創作者能清晰轉譯內在想像的途徑，唯有精準的創造過程才能顯現抽象思緒靈動原貌。對於 21 世紀的金工與首飾藝術家而言，專注於手作或與科技的融合創造是同等重要的。相較其他領域，幸運的是金工與首飾的傳統技法不因時代潮流而弱化消失，卻有著不斷革新研發的能量源源不斷加入，促使當代金工與首飾藝術面貌如此多元如此充滿魅力，自由呈現當代藝術家豐富內在情感、精神信念、自我性靈與哲學思維。

最後讓我再一次感謝所有參展藝術家，因為您們的慷慨參與與熱情支持，讓我們在如此精彩豐富、多元多彩的創作中，得以採擷當代台灣金工與首飾藝術的景況風貌，即使南轅北轍卻是自在悠遊於藝術天地，藉此舒展藝術的無限維度，讓我們一同探索臺灣當代金工與首飾藝術思潮與工藝美學。

Forward

Curator Dr. Kuo-Jen, Chen

First of all, as the curator of "Dazzling Metal - Taiwan Contemporary Metalwork and Jewelry Art Exhibition," I would like to express my deep gratitude towards the 200 metalwork and jewelry artists who participated in this exhibition. Through their exceptional work, we get to see the diversity of contemporary metalwork and jewelry art in Taiwan. Among the artists in the exhibition, some are already celebrated artists around the globe, some are daring and innovative young artists, some are professors who have been nurturing young talents in universities for years, some are entrepreneurs who built their own brands, while more are full-time artisans painstakingly running their own studios. No matter how we choose to approach our work, what all of us have in common is the love and dedication for art we show through our creation.

Contemporary metalwork and jewelry art breaks through traditional impressions, as it focuses on artistic expression, awareness of the self, and the delivery of concept. Artisans not only have good command of the material and its handling skill but also create unique forms and shapes informed by experimentation. All of this results in an artistic language that is unique to the maker. Through experimentation and practice, the formation of metalwork allows the creator to translate their imagination into tangible forms. Only through a precise process of creation could a piece faithfully embody the abstract inspiration that gave birth to it.

For metalwork and jewelry artists in the 21st Century, focusing on artisanship and incorporating new technology is equally important. Fortunately, in comparison to other fields, traditional techniques in metalwork and jewelry art do not fade with the passage of time. Moreover, innovation continues to flow in, making contemporary metalwork and jewelry art more diverse and full of charisma, showcasing the rich emotions, beliefs, and philosophy of contemporary artists.

Lastly, allow me to express my gratitude to all participating artists once again. It is thanks to your participation and support that we get to capture and showcase the scene of contemporary metalwork and jewelry art in Taiwan in such a diverse and captivating collection. Our styles and approaches may be poles apart, yet, we are all exploring the world of art and its infinite possibilities with a free spirit. Let us explore and discover the artistic trends and artisanship of contemporary metalwork and jewelry art in Taiwan.

專文

陳國珍 博士

由古至今金屬工藝對人類文明的發展，佔有舉足輕重的地位，特別是它歷久彌堅的特性，對於文化的貢獻與傳承有著不可抹煞的功勞。今日金屬工藝形成一門相當專業而細膩的學科，各項技法皆有其造形上的獨特表現，雕、鍛、鑄、鑲等技法自成特殊之質感與視覺美感，堅實的硬度提升器物之實用價值，獨特的金屬色澤閃耀著不凡的美麗，而金屬原料之稀有性，也使得價值不菲的金屬工藝成為人們身份、地位、權利與財富的表徵。

工藝為人類生存、生活、生趣所需。工藝不僅改善了人們的實質生活，並也累積了族群文化的精神內涵與審美經驗。它真誠地呈現了民族多層面、多視角的文化意涵，而屬於文化深層意象與非語言表達心理活動，自然形成視覺圖像展現。藉由工藝，我們得以重新體驗文化的深奧、生活的軌跡與美學經驗。阮文盟作品具有微型雕塑特質的首飾，述說著他對南島語系的台灣印象，作品《熱帶迴響》與《檳榔神靈》等都藏著濃厚的思鄉情懷。來自台灣卑南族的陳聖鈞以卑南神話為題材打造一身勇士金屬鎧甲，描述勇士的英雄故事。一片片串起手工打造的金屬片綴飾，在活動中鎧甲因著光線的折射而閃爍發光不已。而來自鹿港錫器工藝世家的陳志揚則以旅行中的記憶轉化成金屬立體造型，山巒起伏流水涓涓，美景重現。郭晉楓則以大馬士格鋼刀結合浯島城隍為題，打造金門人文特色的刀具組。洪雅芬、鍾潔妮以排灣族琉璃珠為主要材料。以尊貴珠的曙光概念為設計主軸，連結故事中溪水以及排灣族紋樣，呈現 Mulimulitan 以及排灣女性的優雅姿態。

今天，我們生活在充滿新物質的二十一世紀現代生活裡，因為日新月異科技革新使得人類生活更加舒適便利，但是工藝卻能繼續保留手工造物的價值感，令人愉悅的工藝是充滿智慧與情感的多層面觀照，傳達情趣與溫暖，成為了撫慰人們心靈的方式之一。而當代藝術在媒介的固有界線模糊化之後，相對地也帶給當代金工與首飾更大自由實驗與探索。謝份勳大膽嘗試以光碟片作為建構元素，冷接處理成如花般綻放的效果，絢麗的色澤充滿科技未來感。而林蒼玄則善長運用電子材料、塑料、蒙耐合金等材料創作出理性冷靜的首飾作品，用以討論隱蔽性與珍貴性。

工藝經過長久歲月的形成，自是積累了前人的智慧巧思、工藝概念、

成器經驗、工序道理、處世章法、治理能力等各種經驗知識，就如劉勰《文心雕龍》曰：「操千曲而後曉聲，觀千劍而後識器。」，因此，我們藉由對傳統的認識與借鑒，方能成為我們創新的動力。所謂經典之作即是在無數創作過程中洗鍊後自然呈現，它是客觀世界與主觀心靈的適切交融。而陳逸以熟練的鍛敲技法打造的不對稱形瓶子，可以看到創作時對造形行雲流水曲面弧度的掌控度，一定是經過長期累積的經驗才能達到的水平。而簡正鎮對於金屬雕刻投入長期的鑽研，讓創作展現完美無瑕的表面處理，風格典雅雋永令人激賞。

創新與傳統是人類文明不斷演進的過程，今天的創新將成為明日的傳統，換言之，傳統即是文化發展延續的基礎，包涵了前人對於純粹學理與實用操作的應證，對自然、人力手工、機械製作的造物態度，對生活體驗和生命記憶，對美的感受及心靈深層複雜的因子。翁子軒的作品《花間夢》系列以點翠技法搭配金屬鏤刻與流蘇等構成，傳遞他所傾心的浪漫戲曲之美，在傳統形象中帶出創新風貌。李恒擅於使用傳統刺繡的技法在現代數位感十足的首飾作品，作品呈現影像透過電腦螢幕數位格放的影像，帶出嶄新的視覺經驗與意涵。

一件富有內涵的金工首飾作品，往往能反映各種不同層面的議題。依著其特有的材料、形態、使用功能、主題名稱等要素而變化，或因主觀經驗和情感的表現，或因與客觀現實的條件有所改變。對於傳統概念而加以實驗改造，所呈現的創意常是令人驚艷的。技法方面有其不變的固有性，而創新思考可在工序變化：繁複細緻，或技藝精進純熟，或造形美感提升等等。趙丹綺熟捻金屬材料與質感技術，將鎏金技法、皺金法、栗金法與金屬染色技法等運用於當代金工器物，特別是銀器茶具，令人感受濃厚的思古懷舊之情。材料方面可能具有新發明發現，或跨域複合媒材呈現等的突破。例如：光學低溫琺瑯、塑膠影像結合鑲鑽。陳國珍對東方風格的喜好，投注於金工與漆藝的融合創新，在兩者搭配上進行系列實驗，並將結果帶入創作中。她堅持理想勇於嘗試，展現金屬工藝傳統與創新兼融並現的企圖。她的作品反映了一種對大自然的深刻啟發。通過她的作品，觀者在抽象的風景中尋找自己對自然形狀的詮釋，頗有萬物靜觀皆自得的悠然況味。實用功能方面，創新可建立在對於「人—物」關係上的深刻理解及在知覺上傳達訊息：提示功能、象徵功能、形式美學功能等等。游奕晴

創作的茶具《山嵐水色》將品茶的情境添上視覺意象，一如面向湖心小島，靜看山間煙嵐飄動，舒適恬靜。美感的提升，探索造形的真諦。郭昭賢以反式鍛敲結合韓國 Keum-Boo 貼金技法創作了的當代銀飾首飾系列，銀色線條優美飄逸，單純潔淨如雪地微風的吹拂，纖細動人。

生活感動建立在生命歸屬感與生活體驗上的，背後隱含著共同文化的記憶與渴望，也就是一個可供藝術品與觀者之間相互交流的空間，創造集結成一種屬於觀者自我性格的生活樂趣與美學風格。董承濂將金工與首飾藝術推向更大的界線範圍，構成物件到觀者、到環境空間的靈活互動關係，令觀者在體驗虛實互動之間，知覺領悟，思考生命本質。

工藝所正視的是人性價值和生活品質，工藝具有質樸與持續再生的特質，綠工藝是以推動與自然共生概念的創作型態，鼓勵善用在地化符合環保循環、再生永續的材質工序技法。連若均、李雅媛、程蘭淇採用孟宗竹材進行竹編，並以漆藝變塗技法，結合創作系列時尚都會風的首飾項鍊，造形大方亮眼。構樹皮所製成的樹衣是南島語系文化中極具代表的物質文化，構樹的植物 DNA 還述說著台灣南島語族的遷移史，侯靖、邱家榆、楊旻馨與黃俞熏將構樹皮加以利用並創造出立體質感，結合首飾建構成大膽炫奇造形。

疫情後的現代社會環境面對巨變，生活型態急遽演變出各種複雜化問題，當今地球暖化的環境議題備受矚目，並極需所有領域共同努力解決，金工與首飾具有質樸與持續再生的特質，其可永續發展的本質符合綠色設計核心價值標準，而培養具備實現生態倫理與環境保育意識的金工與首飾能力，在未來勢必需求與日遽增。藝術家藉由作品傳達面對未知恐慌與焦慮。蘇宸緯、陳重楠、鮑亨艾創作了帶有賽博龐克復古面具，想像 2050 年人們必須仰賴防毒面罩才能生存，展現末世環境下防護新時尚。而何紹慈、蔡宜潔、陳筱婷的作品以寫實及隱晦的風格呈現，刻畫出被霧霾空污籠罩的人們驚嚇面孔，呼籲重視環境安全與保育議題。

當代金工與首飾在藝術與設計之間產生外延加乘的特性，金工與首飾

不僅只是一種造物的手段，也是在融合的實驗過程中擴展創新的可能性，從而達到新材料技術的開發到造形美學的表現。陳亭君在紅銅板上重複「鋸」與「壓」的工序，規律的動作像是呼吸運動，在一吸一吐間，醞釀各樣的生物面貌。透過輾壓和鍛打對金屬材料施加壓力，金屬承接壓力並向外延展，像是以柔克剛的回應，擴展生命的不同姿態。歐立婷運用了工業技術來協助，藉由 3D 電腦繪圖與紙模的反覆試作，使理想中的空間造形具體實現，最後將金屬板材切割、彎折、成形、焊接以建構物件。歐立婷創作靈感源於建築空間與結構。光影賦予作品新的輪廓，並擴展了對於空間的想像，使作品與建築空間產生連結。作品空間的流動性則讓觀者得以透過凝視和位移，去感受每個線條、切面在不同視角變換時所呈現的意象。

當代金工與首飾被視為凝聚自身形象的物品，其屬性根據需求場合而滾動式調整，無論其是否具備純裝飾性與實用功能性，都與人們的日常生活相關，自然的表達使用者的知性感性整合。吳沛的創作技法大部分是石雕，與部分金工組合成完成一件首飾。她的工作方式比較感性和直覺，專注於感覺和情感表達。吳沛試圖以一種能夠引起人共鳴的方式講述這些故事。例如吳沛的胸針，"孝"在華人文化的一個非常獨有以及具有代表性的概念。它是對長輩的全心全意的尊重和順從，是下一代的肩膀上看不見的重量。玫瑰水晶渾圓透亮像一個新生兒一樣柔軟無害，但在一條冰冷金屬別針的外力作用下被擠壓變形。石頭仍然可以與別針分開，但形變與印記將永遠存在。

當代金工與首飾不再僅只是人的感官全面的延伸，更是經由材料與技術，透過造物傳遞個人感受與藝術觀念，使得物件承載更大的感情聯繫與精神力量，不斷的求新求變的發展將當代金工與首飾推向前所未有的多樣面貌。歐軍佑專注於理解自身生活概況與「工作方法」間的聯結；透過一個近似於修補的過程，歐軍佑從概念與材質出發，讓金屬成為某種柔軟且破碎的狀態，作品以簡單色調，如紙片般薄脆碎片一樣的結構互相交疊組合著。聽從自己的直覺，透過手指與材料，純粹抒情地去操作。創造屬於他的獨特造形語彙。

當代金工與首飾開始扮演多重角色；是身份的認同也是態度的展現、是個人情緒感知的表達也是思考的顯現、是心靈的療癒也是精力的釋

放，儘管各式各樣因人而異的功能與需求，但終究當代金工與首飾絕對是一種經歷真實的造物體驗過程。如同陳柏宇《未經省視的過往系列》從盛裝狀態去思考生活甚至是生命中的盛裝，而受到阻礙時會出現的侷限皺褶，隱喻為個人成長的痕跡，是內在的成長也是外在的變化，成就當今個人。李玫儒作品《生命的盡頭是進入新的開始》描寫一個人沿著樓梯走下，象徵生命的終結。疲憊恐懼面臨死亡前的狀態。而胸針的另一面有一個正在等待被營救的人，其象徵著生命在死亡後並不會消失，也可能是下個新旅程的開始。

當代金工與首飾創新有其可變及不可變之處；工藝所正視的是人性價值和生活品質，所謂實用功能以人為本的核心價值，落實在對使用者感知傳達訊息的敏銳探討研究。造形美感的提升是當代金工與首飾探索嶄新形象的前題。善用科技是未來金工與首飾發展的趨勢，帶領金工與首飾走向創新發展道路的一股無限潛力，從新科技的角度思考金工與首飾本質，重新觀照「人」造物的獨特性，突顯「物」的純粹質樸性質，進而發揮極致可能性，豐富人們的視覺感官。陳姵蓉探索了合理規劃結構和參數化設計之間的關係。通過作品她將傳統工藝與現代電腦輔助設計和製造技術以及多種媒材相結合。她最喜歡的自我裝飾形式是眼鏡。她認為眼鏡具有作為功能裝置和裝飾品的雙重用途。它們被用於視力矯正和眼睛保護，也被用於表達文化、社會地位和時尚的工具。隨著近代電腦輔助設計和製造的進步發展，她從傳統工藝的限制中解放，挑戰觀賞者既有的自我裝飾概念。

而在材料方面包含加強從專精材料突破發展，到跨領域多媒材結合運用的多元表現。葉方瑾使用銀與描圖紙為創作媒材。透過材質探索與非傳統銲接技法，轉換日常媒材的視覺經驗，將實驗出的形態與質感運用於作品當中，連結自身的成長記憶與澎湖的微觀風景。創作的過程將實驗中的偶然，轉化為貼近內心寫照的自然形式，金屬熔融的線條與紙張膨脹的有機形態是個人最具代表性的符號。吳孟儒使用自製研發之金屬合金，轉換金屬之物理性質，使金屬達到易脆裂之狀態，影響著材料之質感及紋理，使其獨特，並且透過熔化及破壞金屬表面來達成特殊的質感效果直到裂痕顯現出來。作品如同凝視遺跡及廢墟殘片的同時，穿梭過往記憶，縫隙乘載了時空，模擬建物及殘跡之破損，透過將物件受力破壞並保留其痕跡，

還原不完整的剩餘狀態，凝視情懷，對比廢棄殘片形成，每一個的由來總是擁有著自己獨特的語彙。

而技法方面兼顧深厚傳統的固有專業素養，與現代科技創新的精進純熟，使得當代金工與首飾技術發展產生積極交融與創新特質。金工與首飾的傳統是前人造物實踐累積的經驗與具體藝術呈現。陳婕薇設計現代女性宴會包結合科技智慧，將傳統金銀細工 Filigree 精巧細緻的風格巧妙融合東方美學與西方現代風格，代表賦予全新的樣貌。黃照津主要的創作方式是金屬鑲嵌技法，作品使用金、銀、銅與各種銅合金為材料，結合金屬象嵌、各種發色方法及其他裝飾技法，呈現金屬媒材的多元裝飾表現，並試圖透過作品傳達工藝優雅而溫暖的力量。黃照津作品所描寫的對象是曾經給予自己感動的自然，亦或是各種曾經經歷過的日常美好事物與感受。將它們從記憶中抽取出來轉化為造形與圖案，這些由現實與想像交融而生的形與象所構成的「心象風景」即是創作者理想時空的實現。

而所謂經典之作是經過無數精練取捨淘汰自然呈現，因此金工與首飾水準的提升，循序漸進而非一蹴可及的。傳統金工與首飾經過歲月的累積形成，充滿了前人的智慧巧思、金工與首飾概念、成器經驗、工序道理、處世章法、治理能力等等。周立倫善長使用電腦輔助設計來進行創作，並透過他純熟的金工技法、精準製作及質感的運用，金屬質感與色彩的掌控自如，作品零件可拆散，重新組裝。充份的表現陽剛理性風格、完美冷靜金屬本質和三度空間結構的美感。

創作者藉由作品表達造物的內涵思想與獨特性，反映個人與民族獨有的感觸力，展現當代金工與首飾富有人文內涵，也反映各種社會多元文化層面。張建瑋的大部分作品都通過將金屬與其他天然材料（如木頭、竹子或發現的物品）結合起來，展現出強烈的東西方美學和文化參考。在他對金屬作為材料的熱情和對整個製作過程儀式的個人興趣的驅使下，每件作品描繪了他作為一名在英國生活和工作的工匠的不同階段。張建瑋作品《接連不斷

(No.3)》敘述 2000 年他離鄉背井展開旅程。作品真實呈現其心路歷程：轉壓力為助力，創作更精進向上。

當代金工與首飾可成為人們接近自然、傳遞舒適與單純、創造情趣與溫暖的一種生活方式。 曾永玲的創作以當代美學探索為核心，以物件、器物或首飾為載體，以工藝與科技展現探索人文的各種面貌。《蒔時 - 一花一世界之 05》一花一世界，蒔花養慧。以缽容器作為個人修持的象徵，有各式各樣不同顏色與質感猶如不同的個體差異，內部有一微型心臟，由此心臟長出一朵心花，像樹或像果。當代金工與首飾作品隱含著豐厚的共同文化的記憶與渴望，也是提供使用者互動交流、傳意達意的社交載體，讓使用者體驗感受生活、定義生活的步調與節奏。當代金工與首飾的價值不僅是人們身份、地位、權利與財富的表徵，也讓生活變美，創造樂趣，並開創現代人文風格與生活美學的和諧願景。

Special Article

Writer Dr. Kuo-Jen, Chen

Metalwork has played a pivotal role since the beginning of human civilization, and its enduring nature has played an exceptional and undeniable role in contributing to cultural heritage and legacy. Today, metalwork is a highly professional and specialized discipline. Each technique takes its own unique expression in terms of form, whether by engraving, forging, casting, or inlaying, which comes with their own texture and visual beauty. The hardness of metalwork materials enhances the practical value of the made objects, and their unique metallic colors shine lustrously with extraordinary beauty. The rarity of metal materials makes metalwork a veritable symbol of status, position, power, and wealth.

Craftsmanship is vital for humans' survival, living, and pleasure. It not only improves our material aspect of life, but is also a symbol of the accumulation of the spirit and aesthetic value of a community. Craftsmanship often faithfully showcases the multi-dimensional and multi-faceted cultural connotations of a community, and it is a deep, non-verbal cultural imagery that conveys what lies within the psyche in a visual form. Through craftsmanship, we can re-experience the profundity of culture, the trajectory of life, and aesthetic experience. Weng-Mong, Ruan's miniature sculptural jewelry speaks to the imagery he has for Taiwan as part of the Austronesian family, while his Tropic Echo and Spirit of Betel Nuts imply a strong longing for home. Sheng-Chun, Chen, from the Puyuma tribe in Taiwan, created the warrior's metal armor based on Puyuma mythology, describing the bearer's heroic story. With pieces of handmade metal ornaments strung together, the armor glitters with the refraction of light with movement. Chih-Yang, Chen, from the long-established tinware family of Lugang, transformed memories of his travels into three-dimensional metal forms, showing picturesque scenes of mountains and gentle streams from his journey. Chin-Feng, Kuo, uses a Damascus steel knife in combination with the Wu Dao City God to create a knife set with the humanistic cultural characteristics of Kinmen. Ya-Fen, Hung and Chieh-Ni, Chung use Paiwan glass beads as the main material. With the concept of the noble pearl of light(Mulimulitan)from a story of Paiwan legend as the core, their design echoes the stream and the patterns from the story. Their work represents the elegance of Mulimulitan and Paiwan women.

Today, in the 21st century, we live in an era full of new materials and technological innovations that make life all the more comfortable and convenient. Yet, it is in craftsmanship that the spirit of hand making and artisanship is preserved. Craftsmanship that sparks joy is a testament to the wisdom and care it embodies, and it brings out pleasure and warmth, becoming one of the sources of comfort for people. As contemporary art became less conventional and more encompassing with its used media, it concurrently brought in more space for experiment and exploration for contemporary metalwork and jewelry art. Yi-Shun, Hsieh, boldly experimented with optical discs as a constructive element. Using cold-jointing

riveting to create an effect simulating flowers blooming, the piece shines with gorgeous colors that give out a sense of technological futurism. Tsang-Hsuan, Lin, is skilled at using electronic materials, plastic, Monel and other materials to create jewelry pieces that bring out senses of rationality and calmness that invite people to ponder on anonymity and rarity.

Craftsmanship was formed in a long, accumulated process of the wisdom, ingenuity, experience in creating, orders of processing, social rules, capability of ruling, and so on of our predecessors. As the quote in Xie, Liu's The Literary Mind and the Carving of Dragons goes: "Only when you have played thousands of songs could you know the ways of music, and only when you have observed thousands of swords could you know the ways to their identification." Therefore, by looking into and learning from traditions, we could gain momentum for innovation. A so-called classic came about through the intricate process of trial and creation, and it embodies a balanced mixture of the objectivity of the world and the subjectivity of the mind. The asymmetrical bottles created with Yi, Chen's skilled hammering technique reveal the precise control the maker has over the flowy curves on the vessels. Such high level of skill could only be achieved through extensive experience. While Cheng-Chen, Chien's long-term research into metal engraving has resulted in the creation of a flawless surface finish that embodies great elegance and timelessness that commands appreciation.

Innovation and tradition are part of the continuous evolution of human civilization, as innovations of today will become traditions of tomorrow. In other words, tradition is the foundation for cultural development. It encompasses our predecessors' searching for truth in both theory and practice, in the different dynamics among nature, human-made, and manufacturing, in life experiences and memory, in humans' sensing of beauty, and the complexity of the psyche . Tzu-Hsuan, Wong's Dream of Flowers series is composed of Kingfisher feather art(Tian-tsui)with metal chasing and tassels, conveying the beauty of romantic opera that captivates his interest. Dream of Flowers brings out a traditional image with an innovative spark. Heng, Lee specializes in the use of traditional embroidery techniques on jewelry creation that gives out a touch of the modern, digital age. Lee's works encompass the digital grid image of computer screens, bringing forth a new visual experience and connotation.

A richly connotative metalwork or jewelry piece could often echo relevance to past and current issues. The connotation of the unique material, form, function, theme, and other elements of the piece grows organically with the subjective expressions of emotion or the objective conditions of reality. The creativity brought about by experimenting and refining traditional concepts is often quite surprising. While the technique may remain rather consistent, innovative approaches could bring variations to the making processes: adding complexity and delicacy, further technical refinement, or the enhancement

of aesthetics in form. Tan-Chi, Chao is well versed in metallic materials and textural techniques. She applies gilding techniques such as parcel-gilt, reticulation, granulation, and patination techniques to contemporary metalwork. In particular, her silver tea sets invite a great sense of nostalgia.

In terms of materials, there are often new discoveries or breakthroughs in the presentation of cross-disciplinary composite media. For example: optical low temperature enamel, or plastic images combined with diamond settings. Kuo-Jen, Chen's preference for Oriental styles has led to a series of experiments on the fusion of metalwork and lacquer art, with the results brought into her creations. She is persistent on her ideals and experimentation, showing her attempt to balancedly combine tradition and innovation in metalwork. Kuo-Jen, Chen's metalworks reflect the deep inspiration and insight she gained from nature. Through her works, viewers could seek interpretations of natural shapes in abstract landscapes at their own pace, which is a testament to the ideal that once we slow down to observe, we notice the beauty in everything we lay eyes on.

In terms of practical functions, a deep insight of the "human-object" relationship and perceptual communication could be the foundation for innovation, such as functions stemming from cueing, creating symbolic meanings, Formalism, and so on. Yi-Ching, Yu's tea set Mountain Lake adds visual imagery to the scene of tea drinking, as if one is facing an island at the center of a lake with mountain mist gently floating by- a scene of ease and tranquility. Elevated aesthetics explores the true essence of form. Chao-Hsien, Kuo created a contemporary silver jewelry series by combining anticlastic raising and Korean Keum-Boo gilding techniques. The elegant and refined silver lines are like breezes on a snowy land - gentle and moving.

Our affection for life is built upon a sense of belonging to life and lived experience. What lies within are the cultural memory and sense of longing we shared, and that is a space that allows artworks and viewers to communicate. It creates and assembles pleasure of life and aesthetic style that belong to the viewers' personal characteristics. Nick Dong has pushed the boundaries of metalwork and jewelry art to a greater spectrum, constructing a flexible interactive relationship among the objects, the viewers and the environment and space. This moves the viewers to perceive, comprehend, and contemplate the nature of life while experiencing the interaction between the virtual and the reality.

Craftsmanship faces up to human values and quality of life; it features modesty and sustainability. Green Craft is a creative style that aims at promoting symbiosis with nature. It encourages the use of materials, processes and techniques that are localized, eco-friendly and sustainable. Ruo-Chun, Lien, Ya-Yuan, Li, and Lan-Chi, Cheng used Moso bamboo for bamboo weaving, in combination with traditional Chinese lacquer painting

techniques, to create a series of stylish urban jewelry necklaces that are stellar. Paper mulberry bark cloth plays a significant role in Austronesian material culture, and the DNA of the plant even tells the story of the migration history of the Formosan Austronesian peoples. Ching, Hou, Chai-Yu, Chiu, Yu-Xun, Huang, and Min-Hsin, Yang made further use of paper mulberry bark to fabricate a three-dimensional texture, combining it with jewelry to create bold and unconventional shapes.

The environment is currently faced with tremendous changes in this post-pandemic modern society, and a variety of complications are developed rapidly concerning our lifestyles. People nowadays pay extreme attention to one particular environmental issue, global warming, which requires urgent joint efforts in all disciplines. Metalwork and jewelry share the features of modesty and sustainability, and its nature of sustainable development conforms to the core value of green design. Without a doubt, the demand for cultivating craftsmanship and jewelry crafting, which helps realize ecological ethics as well as environmental awareness, will surely be increasing in the future.

Artists express panic and anxiety of the unknown through their artwork. Imagine how people in 2050 can't live without gas masks. The cyberpunk retro masks created by Chen-Wei, Su, Chung-Nan, Chen, and Heng-Ai, Pao perform the new fashion of protective wears under an apocalyptic environment. Works by Shao-Tzu, Ho, Yi-Jie, Tsai, and Xiao-Ting, Chen are presented in a realistic and subtle style. The works depict frightened faces of people who are shrouded under smog and air pollution, advocating the importance to environmental safety and conservation.

Contemporary metalwork and jewelry art generates a property of extensions and additions between art and design. Metalwork and jewelry are more than just creating things; it's also expanding the possibility of innovation during the experimental process of fusion, and thereby reaching the goal of developing new material technology and presenting aesthetics of form. Ting-Chun, Chen repeated the process of "sawing" and "compacting" on the red copper plate, and the regular movements were like breathing exercises. With each inhalation and exhalation, various biological features were infused. The artist exerted pressure on metallic materials through mangling and forging while the metal kept holding out the pressure to further extend. This was like life's tender response to the rigid so that it got to expand into its unique appearances.

Li-Ting, Ou drew support from industrial technology, through iterative trial and error of 3D computer graphics and paper matrix, to actualize her ideal form of space. She finished constructing the objects by cutting, bending, shaping and welding the metallic plate materials. Li-Ting, Ou was inspired by architectural space and structure. Light and shadow endow the works with different outlines, expanding the imagination towards space and creating

connections between her work and architectural space. Through gazing and displacement, the fluidity provided by her works allows viewers to sense the presented images when curves and cutting planes change along with switches of viewing angles

Contemporary metalwork and jewelry art is regarded as a cohesive item of self-image, and its attribute is adjustable from occasion to occasion. Regardless of them being simply decorative or actually practically functional, they are inseparable from our daily life because they naturally express the integration of the users' intellectuality and sensibility. Pei, Wu frequently uses a creative technique, stone carving, partnering with some parts of metalwork to complete a piece of jewelry. She works more with her sensibility and intuition, focusing on feelings and emotional expressions. Wu tries to tell stories in a way that people can relate to. Take Wu's brooch as an example, "Xiao," which stands for Chinese parental respect, is a unique and representative concept in Chinese culture. It is to have complete respect and obedience to elders; it is the weight younger generations silently carry on their shoulders. Rose quartz is round and crystal clear, and it is vulnerable and innocent like a new-born baby. Yet, with the external force of a cold metallic pin squeezing into it, it deforms. The pin can be removed from the crystal, but the deformation and the marks stay for good.

Contemporary metalwork and jewelry art is no longer a mere comprehensive extension of human senses but a medium to deliver personal feelings and artistic concepts through creation. This enables objects to carry greater emotional connections and spiritual power. The ever-changing development will give contemporary metalwork and jewelry art a new, diverse facade. Jiun-You, Ou's focus is on connections between personal life understandings and working methods. Through a process similar to patching, Ou sets off with concepts and materials, turning metal into a certain soft and fragmented state. His work is of a simple color tone, and its paper-like thin and fragile structure overlaps with one another. He followed his heart, worked purely and lyrically with his fingers and materials, and created his one-of-a-kind language of form.

Contemporary metalwork and jewelry art plays multiple roles. It can be for self-identity, demonstration of attitude, expression of perceptions, visualization of thinking, mental healing, and energy release. In spite of diverse functions and needs that vary from person to person, contemporary metalwork and jewelry art is undoubtedly a creative process of experiencing reality. As in Bo-Yu, Chen's work, Heretofore Series, from the perspective of containing status, he contemplates over day to day and even the containing within life. The confined creases appear when facing obstacles are used as metaphors for personal growth trajectory. It is internal growth together with external changes that makes us who we are. The Next Section of Death by Mei-Ju, Lee depicts a person walking down the stairs, which symbolizes the end of life and a state of exhaustion and fear before death. On the other side of the brooch sits a person waiting for rescue, which represents that life does not vanish after death. Death can be the beginning of another journey.

Innovation in contemporary metalwork and jewelry art has its variability and invariability. Craftsmanship faces up to human values and quality of life. Its core value of practicality stems from humanism, and it's enacted in keen investigation and study in delivering messages to users' perceptions. To explore a brand new image of contemporary metalwork and jewelry art, elevating aesthetics of form is the premise. Putting technology to good use will be a trend for future contemporary metalwork and jewelry art, and it's highly potential that it can lead contemporary metalwork and jewelry art on a journey of innovative development. Looking at contemporary metalwork and jewelry art from aspects of new technology, observing the uniqueness of "human"-made objects, and highlighting pureness and modesty of "objects" can further push contemporary metalwork and jewelry art to unlimited potential and enriched visual sensation for people. PJ Chen explores the relation between legit structure planning and parameterized design. She puts together traditional craftsmanship, modern CAD, manufacturing techniques and multiple media in her works. Her most favorable form of personal adornment is glasses. She believes that glasses serve dual functions as functional devices and adornments at the same time. They are used for vision correction and as tools to express culture, social status, and fashion. With the advancement of CAD and manufacturing, she was freed from the restrictions of traditional craftsmanship and got to challenge viewers' established concept of personal adornments.

Material-wise, enhancing the breakthrough of development from specialized materials, diverse presentations of integration, and applications of interdisciplinary multimedia materials help with better innovation. Fang-Jin, Yeh turned to silver and tracing paper as creative media. With material exploration and unconventional welding techniques, Yeh converted visual experience of daily media and applied the experimental configurations and textures to her works. Her works also show close connection to her personal memories growing-up and micro landscapes of Penghu During her creative process, she transformed the trial randomness into natural forms that stand close to the reflection of what's in her heart. Curves of metal melt and organic forms of inflated paper are her signature symbols. Meng-Ju, Wu converted the physical property of metal with his self-developed metal alloy, having it reach a state of fragility. He interfered with the texture and lamination of the material, making it distinctive, and further broke down the surface by melting to attain a particular texture effect until cracks appeared.

When appreciating Wu's work, it's like gazing into remnants and pieces of ruins. In the meantime, his work walks us down memory lane; time and space are engraved in the slits.

He simulated damages of constructions and wreckages by destroying objects with forces and having the traces preserved. He restored its incomplete state of residue, looked into the feelings and emotions within, and contrasted them with the forming of fragments. Each one has its unique origin and language.

Technique-wise, traditions and established professionalism as well as advancements of innovative modern technology are given the same level of consideration. This prompts the development of skill in contemporary metalwork and jewelry art to form an unusual trait of active blending and innovation. The tradition of metalwork and jewelry is a concrete presentation of art that was born from creative practices and experiences of our predecessors. When designing lady banquet bags, Chieh-Wei, Chen integrated intellectual technology within. She ingeniously made her works a combination of the delicate style of traditional Filigree, Oriental Aesthetics and Occidental modern styles, which give her works an unusual and special look.

Jaw-Jin, Huang's main creative method is metal inlay technique; gold, silver, copper, and various copper alloys were used as materials. Combining metal inlay, a variety of color emission methods, and other decorating techniques, Huang presents diverse presentations of decorations of metallic media and attempts to spread the elegant and warm power of artisanship with her works. Huang's works depict nature which used to warm her heart, and also, the beauty she's seen and experienced in daily life as well as her feelings are put into her works. Huang took them out from her memories and converted them into shapes and patterns. These "imagined sceneries" composed of shapes and looks of the fusion of reality and imagination are the realization of the artist's ideal time and space.

Classics are made naturally after countless refinements, trade-offs and selections. Thus, the level-up of metalwork and jewelry was not made all at once. Conventional metalwork and jewelry formed gradually as time went by; it's filled with ancient wisdom and ingenuity, concepts of metalwork and jewelry, experience in creating, orders of processing, social rules, capability of ruling, etc. Lih-Luen, Jou is especially good at creating with the help of CAD. Through his mature metalwork techniques, precise making and application of texture, he gets to take control of metallic textures and colors freely. Parts of the work can be deconstructed and reassembled. It fully performs aesthetics of masculine rationality, perfect and calm nature of metal and three dimensional space.

Creators express the connotation and uniqueness of creating through their works. These works not only serve as reflections of exclusive sensibility of individuals and communities, and show the humanistic connotations of contemporary metalwork and jewelry art, but they also serve as reflections of various cultural perspectives of society. Most of Chien-Wei, Chang's works present strong Oriental and Occidental Aesthetics along with cultural references through putting together metal and other natural materials(such as wood, bamboo, or other objects found). Driven by passion for metal as materials and personal interests in the whole production process and rituals, each of his work depicts a different phase of him as a craftsman living and working in the UK. Chang's work One after Another No.3 describes him leaving his hometown and embarking on a new journey in 2000. This work presents his feelings and experience faithfully: turning stress into motivations and pushing himself up to a higher creative level.

Contemporary metalwork and jewelry art can serve as a lifestyle that allows people to get closer to nature, deliver comfort and simplicity, and create fun and warmth. Yung-Ling, Tseng's works center contemporary aesthetics, taking objects, containers or accessories as carriers and presenting different faces of exploring humanities with artisanship and technology. In the World- 05 symbolizes the ideas of personal spiritual practice that every flower has its universe, every flower planted grows wisdom, and that every urn makes a perfect container. In the work we see a diversity of colors and textures indicating individual differences. From a miniature heart like a tree or a fruit within, a flower grows.

Contemporary metalwork and jewelry art encompasses the rich cultural memory and sense of longing we share, and it also serves as a social carrier that users can interact, communicate and express feelings with one another. Users can also experience life and define their pace of living with it. The value of contemporary metalwork and jewelry art is more than symbolizing one's identity, social status, power and wealth; it's also a harmonious vision of beautifying life, creating fun, and cultivating a modern humanistic style and aesthetics of life.

金工

Metalwork

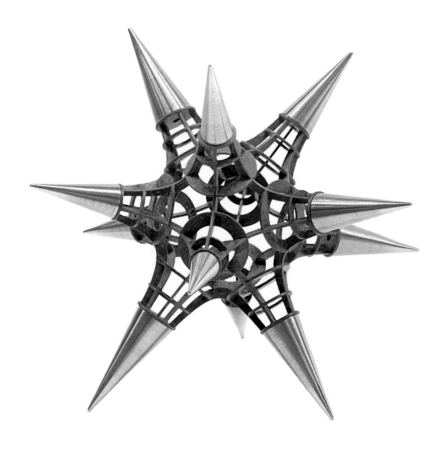

周立倫 Lih-Luen, Jou - 《新星系列 - 1》《Nova series - 1》

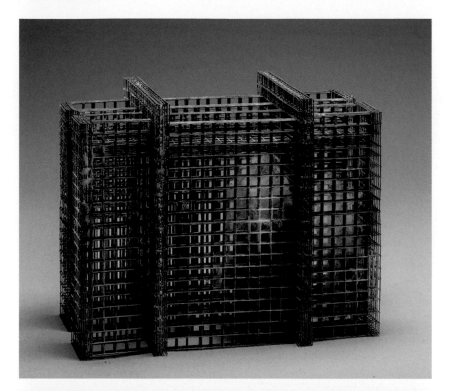

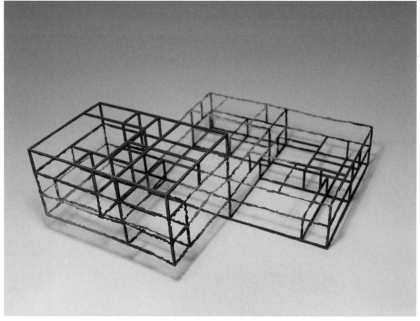

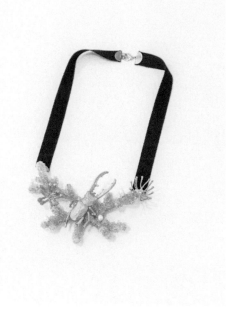

張珈釩 Chia-Fan, Chang

1.《未知的內在》《Unknown inside》
320×210×24mm
金屬網、羊毛、琺瑯、不銹鋼線
Wire netting, wool, enamel, stainless steel wire
2015

2.《囓食》《Nibble》
330×330×135、440×240×100mm
黃銅、釣魚線
Brass, fishing line
2016

3.《福壽》《Fu shou》
215×125×20mm
珍珠、玻璃、不鏽鋼、服裝配件、黃銅、鍍 24K 金
Pearl, glass, stainless steel, accessories, brass, 24k gold plated
2019-2020

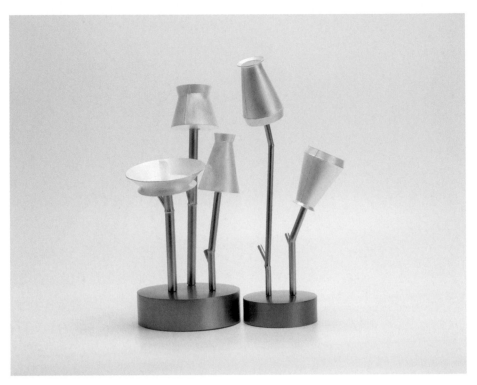

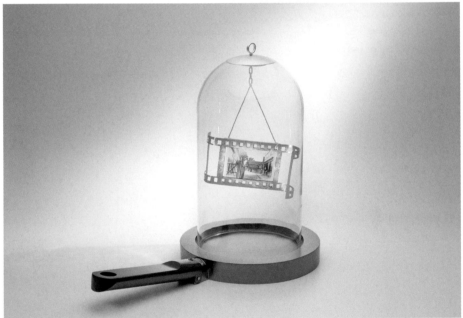

張建瑋 Chien-Wei, Chang

1.《接連不斷 No.3》《One after another no.3》
250×150×370mm
銀、青銅、仿金金屬
Silver, brass, gilding metal
2020

2.《懷舊誤人》《Nostalgia is a bitch》
460×245×400mm
銀、仿金金屬、青銅、玻璃、古董玻璃黑白照片
Silver, gilding metal, brass, glass, colourtype
2019

3.《我打碎掉的湯匙》《My broken spoon》
140×80×30mm(此為單件尺寸,共 7 件一組)
銀、青銅、紅銅、仿金金屬、鐵、繡鐵釘、金箔、棉線、 一隻打碎的磁湯匙
Silver, brass, copper, gilding metal, mild steel, rusty nails, cotton thread,
gold leaf, a broken Chinese porcelain spoon
2014

1
2
3

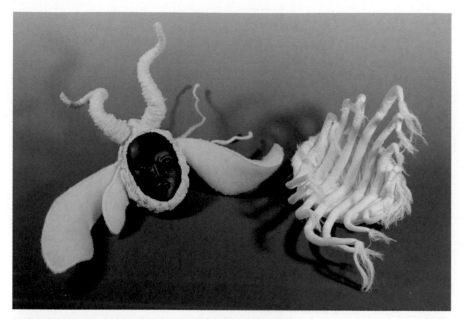

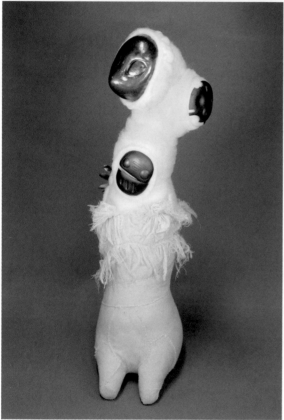

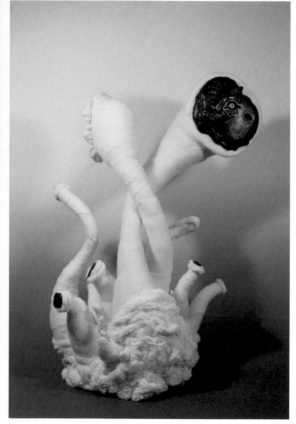

張惠竹　Hui-Chu, Chang

1. 《自我消弭》《Dissociative disorder》
250×320×260、340×530×350mm
鋁線、鋪棉、棉花、棉布、黃銅、紅銅
Aluminum wire, cotton, cotton cloth, brass, copper
2019

2. 《多我狀態》《Manic episode》
550×400×820mm
白鐵線、棉布、鋪棉、琉璃沙、紅銅、綿羊絨
White iron thread, cotton, cotton cloth, glazed sand, copper, cashmere
2021

3. 《集合體》《Personas》
200×270×600mm
白鐵線、鋪棉、棉花、紅銅
White iron thread, cotton cloth, cotton, copper
2021

1	
3	2

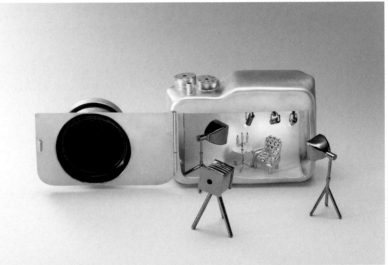

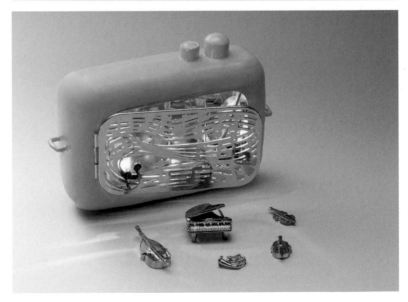

張柔婕　Rou-Jie, Chang

1.《幕後英雄 - 化妝間》
《Heroes behind the scenes - makeup room》
160×120×60mm
紅銅、漆器
Red copper, cashew paint
2021

李罄彣　Ching-Wen, Li

2.《幕後英雄 - 攝影棚》
《Heroes behind the scenes - photostudio》
150×105×105mm
紅銅、黃銅、銀、環氧樹脂、生漆
Copper, brass, silver, epoxy, natural lacquer
2021

金凡淇　Fan-Chi, Chin

3.《幕後英雄 - 音樂廳》
《Heroes behind the scenes - concert Hall》
180×120×80mm
紅銅、黃銅、925 銀、漆器塗裝、電鍍
Copper, brass, silver, epoxy, natural lacquer
2021

| 1 |
| 2 |
| 3 |

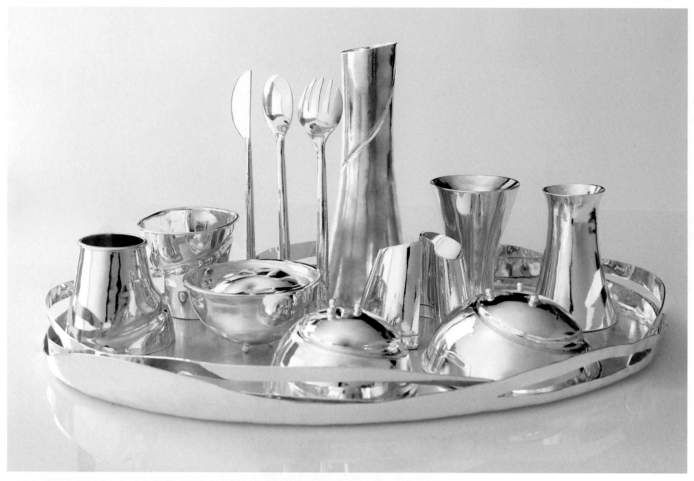

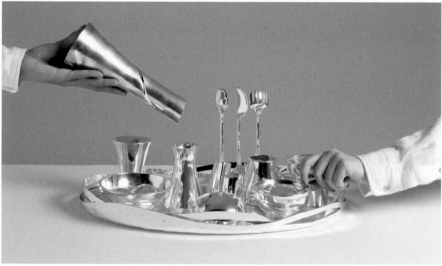

張益弘 / 宋沛緼 / 李弦庭 / 錢薇
Yi-Hung, Chang / Pei-Yun, Sung / Shian-Ting, Li / Wei, Chien

《未來盛市》《Future city》
500×300×200mm
銀
Silver
2021

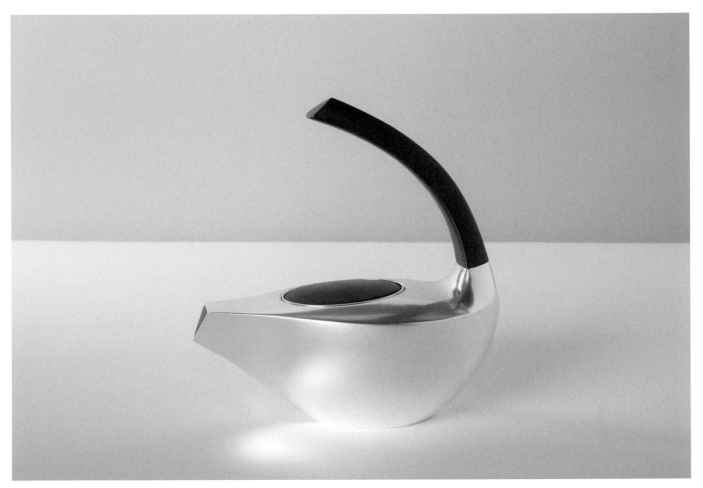

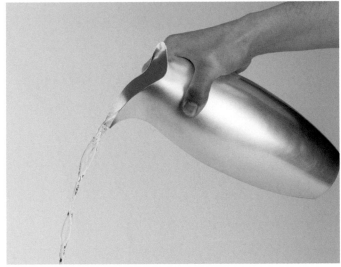

張 佑 群　Yu-Chun, Chang

1.《兩杯 - 茶壺》《Zwei tasse - teekanne》
170×170×90mm
925 銀、 烏木、不鏽鋼彈簧線
925 silver, ebony, spring wire
2015

2.《相框》《Rahmen im rahmen》
185×170×65mm
黃銅鍍銀、碳纖維
Brass with silver plating, carbon fiber
2017

3.《無題》《Untitled》
90×120×275mm
925 銀
925 silver
2016

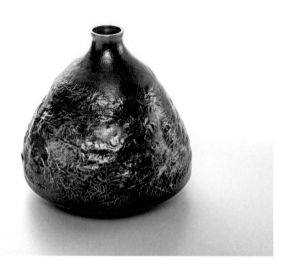

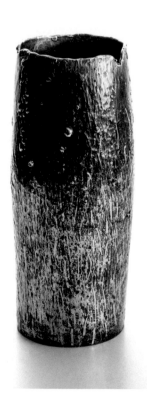

趙丹綺 Tan-Chi, Chao

1.《鎏金歲月 - 季系列》
《The golden times - season series》
160×160×155mm
金、銀
Gold, silver
2020

2.《鎏金歲月 - 木系列》
《The golden times - trunk series》
70×70×165mm
金、銀
Gold, silver
2020

3.《鎏金歲月 - 盛系列》
《The golden times - ladle series》
170×170×45mm
金、銀
Gold, silver
2020

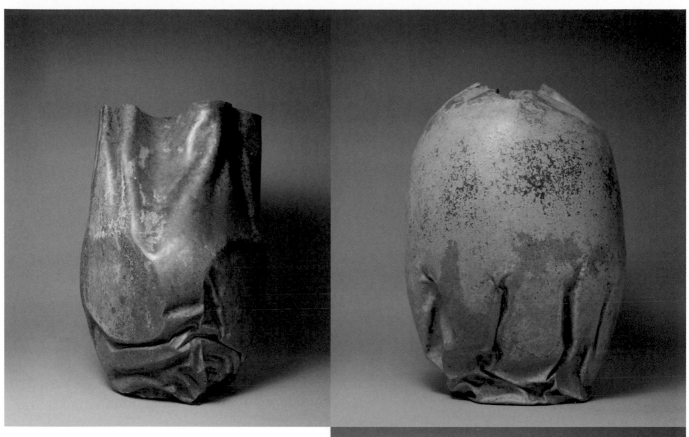

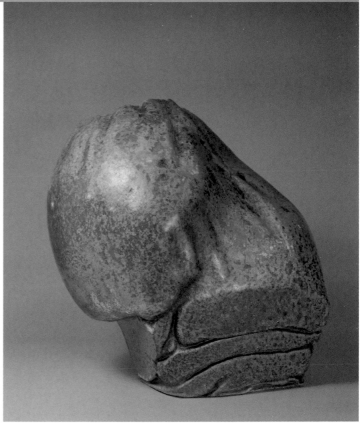

陳柏宇 Bo-Yu, Chen

1. 《未經省視的過往 - 方》 《Heretofore - square》

235×235×44mm
紅銅、化學染色
Copper, patina
2021

2. 《未經省視的過往 - 圓》 《Heretofore - around》

280×280×410mm
紅銅、化學染色
Copper, patina
2021

3. 《未經省視的過往 - 溢》 《Heretofore - overflow》

320×370×400mm
紅銅、化學染色
Copper, patina
2021

| 1 | 2 |
| 3 | |

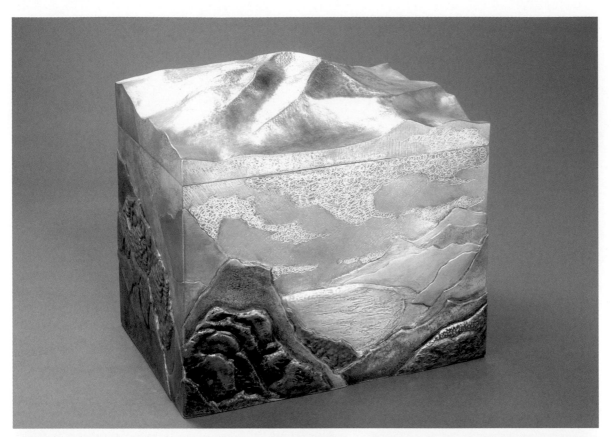

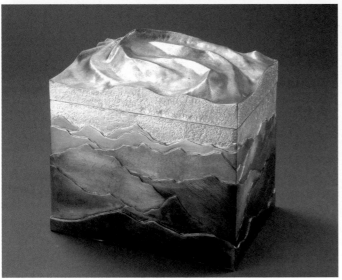

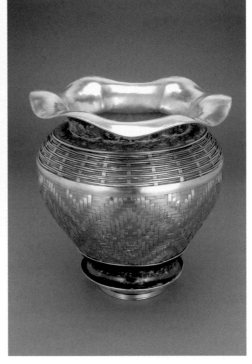

陳志揚 Chih-Yang, Chen

1.《旅的記憶》《Memory of trip》
33×24×32mm
錫、鉛、錫鉛合金、紅銅、青銅、黃銅、磷銅、不鏽鋼
Tin, lead, pewter, copper, bronze, brass, phosphor bronze
2004

2.《旅的記憶_山》《Memory of trip, the mountains》
28×20×25mm
錫、紅銅、青銅、化學染色
Tin, copper, bronze, tint
2004

3.《秀外慧中》《Vase》
42×30×30mm
錫、紅銅、青銅
Tin, copper, bronze
2003

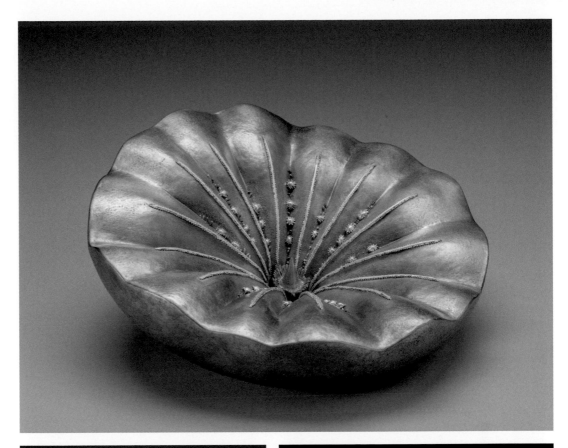

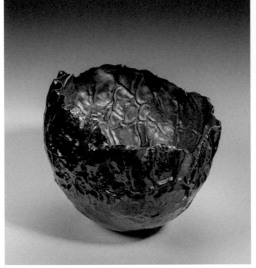

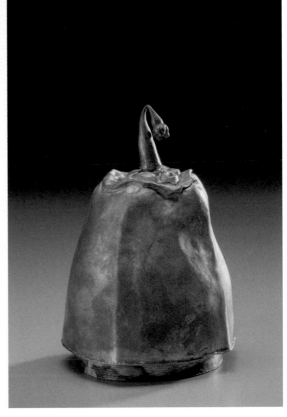

陳 綉 怡　Hsiu-Yi, Chen

1.《津津》《Marvelous feast》
240×260×90mm
925 銀、紅銅、黃銅
Sterling silver, copper, brass
2018

2.《異界居所》《Whose house? - have a look!》
95×95×150mm
紅銅
Copper
2016

3.《甜蜜守護者》《Sweet guard》
245×210×180mm
紅銅、天然漆
Copper, lacquer
2016

1
3

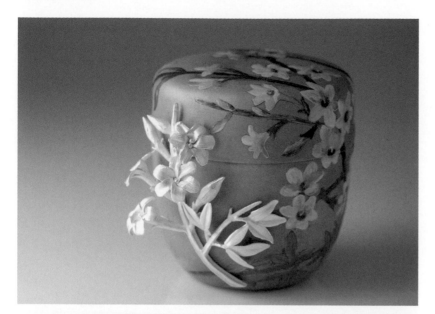

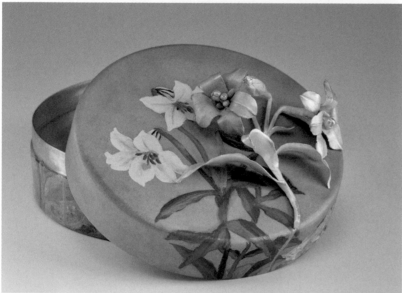

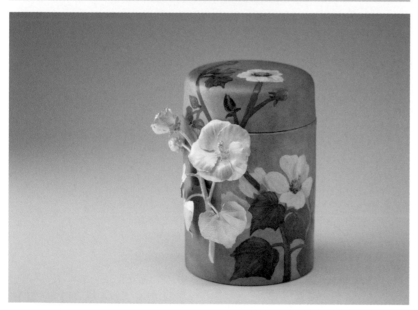

陳立輝 Li-Huei, Chen

1.《迎春花》《Winter jasmine》
75×65×80mm
銀、黃銅、漆、油彩
Silver, brass, lacquer, oil color
2018

2.《台灣百合》《Taiwan lily》
100×100×70mm
銀、黃銅、漆、油彩
Silver, brass, lacquer, oil color
2018

3.《山芙蓉》《Taiwan hibiscus》
100×70×110mm
銀、黃銅、漆、油彩
Silver, brass, lacquer, oil color
2018

| 1 |
| 2 |
| 3 |

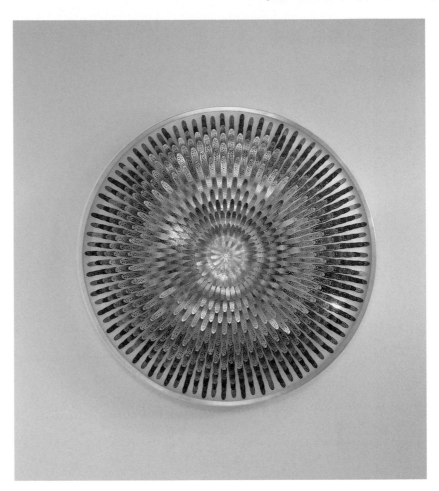

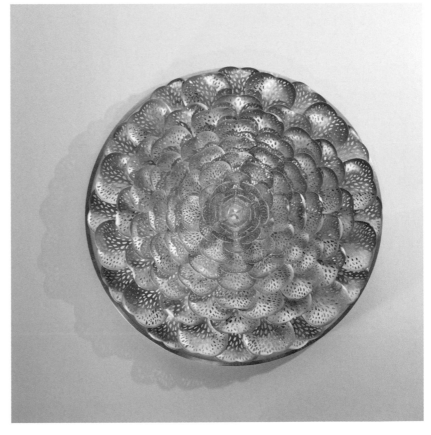

陳彥如 Yan-Ru, Chen

1. 《每日小紅花》 《Daily life of little red flower》
570×570×570mm
不鏽鋼圈、Ice color 壓克力、5052 鋁
Stainless steel, ice color acrylic, 5052 aluminum
2016

2. 《茶花園》 《Camellia garden》
570×570×570mm
不鏽鋼圈、Ice color 壓克力、5052 鋁
Stainless steel, ice color acrylic, 5052 aluminum
2016

1
2

1.《不對稱形・瓶子 II》《Asymmetrical・vase II》 2.《不對稱形・瓶子 III》《Asymmetrical・vase III》 3.《渴望》《Thirsty》
170×110×90mm 155×105×75mm (Teapot)230×140×310、(Cup)50×50×30mm
純銀 純銀 純銀
Fine silver Fine silver Fine silver
2019 2020 2013

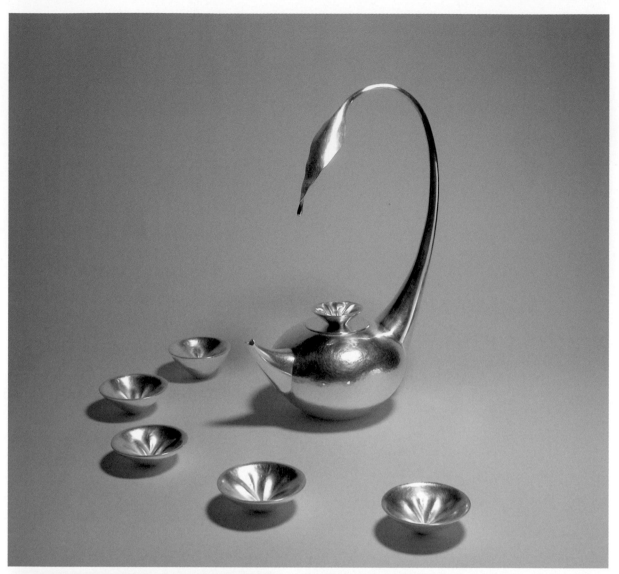

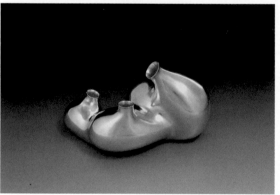

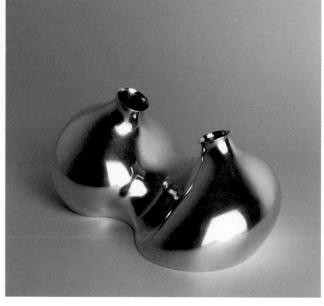

陳逸　Yi, Chen

| 3 |
| 1 | 2 |

1. 《次方 II #25・7、#26・3》
《The power series II #25・7, #26・3》
（左）300×300×160、（右）200×200×400mm
紅銅、琺瑯
Copper, enamel
2017

2. 《藻・數列》《Algae . sequence》
100×100×40、80×80×50、100×100×45、100×85×50、
135×135×55、115×115×60mm
紅銅、琺瑯
Copper, enamel
2017

3. 《次方 I #25、#26》
《The power series I #25, #26》
（左）200×120×100、（右）150×150×55mm
紅銅、琺瑯
Copper, enamel
2017

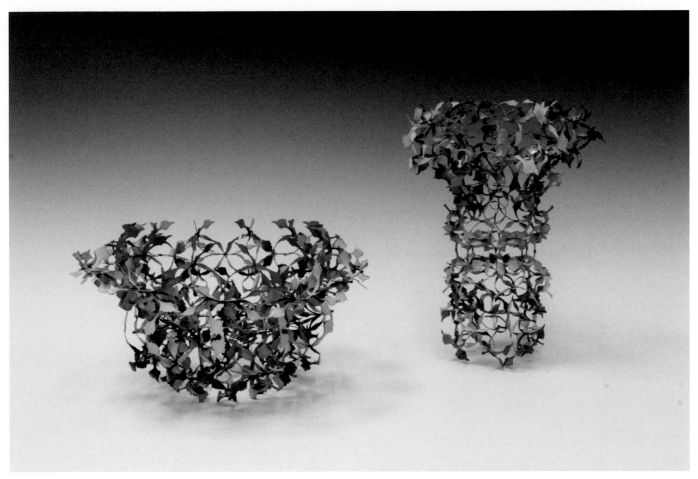

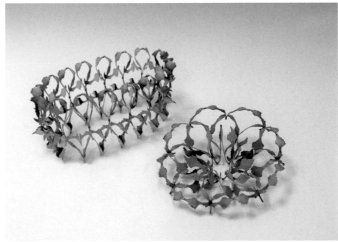

陳怡汶 Yi-Wen, Chen

1. 《次方 II #25・7、#26・3》
《The power series II #25・7, #26・3》
（左）300×300×160、（右）200×200×400mm
紅銅、琺瑯
Copper, enamel
2017

2. 《藻・數列》《Algae . sequence》
100×100×40、80×80×50、100×100×45、100×85×50、
135×135×55、115×115×60mm
紅銅、琺瑯
Copper, enamel
2017

3. 《次方 I #25、#26》
《The power series I #25, #26》
（左）200×120×100、（右）150×150×55mm
紅銅、琺瑯
Copper, enamel
2017

1	
2	3

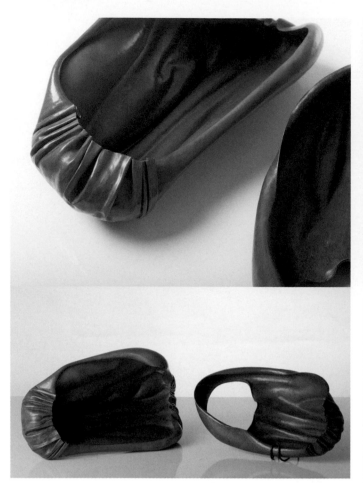

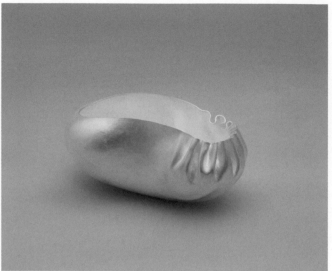

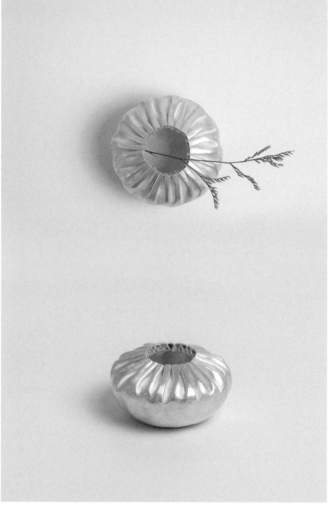

鄭 亞 平　Ya-Ping, Cheng

1. 《收縮體 - O》《Contraction - O》
400×200×150、350×200×100mm
紅銅
Copper
2017

2. 《收縮體 - II》《Contraction - II》
130×76×65mm
銀
Silver
2021

3. 《收縮體 - V》《Contraction - V》
68×68×36mm
銀
Silver
2021

1	2
3	

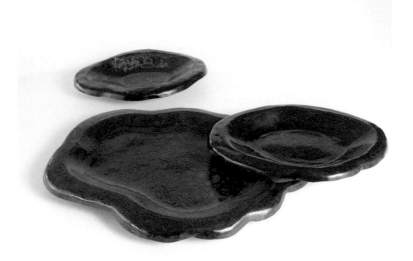

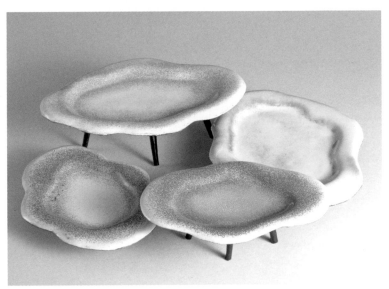

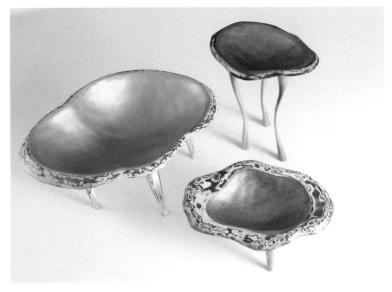

鄭瑜婷 Yu-Ting, Cheng

1.《美好的旅程》《Wonderful journey》
270×210×40、260×200×40、400×280×50mm
紅銅、漆
Copper, lacquer
2010

2.《美好的旅程》《Wonderful journey》
210×160×100、210×160×15、210×160×150、
160×100×50mm
紅銅、琺瑯
Copper, enamel
2010

3.《美好的旅程》《Wonderful journey》
150×100×200、150×100×250、250×200×200mm
紅銅、漆
Copper, lacquer
2010

| 1 |
| 2 |
| 3 |

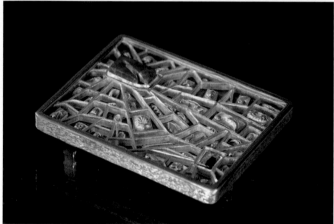

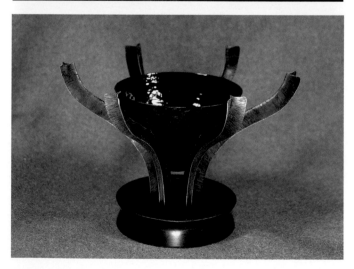

姜秀傑　Hsiu-Jye, Chiang

1. 《核》《Core》
66×66×66mm
925 銀、木目金
Sterling silver, mokume gane
2005

2. 《佇離之間 - 皮帶扣》《In between - belt buckle》
70×58×16mm
925 銀、青金石、黑蛋白石、木目金、壓克力、金箔
Sterling silver, lapis lazuli, black opal, mokume gane, acrylic sheet, gold leaf
2020

3. 《綻放 - 咖啡濾杯》《Blossom - coffee dripper》
200×200×140mm
紅銅、黑檀木、生漆
Copper, rose rood, lacquer
2022

| 1 |
| 2 |
| 3 |

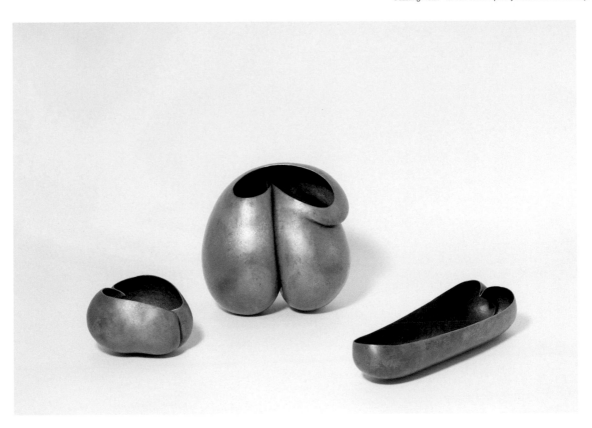

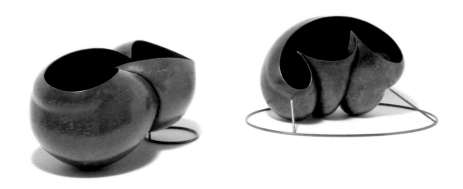

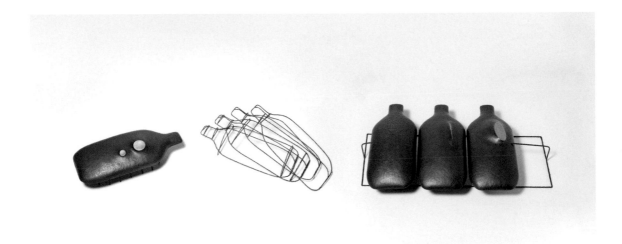

江郁航 Yu-Hang, Chiang

1.《身體與容器：殼》《Body and container : shell》
190×150×200、60×60×50、110×100×70mm
紅銅、化學染色
Copper, chemical patina
2021

2.《身體與容器：摺》《Body and container : fold》
270×160×150、210×125×120mm
紅銅、黃銅、化學染色
Copper, brass, chemical patina
2021

3.《BM015》
700×200×80mm
紅銅、鐵、化學染色
Copper, steel, chemical patina
2021

1
2
3

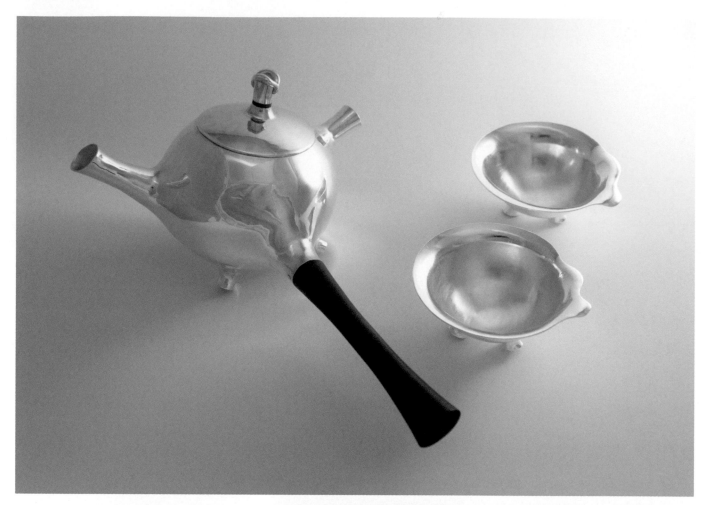

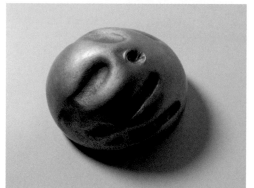

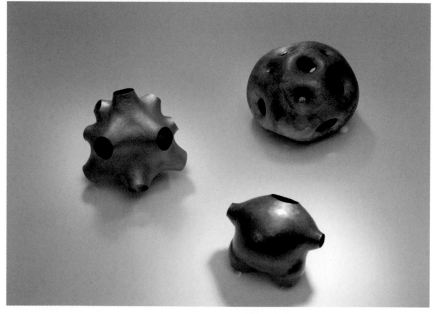

簡辰峰 Chen-Feng, Chien

1.《束腹》《Constraint》
180×140×95mm
紅銅
Copper
2020

2.《慾見、擇中、抑慾 - 釋放系列》《Desire, compromise, constrain- a series of release》
（左）慾見 - 本我 210×210×270、（下）擇中 - 自我 200×210×180、（右）抑慾 - 超我 290×280×200mm
紅銅
Copper
2020

3.《施放》《Release and pressure》
茶壺 160×240×100、茶杯 80×80×40mm
999 銀、925 銀、黑檀木
999 silver, 925 silver, ebony
2020

	3
1	2

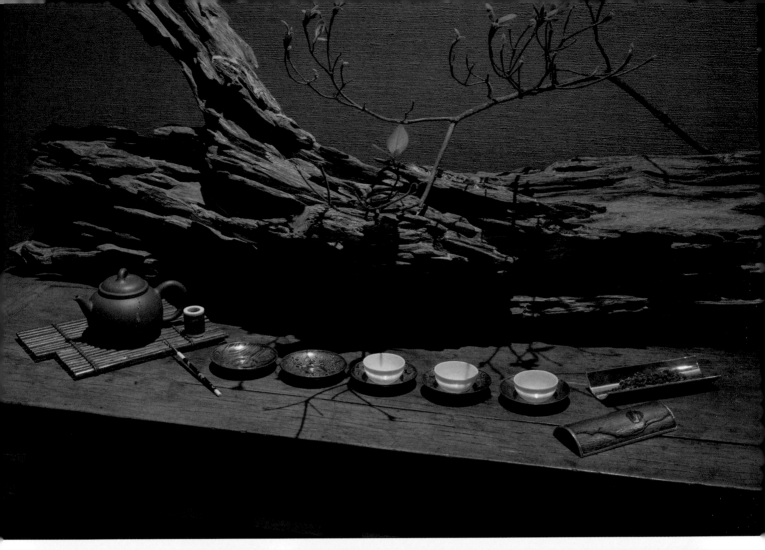

簡正鎮 Cheng-Chen, Chien

1. 《紅運當頭 - 香盒》 《Good luck - incense ware》
80×80×30mm
銀、24K 金、紅銅
Silver, 24k gold, copper
2014

2. 《水舞 - 香則》 《Water study - incense ware》
50×100×10mm
銀、24K 金、鐵
Silver, 24k gold, iron
2014

3. 《流動‧留動 - 品茶道具組》 《Time still - tea utensils》
900×300×90mm
銀、24K 金、紅銅、木目金
Silver, 24k gold, copper, mokume-gane
2015

3
1

朱彥瑞 Yen-Jui, Chu

1.《永發 - 充電座》《Yongfa - charging dock》
42×78×120mm
黃銅、黑色壓克力
Brass, black acrylic
2015

2.《永發 - 揚聲器》《Yongfa - horn》
40×78×100mm
黃銅、黑色壓克力、矽膠
Brass, black acrylic, silicone
2015

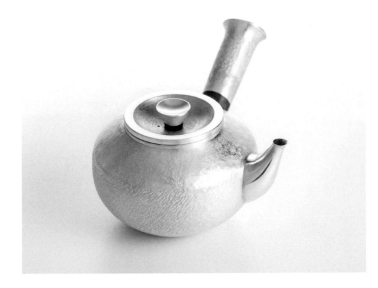

關 承 慧 Cheng-Hui, Chueh

1.《岩途風景 III - V》《The scenery on the way, III - V》
直徑 90 高 16mm
純銀
Silver
2017

2.《山海微觀》《The extend of mind - V》
95×130×70mm
純銀、木頭
Silver, wood
2019

3.《山海微觀系列 - 純銀酒器 VII》《The extend of mind - VII》
直徑 65 高 105mm
純銀
Silver
2021

1	
3	2

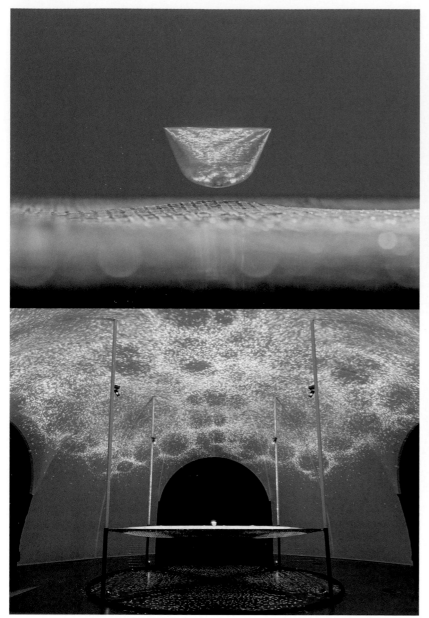

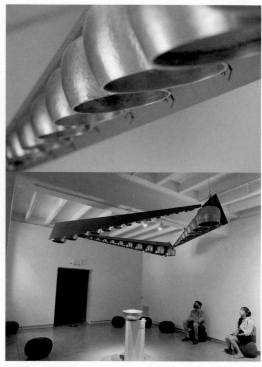

董承濂 Nick, Dong

1.《若水》《Becoming horizon》
9144×9144×3886mm
複合媒材
Mixed medias
2021

2.《沉 - 浸》《Immersion》
3556×3048×508mm
複合媒材
Mixed medias
2021

3.《復圓計劃》《Mendsmith project》
現成物首飾改造
Modify existing jewelry pieces
2019

1	2
3	

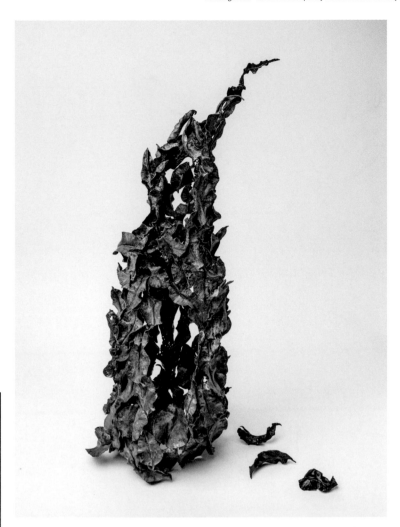

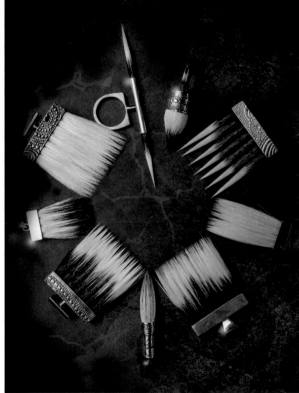

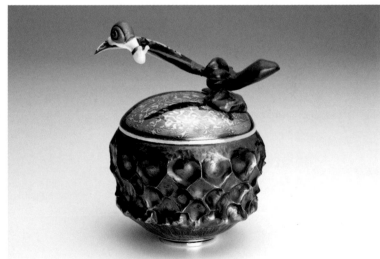

何堂立　Tang- Li, Ho

1.《初夏 - 茶倉》《Early summer》
120×120×170mm
銀、紅銅、玉石、木目金
Silver, copper, jade, mokume gane
2015

2.《生命之葉》《Leaves of life》
420×300×530mm
銅、化學染色
Copper, patination
2020

3.《綠工藝 - 毛筆飾品》《Green craft - writing brush jewelry》
350×300×100mm
銀、動物毛
Silver, animal fibers
2022

	2
3	1

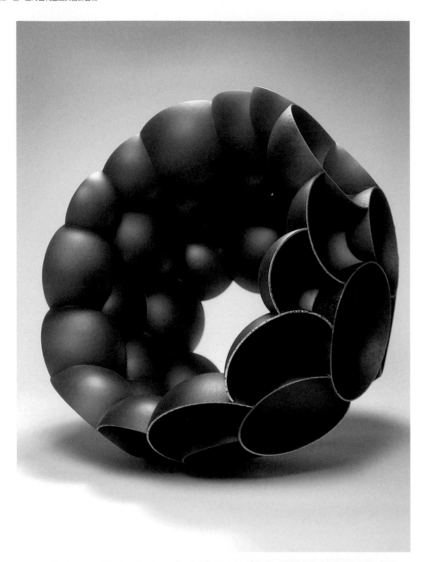

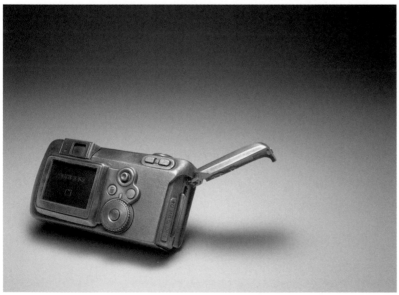

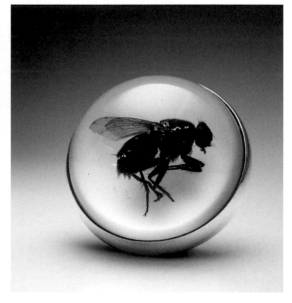

洪寶國　Bao-Guo, Hong

1. 《Prometheus - M & B》
220×240×200mm
黃銅
Brass
2020

2. 《保存記憶的三種方式 - Nikon COOLPIX 3700》
《Three methods to preserve memory - Nikon COOLPIX 3700》
35×95×55mm
紅銅、黃銅、鍍銀
Copper, brass, silver-plated
2010

3. 《Love It？- housefly 2.0》
25×25×18mm
黃銅、POLY 樹脂、昆蟲標本
Brass, polyester resin, insect specimen
2017

1	
2	3

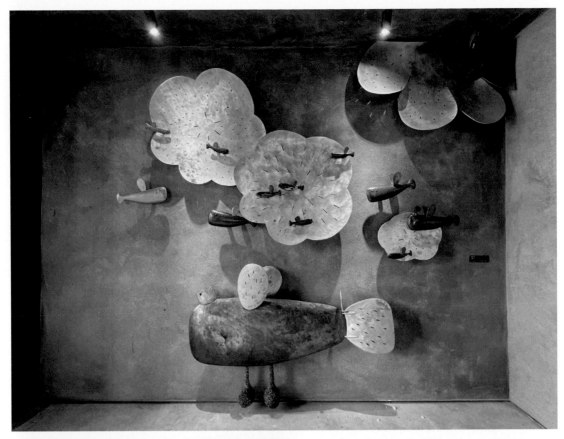

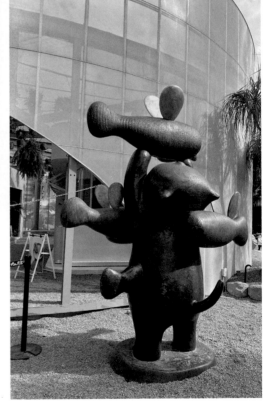

萧明瑜 / 陳煜權 Ming-Yu, Hsiao / Yu-Chuan, Chen

1.《擁抱幸福》《Embracing happiness》
W1700、H2600mm
銅
Bronze
2022

2.《想像之海》《The sea of imagination》
2500×2500×180mm
銅、鋁
Brass, copper, aluminum
2021

3.《海洋上的花》《Flowers on the sea》
900×200×120mm
青銅、銅、錫
Bronze, copper, putter
2021

2
3

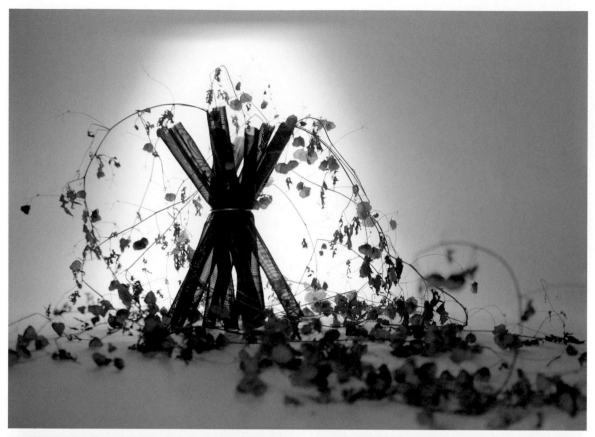

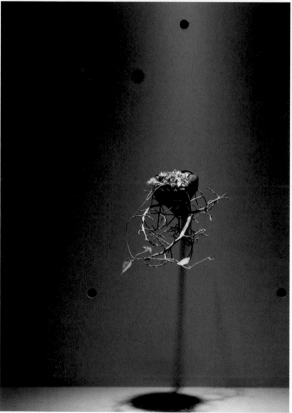

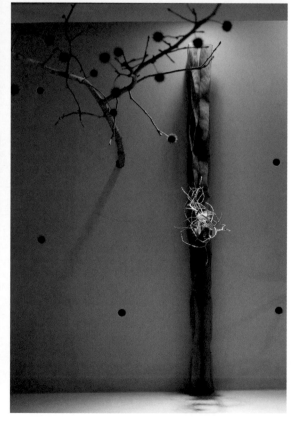

謝旻玲 Min-Ling, Hsieh

1.《不虛 No.1》《Intangible reality no.1》
135×135×115mm
黃銅網、植物
Brass mesh, plants and flowers
2018

2.《不虛 No.2》《Intangible reality no.2》
240×240×450mm
黃銅網、植物
Brass mesh, plants and flowers
2018

3.《不虛 No.3》《Intangible reality no.3》
100×100×1200mm
黃銅網、植物
Brass mesh, plants and flowers
2019

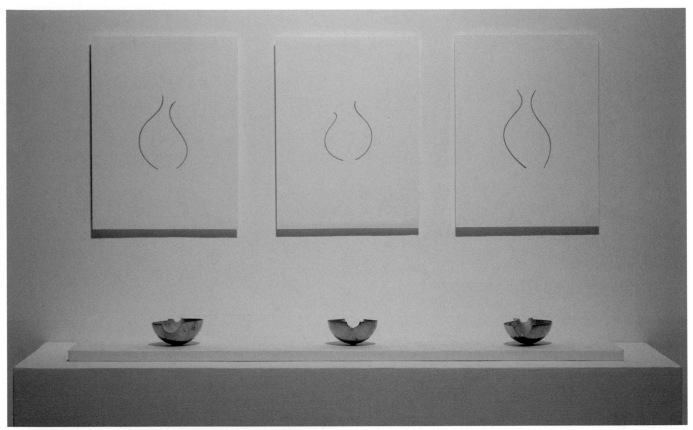

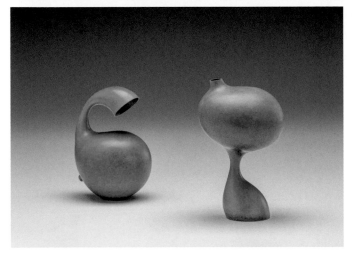

謝毅弘　Yi-Hung, Hsieh

1.《這樣會被人類發現嗎？》《Will we be found ?》
(左)100×90×140、(右)120×120×200mm
紅銅、化學染色
Copper, patination
2021

2.《流線型 I》《Streamline I》
1200×140×200mm
紅銅、鋁
Copper, aluminum
2022

3.《筆跡》《Handwriting》
1000×400×600mm
紅銅、蔗紙、印泥
Copper, hemp paper, ink paste
2021

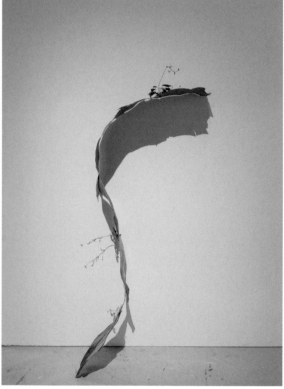

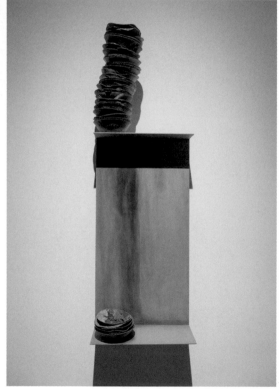

許溱秦 Chen-Chin, Hsu

1.《悠緩》《Peeling calmly》
900×250×1300mm
鋁、石墨
Aluminum, graphite
2021

2.《混I》《Mix I》
300×200×900mm
鋁
Aluminum
2021

3.《槁木》《Dead - alive》
Dimensions variable
鋁
Aluminum
2021

| | 3 | |
| 1 | | 2 |

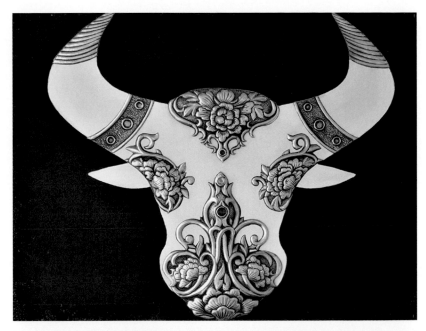

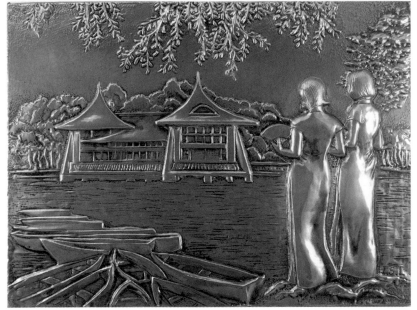

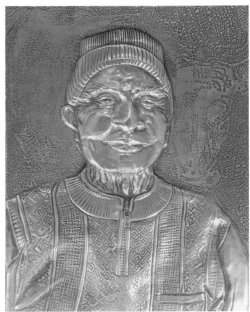

黃淑蘭 Su-Lan, Huang

1.《錫雕 我的父親》 《Tin carving my father》
360×460×280mm
99.9 純錫、壓克力、木材、樹酯
99.9 pure tin, acrylic, wood, resin
2020

2.《遙望台中公園湖心亭》《Looking at lake heart pavilion in Taichung park》
530×430×350mm
99.9 純錫、壓克力、木材、樹酯
99.9 pure tin, acrylic, wood, resin
2021

3.《富貴牛》《Rich cow》
99.9 純錫、壓克力、木材、樹酯
99.9 pure tin, acrylic, wood, resin
2020

3	
2	1

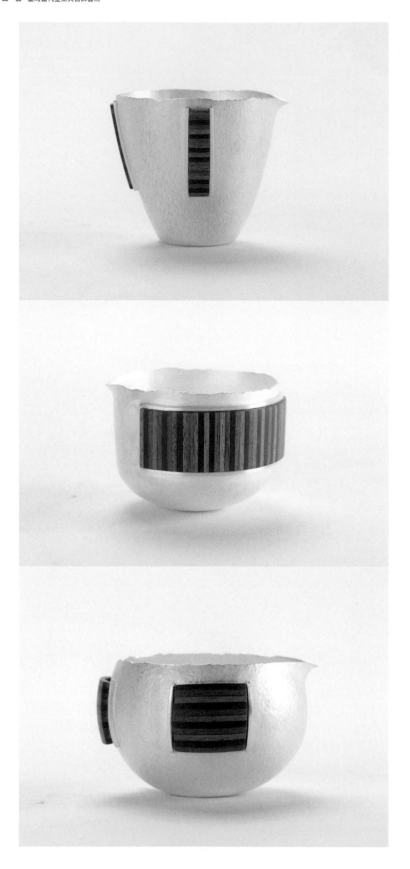

鄭芝琳　Jhih-Lin, Jheng

1.《茶鑲 - 1》《Tea setting - 1》
100×100×70mm
999 銀、花梨木、酸枝、黑檀、綠檀
999 silver, rosewood, ebony wood, green sandalwood
2019

2.《茶鑲 - 2》《Tea setting - 2》
90×90×75mm
999 銀、花梨木、酸枝、黑檀、綠檀
999 silver, rosewood, ebony wood, green sandalwood
2019

3.《茶鑲 - 3》《Tea setting - 3》
95×95×90mm
999 銀、花梨木、酸枝、黑檀、綠檀
999 silver, rosewood, ebony wood, green sandalwood
2019

| 1 |
| 2 |
| 3 |

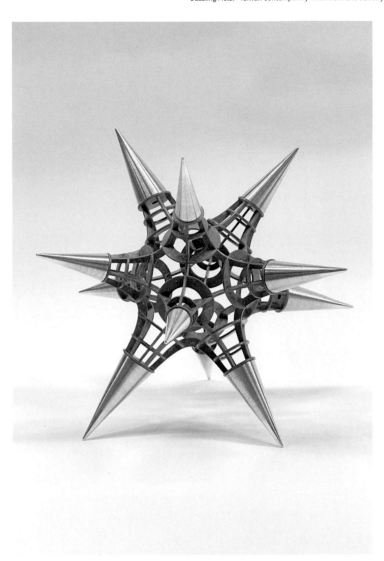

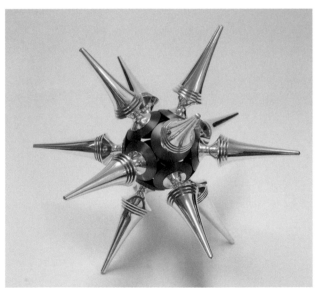

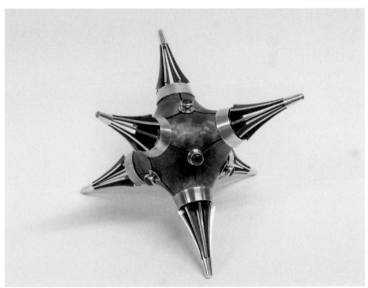

周 立 倫 Lih-Luen, Jou

1.《新星系列 - 1》《Nova series - 1》
240×240×240mm
925 銀（硫化處理）、黃銅（銅綠處理）
925 silver(sulfurized), brass(patinated)
2021

2.《新星系列 - 2》《Nova series - 2》
200×200×200mm
925 銀、鈮（陽極處理）
925 silver, niobium(anodized)
2020

3.《新星系列 - 3》《Nova series - 3》
160×160×160mm
925 銀（硫化處理）、鈮（陽極處理）、綠瑪瑙
925 silver(sulfurized), niobium(anodized), green agate
2019

康嘉文　Chia-Wen, Kang

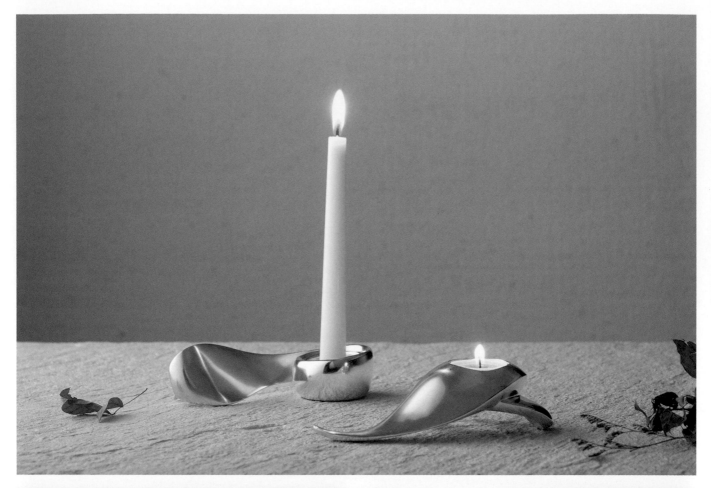

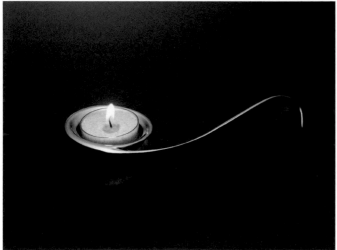

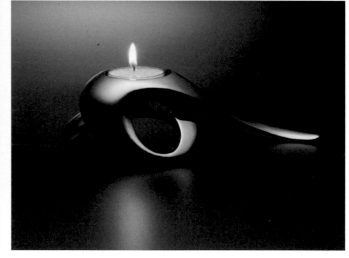

1. 《逐光 I》《Chasing the light I》
170×60×50mm
黃銅鍍銀
Silver-plated brass
2015

2. 《逐光 II》《Chasing the light II》
170×60×50mm
黃銅鍍銀
Silver-plated brass
2015

1 & 2

1 | 2

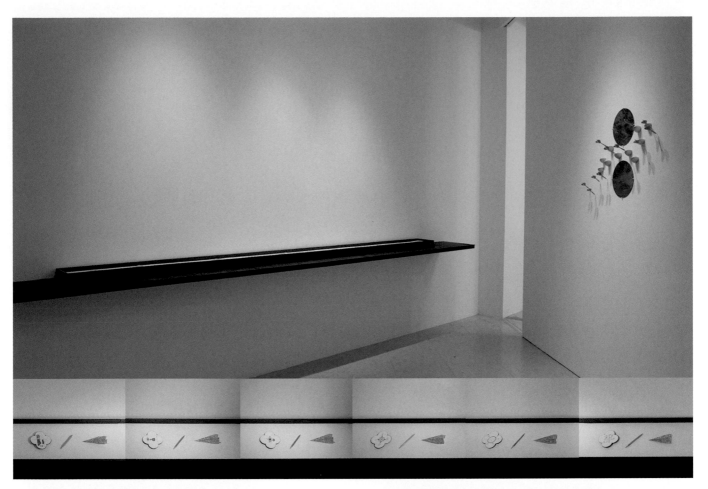

康立穎 Lih-Ying, Kang

1.《童言無忌》《Innocence》
作品尺寸依空間裝置而定 size variable
紅銅、黃銅、木材、紙、琺瑯、化學染色
Copper, brass, wood, paper, enamel, patina
2014

2.《旋轉軸》《Rotation axis》
作品尺寸依空間裝置而定 size variable
黃銅、青銅、鋁、木材、紙、線、化學染色
Brass, bronze, aluminum, wood, paper, thread, patina
2010

3.《我祇是安靜地擺置》《I just place quietly》
作品尺寸依空間裝置而定 size variable
紅銅、青銅、木材、線、化學染色、鍍金
Copper, bronze, wood, thread, patina, gold plated
2016

1	
2	3

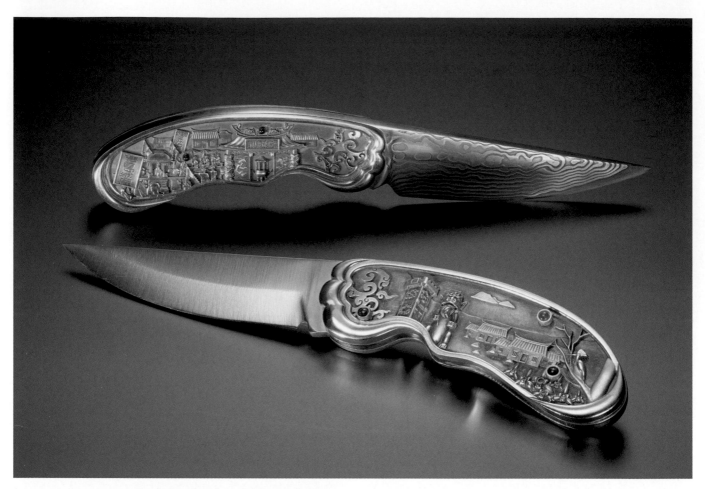

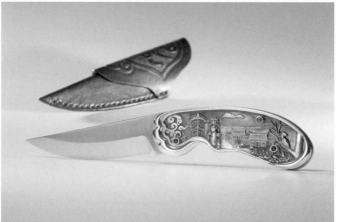

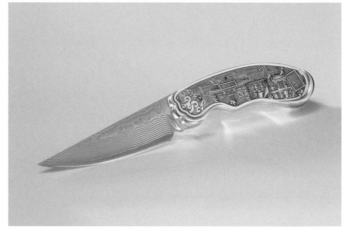

郭晉楓 Chin-Feng, Kuo

1.《浯島》《Kinmen》
170×40×20mm
銅、銅鍍銀、紅寶石、月光石、牛皮
Steel, silver-plated copper, ruby, moonstone, cowhide
2014

2.《城隍》《City god》
170×40×20mm
銅、銅鍍銀、紅寶石、月光石、牛皮
Steel, silver-plated copper, ruby, moonstone, cowhide
2014

| 1 & 2 |
| 1 | 2 |

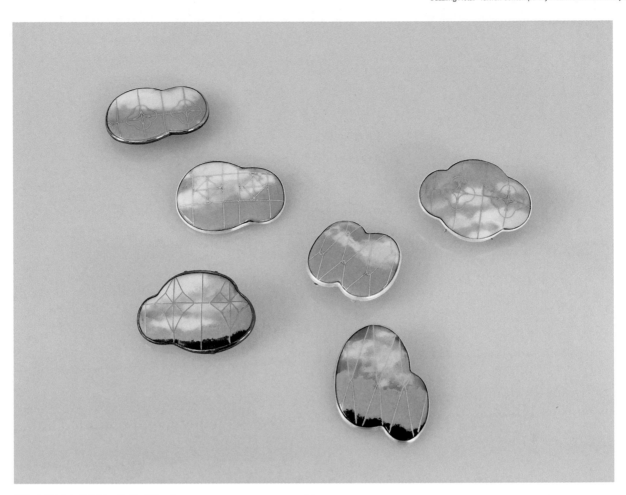

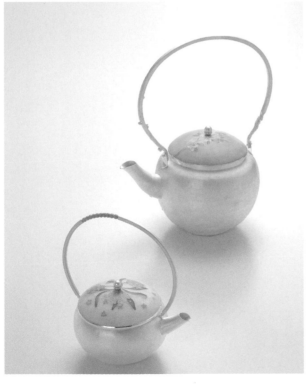

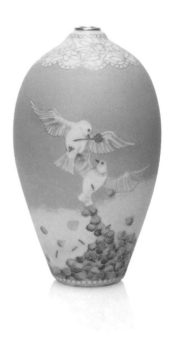

郭宜瑄 I-Hsuan, Kuo

1.《心象風景》《Mental image》
50×40×20mm
琺瑯、銅、銀
Enamel, copper, silver
2020

2.《愛的讚歌》《The hymn of love》
150×150×200、100×100×150mm
琺瑯、銅、銀
Enamel, copper, silver
2021

3.《圓舞曲》《Waltz》
60×60×120mm
琺瑯、銅、銀
Enamel, copper, silver
2022

1	
2	3

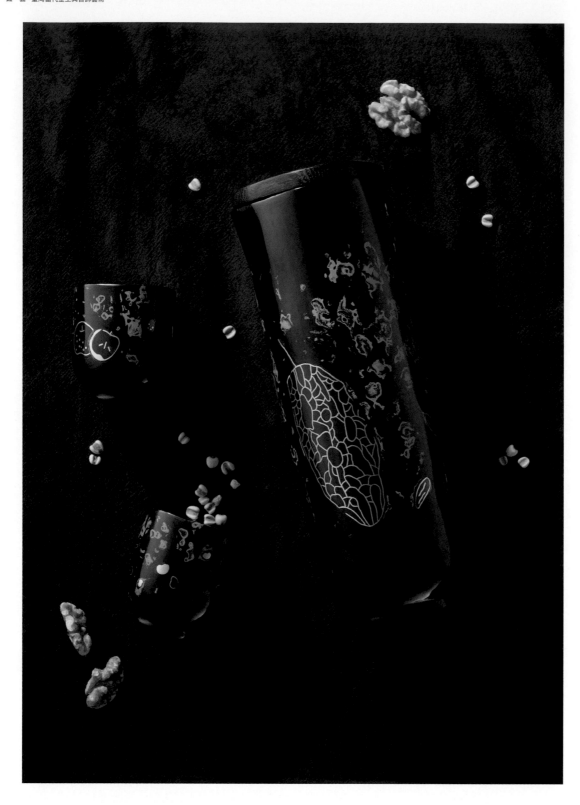

賴芃羽 Peng-Yu, Lai

1.《口日皿品 - 秋》《Kou ri min pin - autumn》
76×85×220mm
金銀錯、漆器、木工
Metal inlay, lacquer art, carpenter
2021-2022

2.《口日皿品 - 秋》《Kou ri min pin - autumn》
50×50×55mm
金銀錯、漆器
Metal inlay, lacquer art
2021-2022

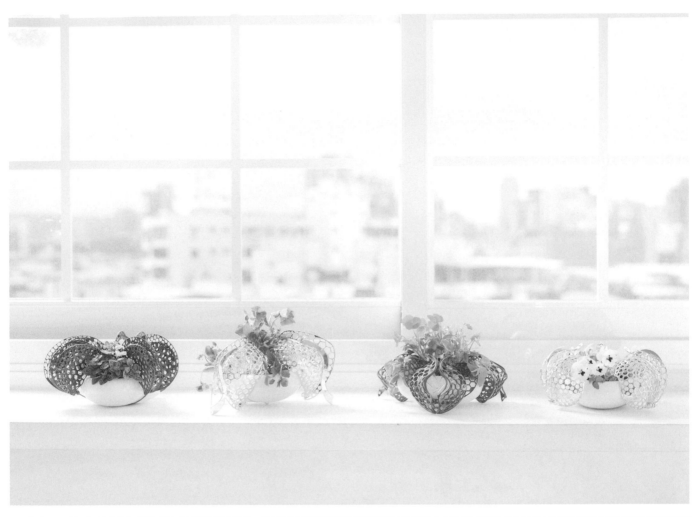

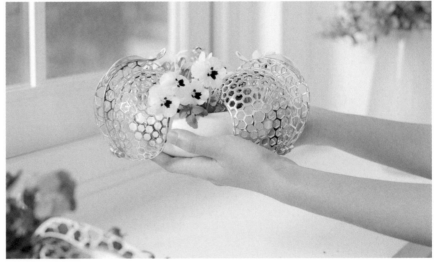

賴維政 / 蔡祐瑄　Wei-Zheng, Lai / Yu-Hsuan, Tsai

《蜂居》《Bee a home》
185×185×100、210×210×130mm
陶瓷、3D 列印、玻璃、銅
Ceramic, 3D print, brass, copper, glass
2019

賴維治　Wei-Zhi, Lai

1.《蝗禍》《Locust plague》
250×110×100mm
銅、環氧樹酯
Copper, epoxy
2020

2.《蝗禍》《Locust plague》
250×110×100mm
銅、環氧樹酯
Copper, epoxy
2020

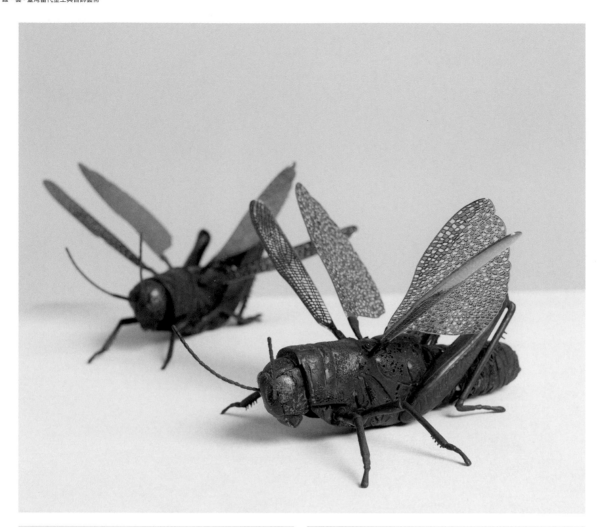
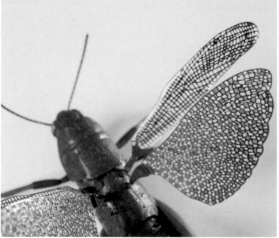
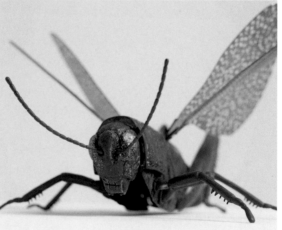

| 1 & 2 |
| 1 | 2 |

1.《曲折 2016》《Shape 2016》

2.《曲折：荷器》《Blossom》

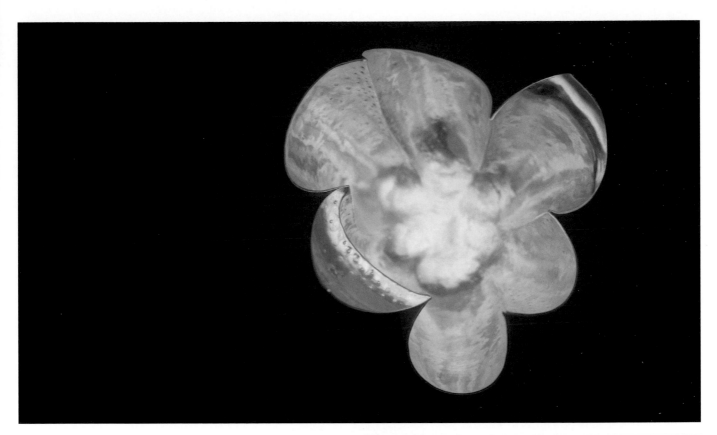

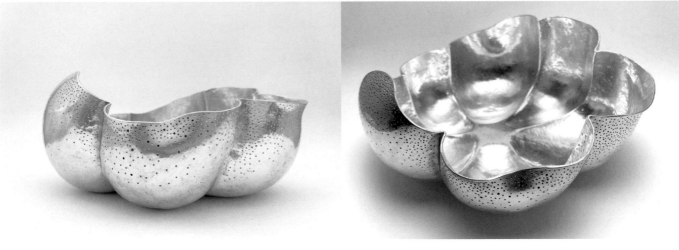

李敏惠 Min-Hui, Lee

1.《曲折 2016》《Shape 2016》
200×200×100mm
純銀
Silver
2016

2.《曲折：荷器》《Blossom》
180×180×8mm
銀
Silver
2018

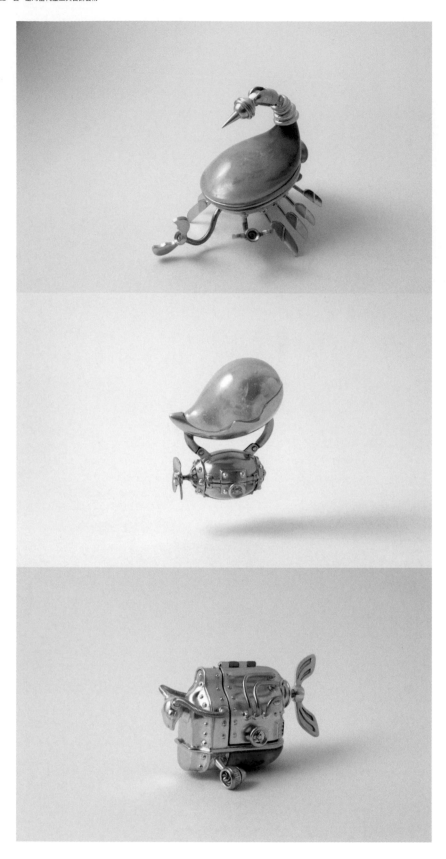

李婉瑜　Wan-Yu, Lee

1.《月間飛行 - 月亮巨蟹》
《Sail to the moon - moon in cancer》
60×48×30mm
銀、黃銅、紅銅、保麗膠
Silver, brass, copper, polyester resin
2021

2.《月間飛行 - 月亮天蠍》
《Sail to the moon - moon in scorpio》
58×68×47mm
黃銅、紅銅、保麗膠
Brass, copper, polyester resin
2021

3.《月間飛行 - 月亮魔羯》
《Sail to the moon - moon in capricorn》
33×57×40mm
銀、黃銅、紅銅、保麗膠
Silver, brass, copper, polyester resin
2021

| 2 |
| 1 |
| 3 |

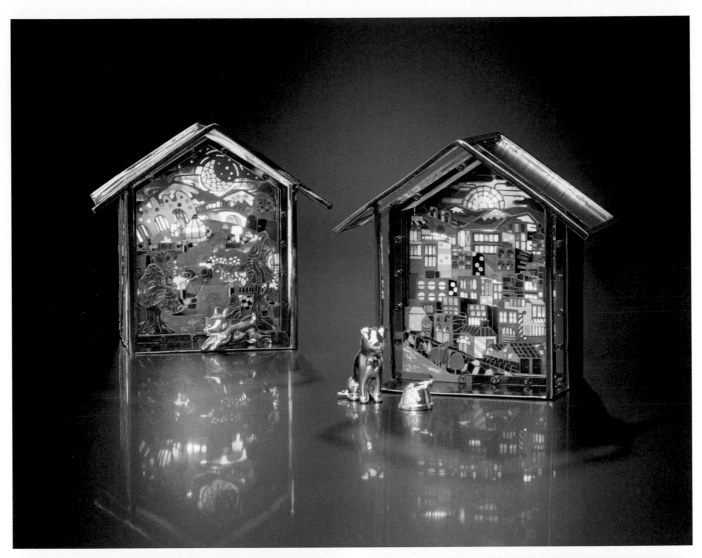

李依軒　Yi-Hsuan, Li

1.《狗狗的旅途因為我們而完整 - 歸宿》
《A Dog's journey - destination》
150×150×200mm
琺瑯、紅銅、鋯石
Enamel, copper, zircon
2017

2.《狗狗的旅途因為我們而完整 - 陪伴》
《A Dog's journey - accompany》
150×150×200mm
琺瑯、紅銅、鋯石
Enamel, copper, zircon
2017

3.《狗狗的旅途因為我們而完整 - 初次相遇》
《A Dog's journey - first meet》
150×150×200mm
琺瑯、紅銅、鋯石
Enamel, copper, zircon
2017

1
2

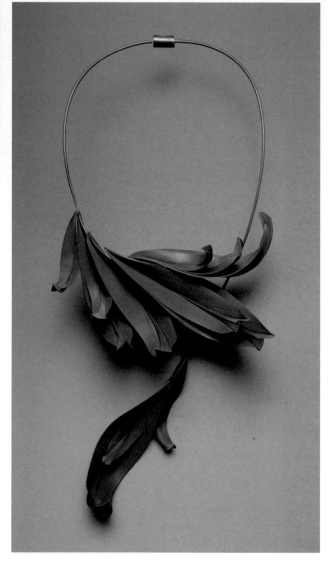

廖建清 Chien-Ching, Liao

1. 《擬真似幻 I》 《Floral simulation I》
360×330×200mm
紅銅、化學染色
Copper, patina
2012

2. 《擬真似幻 II》 《Floral simulation II》
290×270×130mm
紅銅、化學染色、色鉛筆
Copper, patina, prismacolor
2012

3. 《花序 I》 《The sequence of bloom I》
370×200×80mm
黃銅、紅銅、化學染色、色鉛筆
Brass, copper, patina, prismacolor
2012

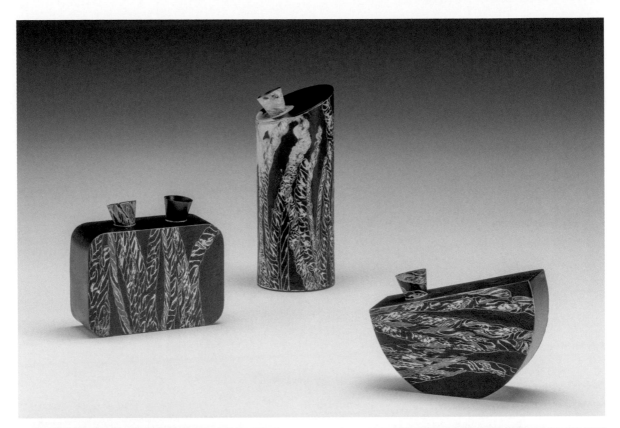

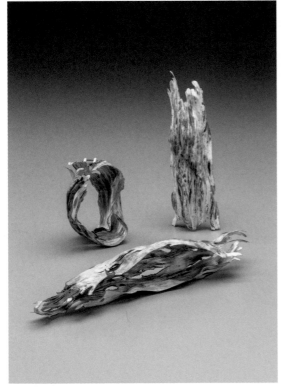

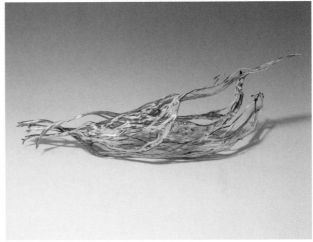

廖婉純　Wan-Chun, Liao

1.《光景》《Scene》
(左)70×30×77、(中)45×45×115、(右)80×27×65mm
銅、焊料
Copper, solder
2022

2.《痕》《Traces》
(左上)90×55×45、(右上)140×40×30、(中下)190×40×35mm
銅、焊料、銀、不鏽鋼針
Copper, solder, silver, steel needle
2021

3.《恍惚》《Dimly》
650×160×240mm
銅、焊料
Copper, solder
2021

1
2

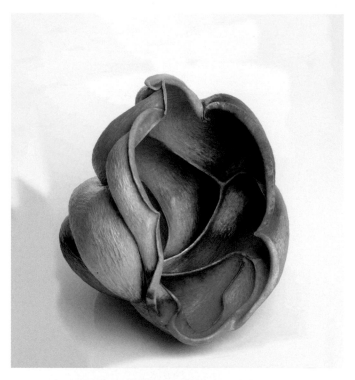

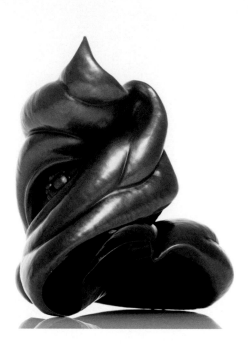

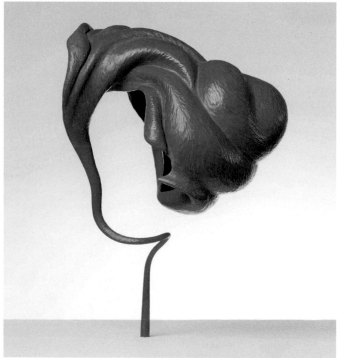

廖偉淇 Wei-Chi, Liao

1.《雲氣我執》《Clouds of hear》
180×230×310mm
紅銅
Copper
2013-2017

2.《拙納自在》《Simple of heart》
230×180×160mm
紅銅
Copper
2017

3.《無際之際》《The eye and mind》
350×270×300mm
紅銅
Copper
2015

2	3
1	

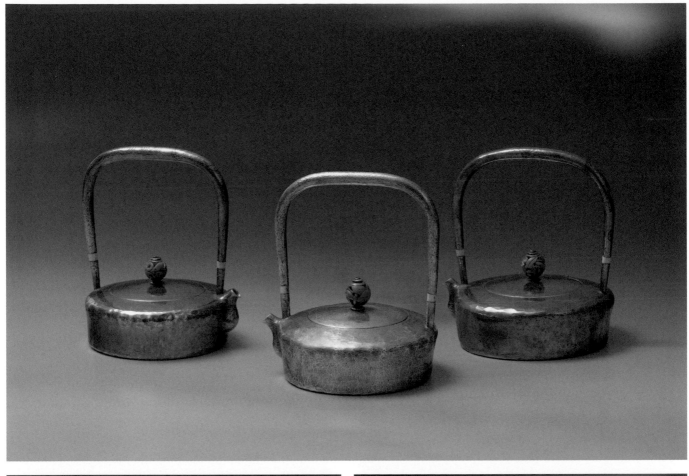

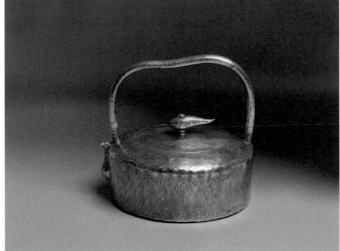

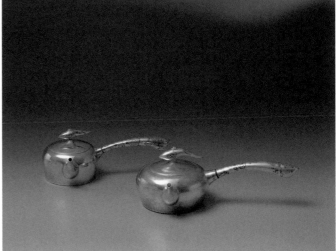

林國信 A-Shinn, Lin

1.《榭 - 口打出銀壺》
《Pavilion - punch out a silver teapot》
160×160×160mm
金、銀、銅
Gold, silver, copper
2018

2.《榭 II - 口打出銀壺》
《Pavilion II - punch out a silver teapot》
110×60×80mm
金、銀、銅、綠松石
Gold, silver, copper, turquoise
2017

3.《澐 - 側把銀壺》
《Yun - side handle silver teapot》
180×80×80mm
金、銀、銅
Gold, silver, copper
2016

2	
1	3

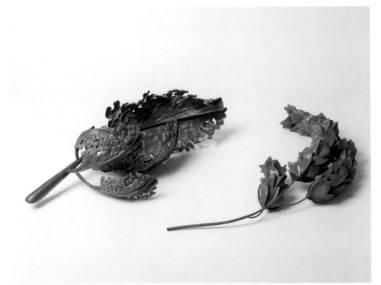

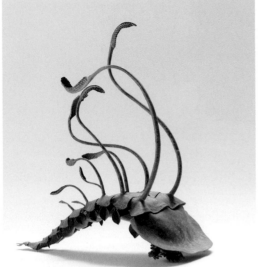

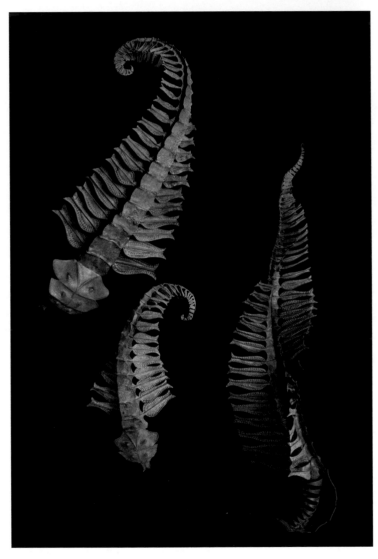

林耕弘　Keng-Hung, Lin

1.《蕨角三葉蟲》《The trilobite with ferning horned》
350×250×400mm
紅銅
Copper
2020

2.《延展》《Fold ferning》
530×250×165、550×300×105mm
紅銅
Copper
2020

3.《石炭紀公園》《Carboniferous park》
600×250×130、410×200×85、740×240×180mm
紅銅
Copper
2020

| 2 | 1 |
| 3 | |

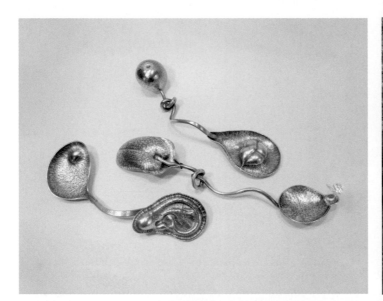

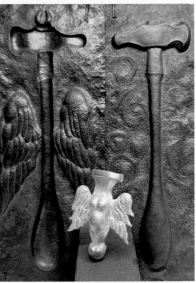

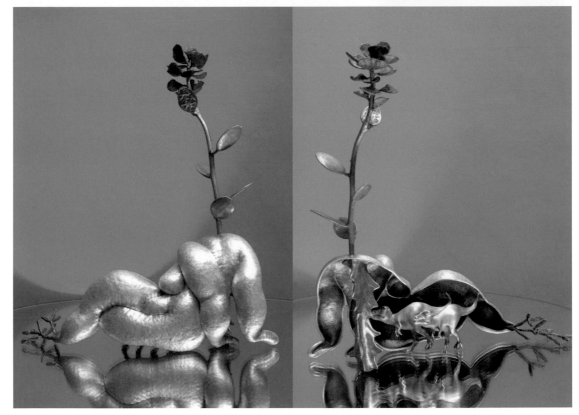

林麗娟 Li-Chuan, Lin

1.《夢行者》《Dream yogi》
250×220×70mm
純銀、925 銀、青銅
Fine silver, sterling silver, bronze
2010

2.《如此，如匙》《Such as spoons》
240×50×30mm(取作品最長尺寸)
純銀
Fine silver
2014

3.《願愛輕盈》《Pray for a lithe love》
300×270×20(銅件)、80×60×15mm(銀件)
純銀、紅銅、金箔
Fine silver, copper, gold leaf
2021-2022

| 2 | 3 |
| 1 | |

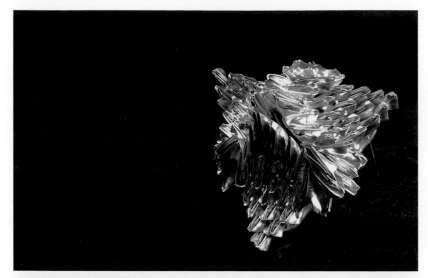

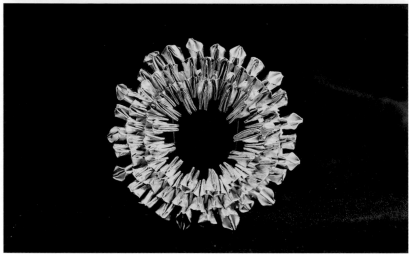

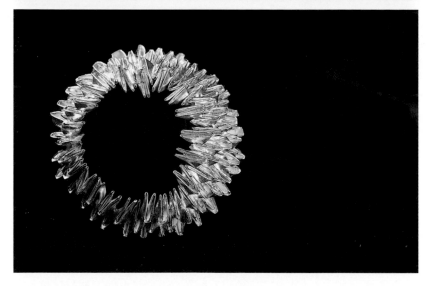

林子翔　Tzu-Hsiang, Lin

1.《生生》《Growing》
40×40×20mm
999 銀、925 銀、彈簧鋼
Fine silver, steeling silver, spring steel
2021

2.《曦和》《Soleil》
51×51×13mm
999 銀、925 銀、彈簧鋼
Fine silver, steeling silver, spring steel
2021

3.《望舒》《Luna》
56×56×20mm
999 銀、925 銀、彈簧鋼
Fine silver, steeling silver, spring steel
2021

林昱廷 Yu-Ting, Lin

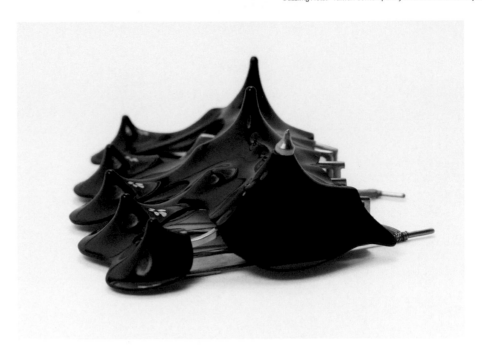

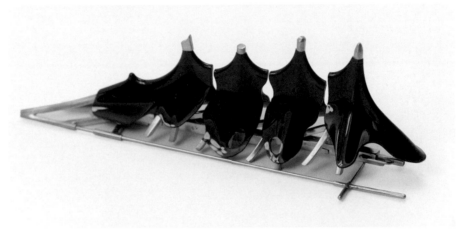

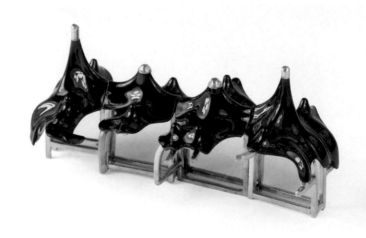

林昱廷 Yu-Ting, Lin

1.《無題》《Untitled》
87.6×74×31mm
銅、塑料
Brass, plastic
2015

2.《無題》《Untitled》
113×22×38mm
銅、塑料、不鏽鋼、彈簧
Brass, plastic, stainless steel, springs
2015

3.《無題》《Untitled》
87.5×36×40mm
銅、塑料、彈簧
Brass, plastic, springs
2015

1
2
3

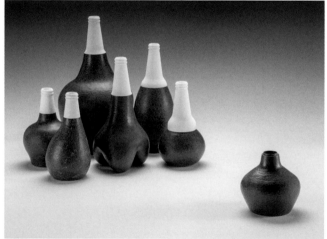

劉宜婷　Yi-Ting, Liou

1. 《失語症》《Aphasia》
(左 / 右)65×37×10、(中)60×35×10mm
紅銅、黃銅、不銹鋼線、PLA
Copper, brass, stainless steel wire, PLA
2018

2. 《群體之外》《Outsider》
700×900×310mm
紅銅、PLA
Copper, PLA
2020

3. 《規格化》《Standardisation》
1000×1000×250mm
紅銅、黃銅、PLA、木頭
Copper, brass, PLA, wood
2019

1	
3	2

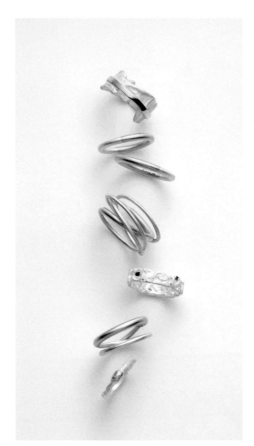

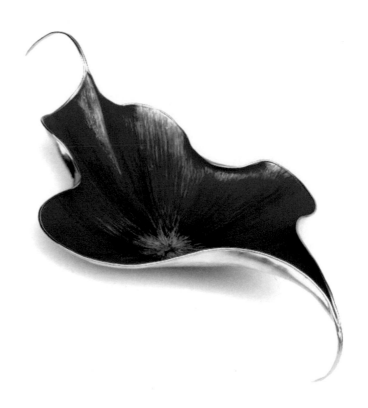

劉冠伶　Kuan-Lin, Liu

1.《印象‧花開》《Impression blossom》
260×300×100mm
銅
Copper
2004

2.《日冕》《Corona》
20×20×6mm
銀
Silver
2017

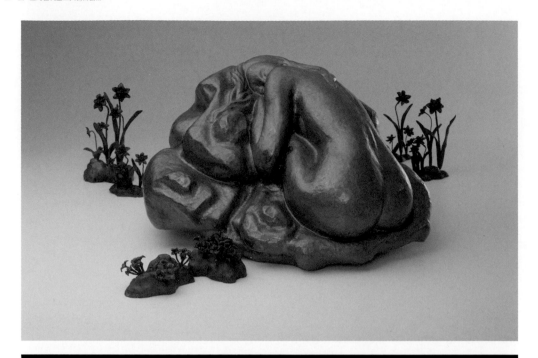

劉書佑　Shu-Yu, Liu

1.《大地之母 - 冬季》《We only have two seasons left》
350×300×280mm
紅銅
Copper
2019

2.《大地之母 - 夏季》《We only have two seasons left》
300×280×200mm
紅銅
Copper
2018

劉紋安 Wen-An, Liu

1.《量米杯》《Rice measure》
70×70×70mm
銅合金
Gilding meta
2018

2.《自體分娩 2》《Fission 2》
Variable
陶瓷、銀、不鏽鋼
Porcelain, sterling silver, stainless steel
2015

劉宜欣　Yi-Shin, Liu

1.《記憶風景 _ 雪日暖光》《Memorable scenes - snow days and warm light》
90×90×5、90×90×8、90×90×8、90×90×12mm
紅銅、琺瑯
Copper, enamel
2021

2.《記憶風景 _ 雪日小森》《Memorable scenes - snow days and little forest》
150×72×5、150×72×8、150×72×12mm
紅銅、琺瑯
Copper, enamel
2021

1
2

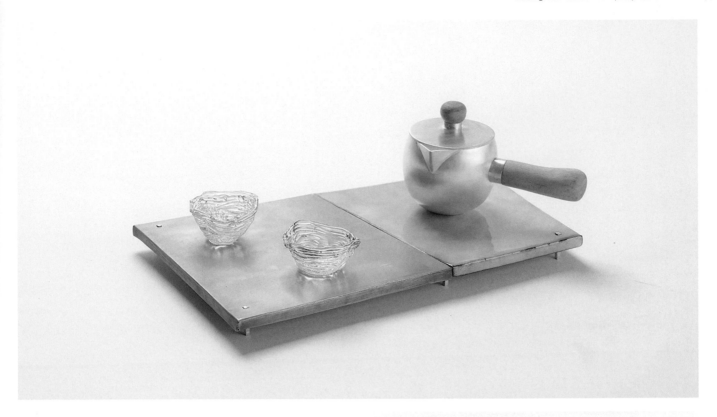

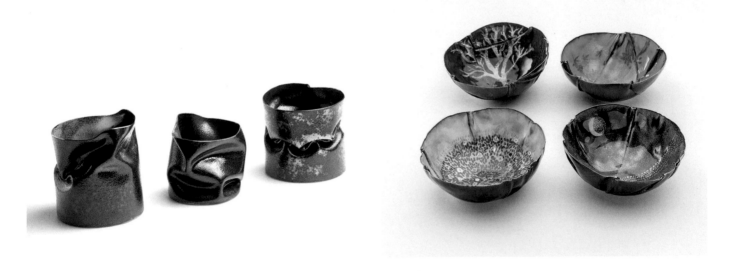

呂涵育　Han-Yu, Lu

1.《日常存有》《Daily being》
70×70×75、80×80×95、80×80×75mm
紅銅、琺瑯
Copper, enamel
2021

2.《伴》《Accompany》
茶盤 270×170×30、銀壺 75×70×130、玻璃杯 45×45×30mm
銀、錫、紅銅、黃銅、琺瑯、玻璃、木頭
Silver, tin, copper, brass, enamel, glass, wood
2019

3.《四季映像》《Four seasons impression》
150×150×60mm
紅銅、琺瑯、金箔
Copper, enamel, gold foil
2018

| | 2 | |
| 1 | | 3 |

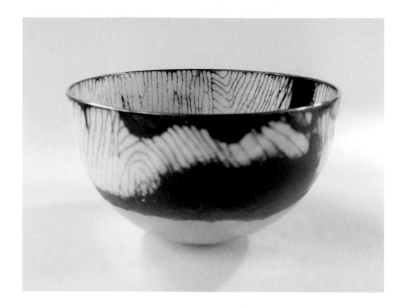

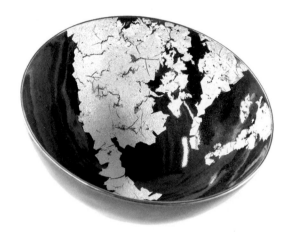

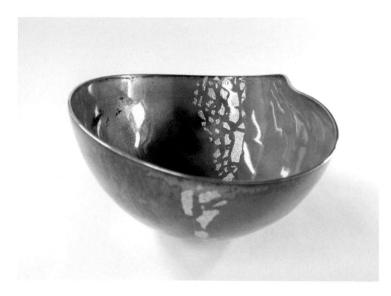

呂 燕 華 Yen-Hwa, Lu

1.《山倒影》《Reflection of mountain》
125×125×8mm
紅銅，琺瑯
Copper, enamel
2018

2.《春之雨》《Spring rain》
125×125×65mm
紅銅、琺瑯、銀箔
Copper, enamel, silver foil
2019

3.《金色月光》《Golden moonlight》
150×150×75mm
紅銅、琺瑯、金箔
Copper, enamel, gold foil
2017

1
2
3

南宇陽 Yu-Yang, Nan

1.《觀風 - 花器創作》
《The floating spirit - vase creation》
Ø 70×230mm
99.99 純錫、黃銅
99.99 pure tin, brass
2021

2.《白墨 - 盤型創作》
《White ink - tea plate creation》
380×140×15mm
99.99 純錫、台灣櫸木
99.99 pure tin, Taiwan beech
2021

3.《品山 - 茶倉創作》
《Taste mountains - tea caddy creation》
Ø100×95、Ø126×120、Ø166×105mm
99.99 純錫、黃銅
99.99pure tin, brass
2022

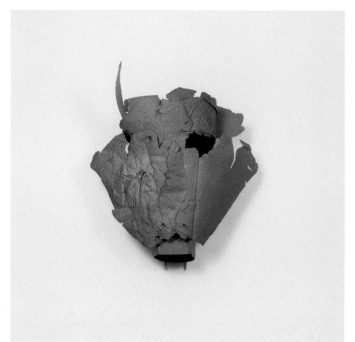

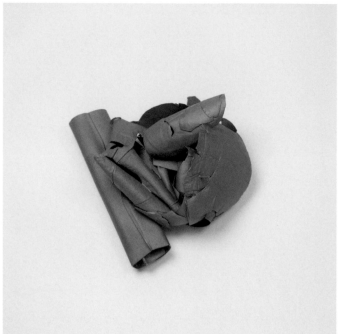

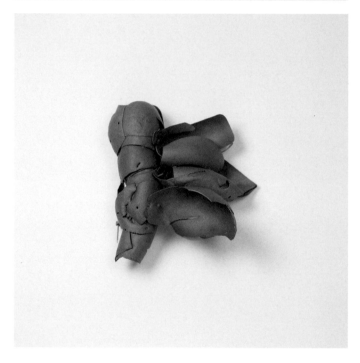

歐軍佑 Jiun-You, Ou

1.《個體神話 - 暗色 #1》
《Individual mythology - dark #1》
110×130×35mm
紅銅、黃銅、銀、不銹鋼線
Copper, bronze, silver, stainless steel wire
2015-2020

2.《個體神話 - 暗色 #2》
《Individual mythology - dark #2》
120×115×45mm
紅銅、黃銅、銀、不銹鋼線
Copper, bronze, silver, stainless steel wire
2015-2020

3.《個體神話 - 暗色 #3》
《Individual mythology - dark #3》
110×95×35mm
紅銅、黃銅、銀、不銹鋼線
Copper, bronze, silver, stainless steel wire
2015-2020

1	2
3	

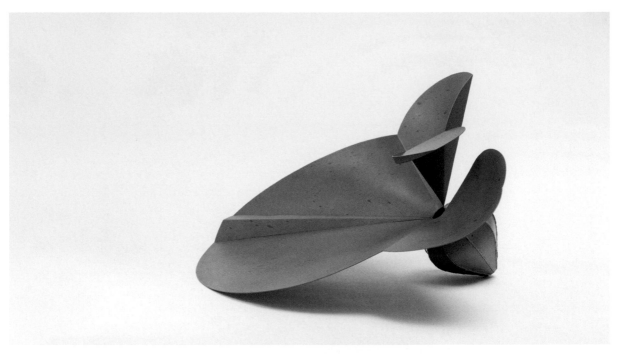

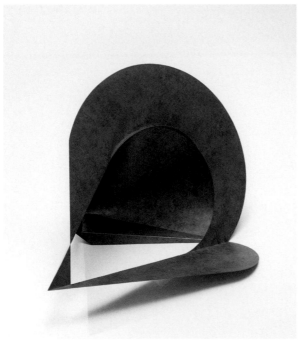

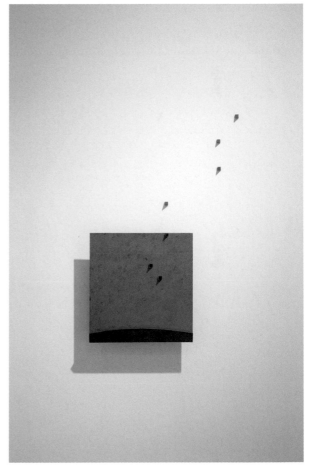

歐立婷 Li-Ting, Ou

1.《之間 V》《Between V》
380×380×240mm
銅板、鏽蝕染色、蠟
Steel, rust bluing, wax
2020

2.《徑 V》《Path V》
560×450×400mm
銅板、鏽蝕染色、蠟
Steel, rust bluing, wax
2019

3.《佇 V》《Stand V》
300×400×50mm
銅板、鏽蝕染色、蠟
Steel, rust bluing, wax
2019

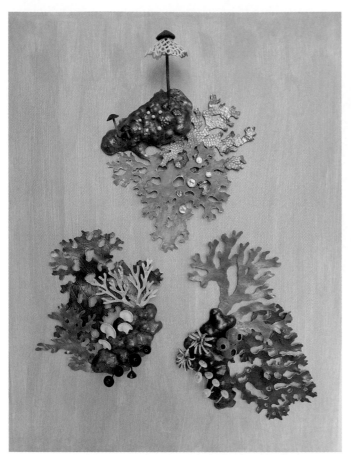

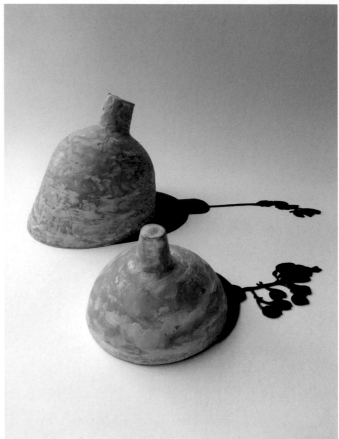

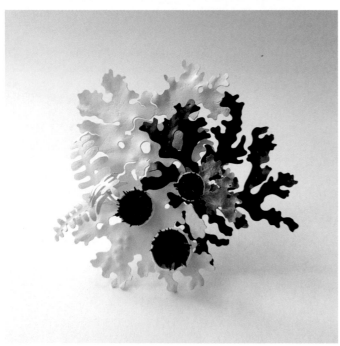

許 美 嘉　Mei-Jia, Syu

1. 《悸動之隅》《Enchanting corner》
350×270×60mm
純銀、紅銅、黃銅、丙烯顏料
Sterling silver, copper, brass, acrylic paint
2022

2. 《器・非器》《Vase in another universe》
230×98×93、143×75×50mm
紅銅、黃銅
Copper, brass
2022

3. 《悄然》《Gently and quietly》
100×100×45mm
紅銅、黃銅、鐵粉
Copper, brass, iron powder
2022

1	2
3	

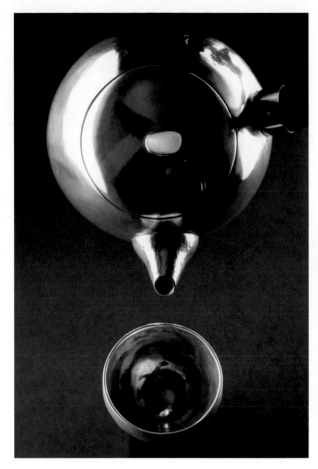

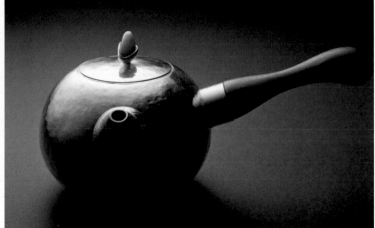

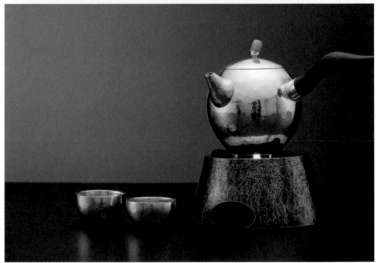

蔡佳雯 Chia-Wen, Tsai

1.《慢。生活》《Slow and simple living》
200×120×130mm
銀、台灣玉石、黑檀木
Silver, jade, ebony
2012

2.《慢。生活》《Slow and simple living》
135×100×90mm
銀、台灣玉石、黑檀木
Silver, jade, ebony
2012

1 & 2 | 1
| 2

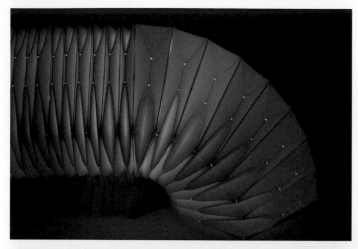

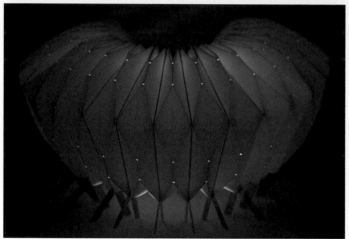

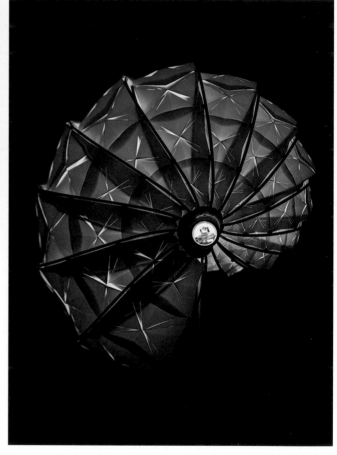

蔡亞潔 Ya-Jie, Tsai

1.《翻翻燈》《Fan - fan - light》
600×500×500mm
不鏽鋼、ＰＰ板、紅銅管、壓克力
Stainless steel, polypropylene(p.p), copper tube, acrylic
2014

2.《翻翻花》《Fan - fan - flower》
500×300×450mm
不鏽鋼、ＰＰ板、螺絲
Stainless steel, polypropylene(p.p), screw
2014

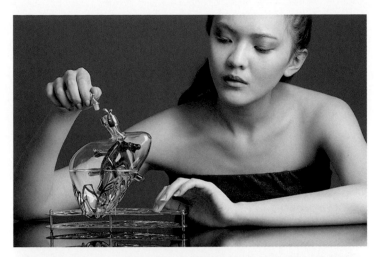

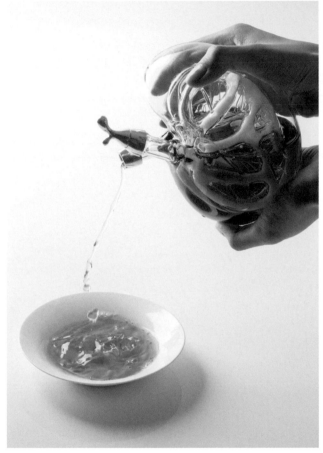

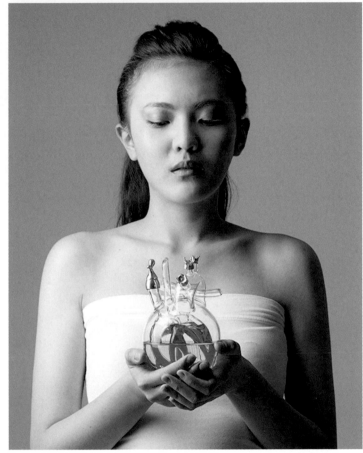

蔡宜蓁 Yi-Chen, Tsai

1.《親愛的內臟 - 腎》《Dear Organs - Kidneys》
300×200×140mm
銀、銅、不鏽鋼、玻璃、矽膠
Silver, copper, stainless steel, glass, silicone
2013

2.《親愛的內臟 - 肝》《Dear Organs - Liver》
300×180×140mm
銀、銅、不鏽鋼、玻璃、矽膠
Silver, copper, stainless steel, glass, silicone
2013

3.《親愛的內臟 - 心》《Dear Organs - Heart》
280×200×140mm
銀、銅、不鏽鋼、玻璃、矽膠
Silver, copper, stainless steel, glass, silicone
2013

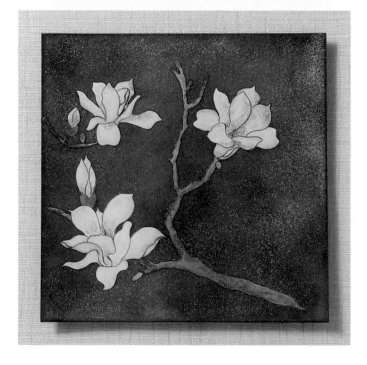

曾莉婷 Li-Ting, Tseng

1.《花時・緣 I》《The destiny I》
365×365×30mm
紅銅、琺瑯
Copper, enamel
2018

2.《花時・緣 II》《The destiny II》
265×265×30mm
紅銅、琺瑯
Copper, enamel
2018

3.《花時・緣 III》《The destiny III》
265×265×30mm
紅銅、琺瑯
Copper, enamel
2018

1	2
3	

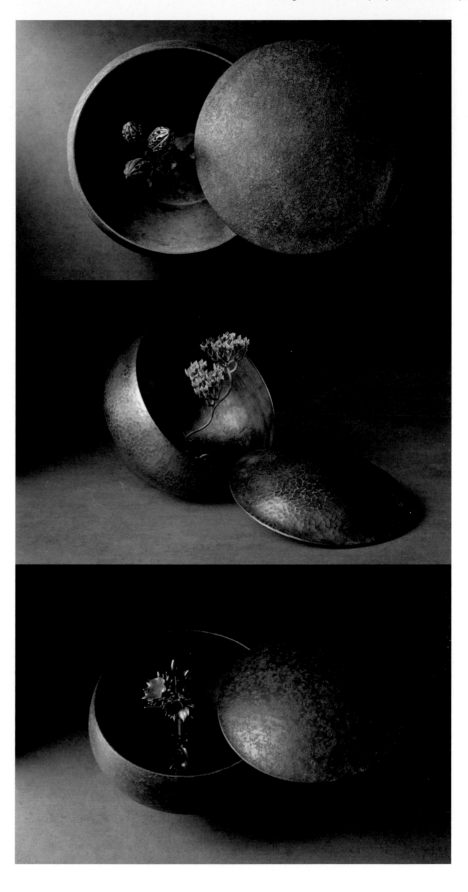

曾 永 玲　Yung-Ling, Tseng

1.《蒔時 - 一花一世界之 01》《In the world - 01》
130×130×90、40×30×90mm
紅銅、黃銅
Copper, brass
2020

2.《蒔時 - 一花一世界之 05》《In the world - 05》
130×130×90、40×50×130mm
紅銅、黃銅
Copper, brass
2020

3.《蒔時 - 一花一世界之 06》《In the world - 06》
130×130×90、40×40×80mm
紅銅、黃銅
Copper, brass
2020

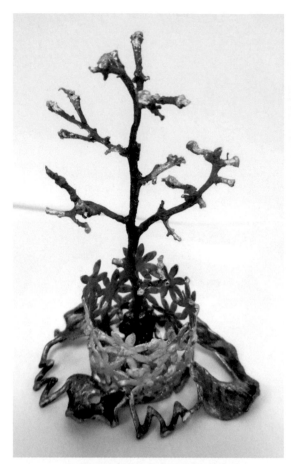

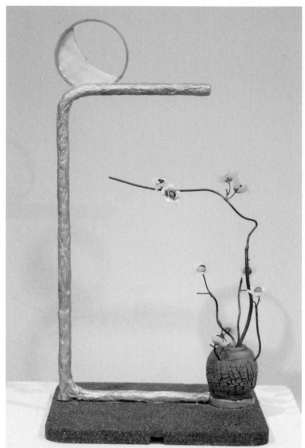

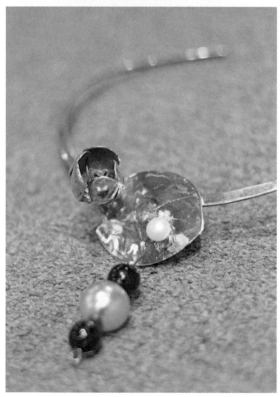

杜嘉琪 Chia-Chi, Tu

1.《秋景》《Autumn scenery》
50×50×80mm
紅銅
Copper
2021

2.《疏影斜月》《Sparse shadow with slanting moon》
300×300×570mm
金屬、玻璃、陶瓷
Metal, glass, ceramic
2021

3.《台灣萍蓬草》《Taiwan yellow water lily》
40×100×25mm
紅銅、珍珠、玉石
Copper, pearl, jade
2021

王安琪 An-Chi, Wang

1.《不入耳》《Silent sound source》
20×300×15mm
瑪瑙、銀
Agate, silver
2021

2.《那些討厭的時刻》《Unresolved moment》
120×15×10mm
瑪瑙、玻璃
Agate, glass
2021

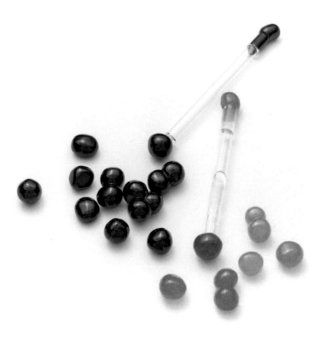

王安琪 An-Chi, Wang

1.《不入耳》《Silent sound source》
20×300×15mm
瑪瑙、銀
Agate, silver
2021

2.《那些討厭的時刻》《Unresolved moment》
120×15×10mm
瑪瑙、玻璃
Agate, glass
2021

1	1
	2

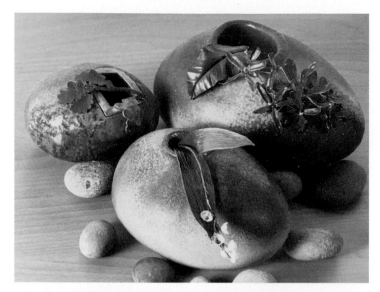

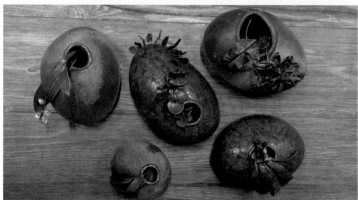

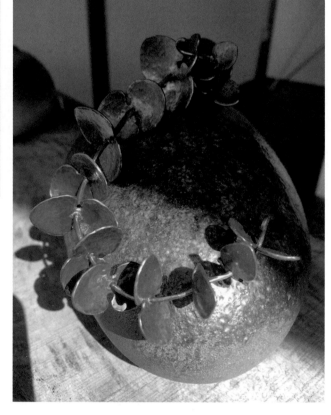

王夏滿　Hsia-Man, Wang

1.《藝想自然系列一》《Art with nature series 1》
50×40×12mm
柴燒陶、紅銅、銀
Firewood pottery, copper, silver
2020

2.《藝想自然系列二》《Art with nature series 2》
69×45×12mm
柴燒陶、紅銅
Firewood pottery, copper
2019

3.《藝想自然系列三》《Art with nature series 3》
69×45×12mm
柴燒陶、紅銅
Firewood pottery, copper
2020

1	
2	3

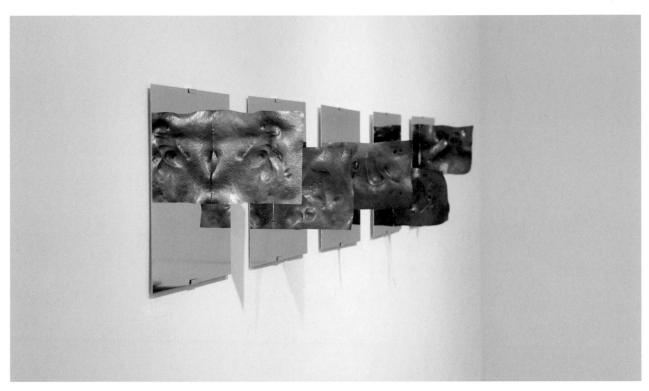

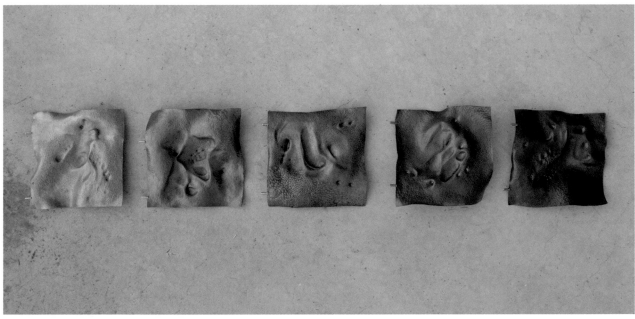

95

王 以 安 I-An, Wang

《沒有焦距的文字系列 - 友、好、心、多、呢》《Out of focus letter - yu, hao, hsin, duo, ne》
190×300×155mm
紅銅、黃銅、不鏽鋼
Copper, brass, stainless steel
2021

王意婷　I-Ting, Wang

1.《佇足 #1、2》《Stay #1、2》
(#1)100×100×150、(#2)100×80×140mm
紅銅、琺瑯
Copper, enamel
2018

2.《佇足 #3、4》《Stay #3、4》
(#3)70×70×210、(#4)70×70×180mm
紅銅、琺瑯
Copper, enamel
2018

| 1 |
| 2 |

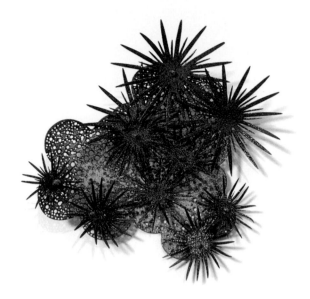

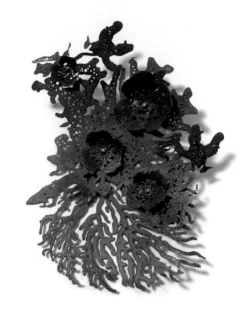

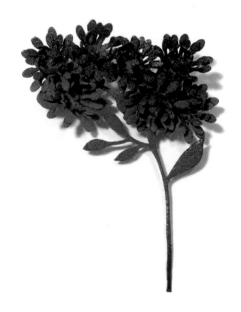

吳 竟 銍　Ching Chih, Wu

1.《海底印象》《The impression of ocean》
110×95×45mm
紅銅、琺瑯、銀
Copper, silver, enamel
2020

2.《火珊瑚》《The fire coral》
130×105×35mm
紅銅、琺瑯、銀
Copper, silver, enamel
2020

3.《末冬》《The end of winter》
70×100×25mm
紅銅、琺瑯、銀
Copper, silver, enamel
2020

1	2
3	

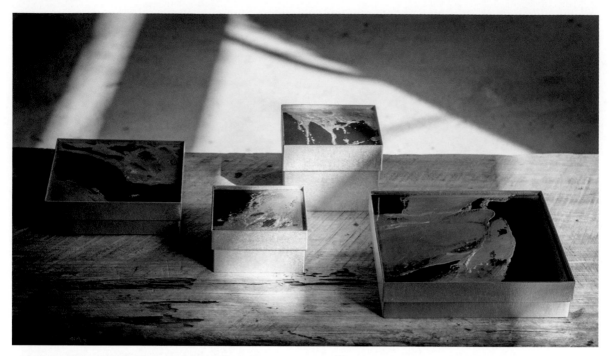

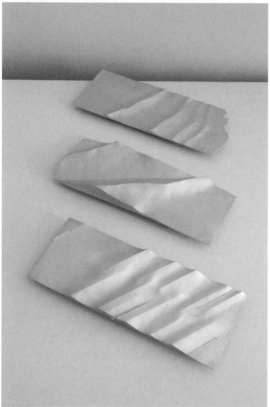

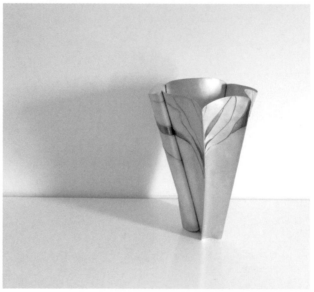

姚怡欣 Yi-Hsin, Yao

1.《錫光茶倉組》《Tin luster / pu'er tea cake box set》
205×205×45、160×160×45、117×117×92、107×107×56mm
紅銅、純錫
Copper, pure tin
2021

2.《印象台東》《Impression of Taitung》
350×140×40mm
黃銅、純錫
Brass, pure tin
2020

3.《生命之舞》《The dance with life》
290×275×410mm
黃銅、純錫、銀箔
Brass, pure tin, silver foil
2019

1	
2	3

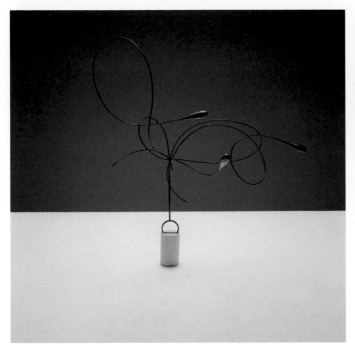

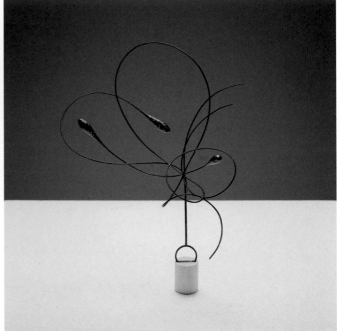

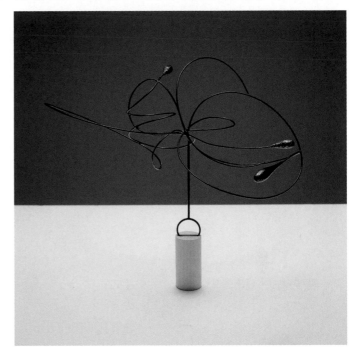

易佑安 Yu-An, Yi

1.《追尋》《Seek》
200×200×150mm
紙、漆、螺鈿
Paper, urushi, raden
2021

2.《追尋 II》《Seek II》
170×170×150mm
紙、漆、螺鈿
Paper, urushi, raden
2021

3.《追尋 III》《Seek III》
200×200×120mm
紙、漆、螺鈿
Paper, urushi, raden
2021

1	2
3	

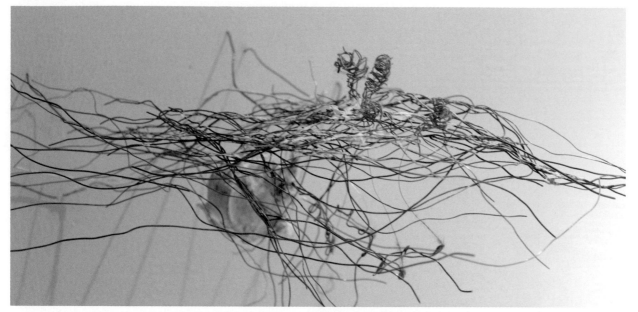

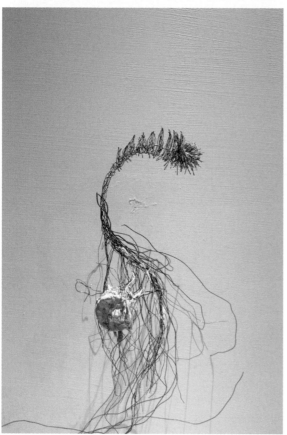

余孟儒 Meng-Ju, Yu

1.《癭 II》《Insect galls II》
150×90×300mm
鐵、馬達、釣魚線、複合媒材
Iron wire, motor, fishing line, mix media
2015

2.《癭 IV》《Insect galls IV》
380×15×200mm
鐵、馬達、複合媒材
Iron wire, motor, mix media
2015

3.《蔓生》《Growing》
8000×400×250mm
鐵絲、馬達、複合媒材
Iron wire, motor, mix media
2016

2	
1	3

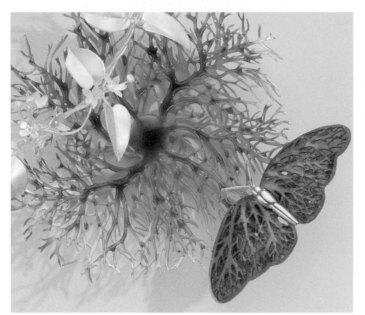

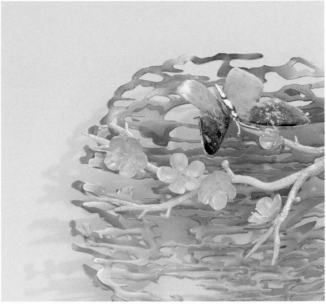

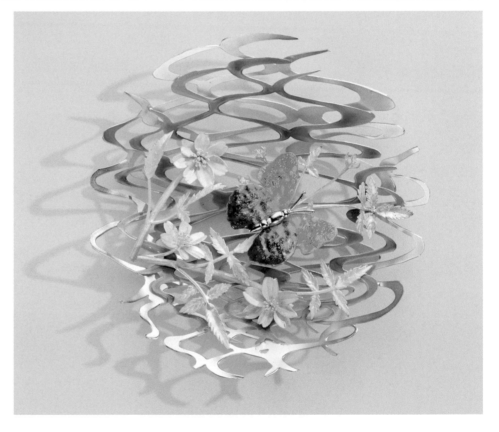

游 雅 帆 Ya-Fan, Yu

1.《夢‧蝶 - 青眼蛺蝶》
《Dream‧butterfly - junonia orithya》
15×15×4mm
925 銀、紅銅、琺瑯、環氧樹脂、不鏽鋼針
925 silver, copper, enamel, epoxy, stainless steel needle
2019

2.《夢‧蝶 - 艷粉蝶》
《Dream‧butterfly - delias pasithoe》
15×15×4mm
925 銀、紅銅、琺瑯、環氧樹脂、不鏽鋼針
925 silver, copper, enamel, epoxy, stainless steel needle
2019

3.《夢‧蝶 - 大絹斑蝶》
《Dream‧butterfly - chestnut tiger》
15×15×4mm
925 銀、紅銅、琺瑯、環氧樹脂、不鏽鋼針
925 silver, copper, enamel, epoxy, stainless steel needle
2019

3	2
1	

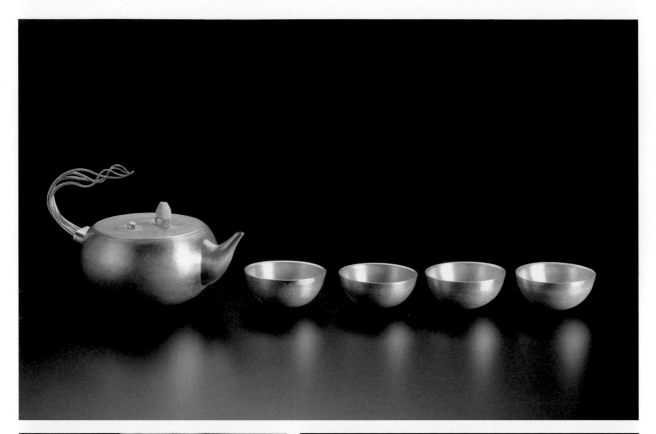

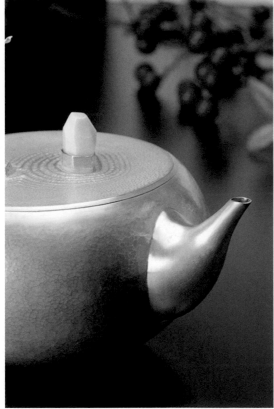

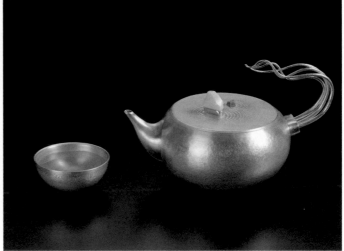

游奕晴 Yi-Ching, Yu

《山嵐水色》《Mountain lake》
120×120×65mm
925 銀、999 銀、白珊瑚
925 silver, 999 silver, white coral
2015

首飾

Jewelery

阮文盟 Weng-Mong, Ruan -《樂島 04》《Happy island 04》

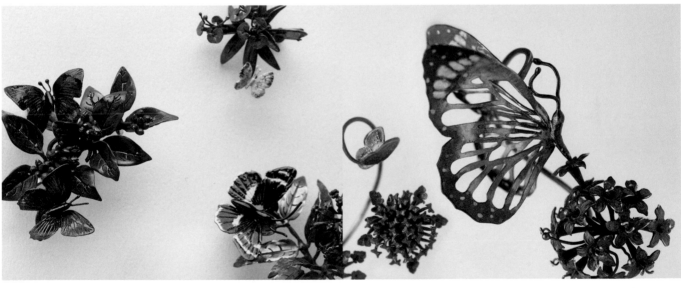

陳臆文　Yi-Wen, Chen

1.《蜜源 1》《With a butterfly 1》
70×40×40、50×30×30、50×50×45、 40×40×35、 60×30×30、50×30×30、
20×20×25mm
銀、紅銅、黃銅、漆
Silver, copper, brass, lacquer
2017

2.《蜜源 2》《With a butterfly 2》
50×30×30、 40×40×35、 20×20×25mm
銀、紅銅、黃銅、漆
Silver, copper, brass, lacquer
2017

陳映秀 Ying-Hsiu, Chen

陳映秀 Ying-Hsiu, Chen

1.《凝視 I》《Gaze I》
70×63×23mm
黃銅、現成物、不繡鋼線
Brass, found object, stainless steel wire
2011

2.《寫生系列》《Sketch series》
65×75×70mm
塑形土、織品、黃銅鍍 18K 金
Craft clay, fabric, 18k plated brass
2012

3.《寫生系列》《Sketch series》
65×75×70mm
合金鍍 18K 金、合金鍍白金
18k plated alloy, rhodium plated brass
2018

2	1
3	

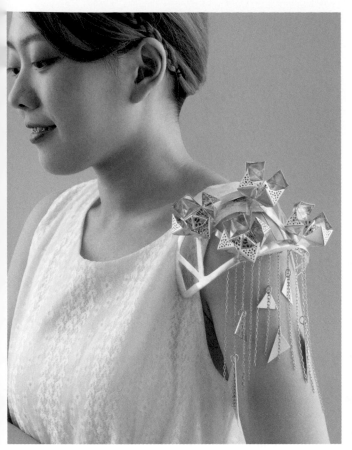

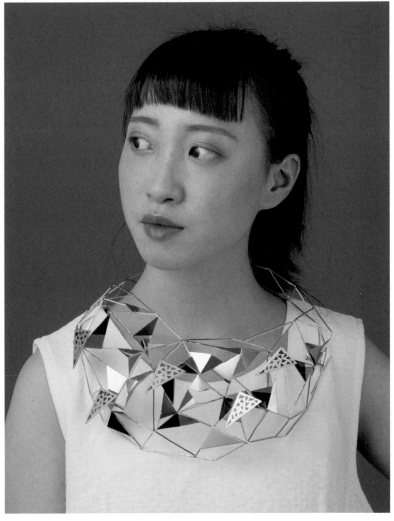

陳韋伶 / 湛佩璇　　Wei-Ling, Chen / Pei-Hsuan, Chan

1.《童樂 - 套鍊》《Child joy - collar necklace》
25×20×13mm
黃銅、銀、窗飾琺瑯、黃銅、冷琺瑯
Brass, silver, plique-à-jour enamel, brass, zircon
2018

2.《童樂 - 肩飾》《Child joy - shoulder ornament》
13×10.5×19mm
黃銅、冷琺瑯、黃銅、銀、窗飾琺瑯
Accessories, zircon, brass, silver, plique-à-jour enamel
2018

<div style="text-align:right">| 2 | 1 |</div>

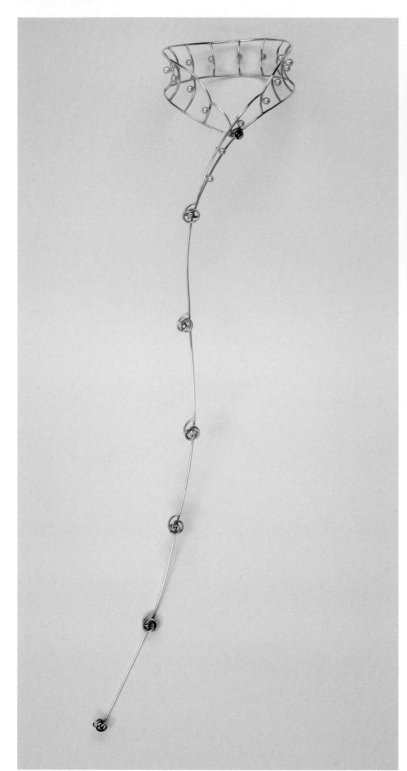

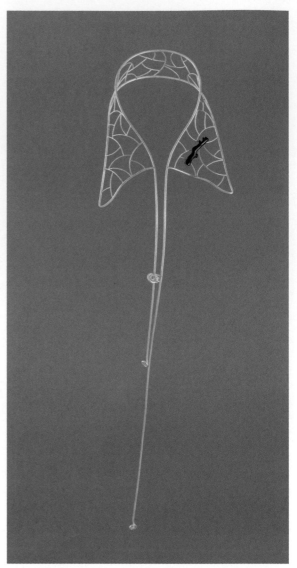

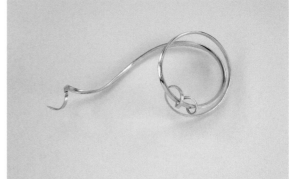

鄭巧明 Chiao-Ming, Cheng

1.《九個女子 #3》《Nine women III》
150×40×820mm
銀、粉紫珍珠
Silver, pink, purple pearls
2006

2.《九個女子 #9》《Nine women IX》
150×50×870mm
銀、紅珊瑚
Silver, red coral
2006

3.《穿越雲朵》《Through the clouds》
80×30×30mm
銀
Silver
2006

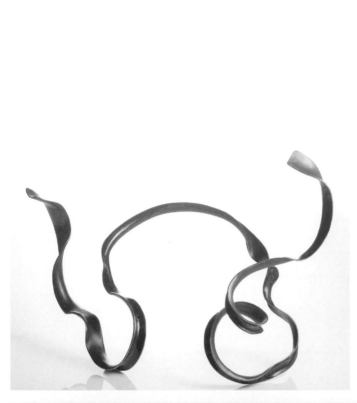
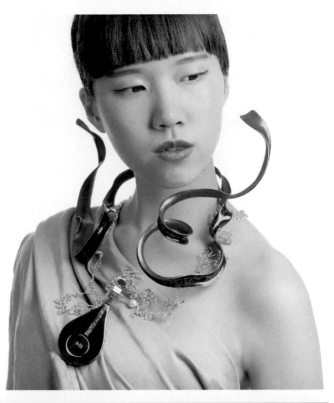

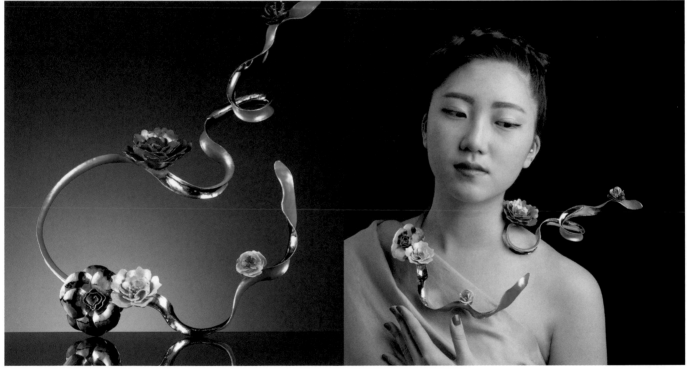

鄭聿婷 Yu-Ting, Cheng

1.《伎樂飛天》《Musical fairy》
300×250×120mm
銅、天然漆、螺鈿、珍珠
Copper, brass, natural lacquer, raden, pearl
2014

2.《散花飛天》《Flowing petals》
350×240×100mm
銅、天然漆
Copper, natural lacquer
2014

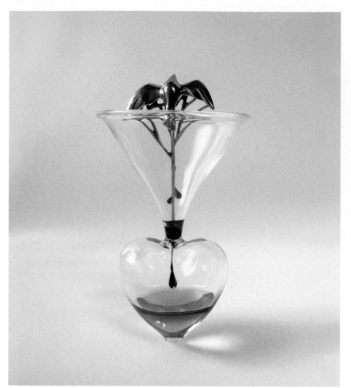

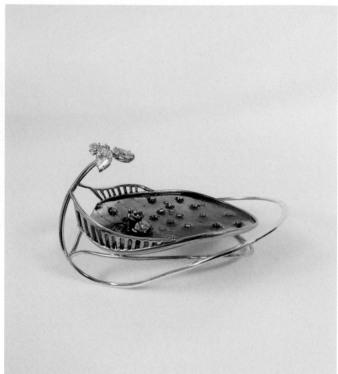

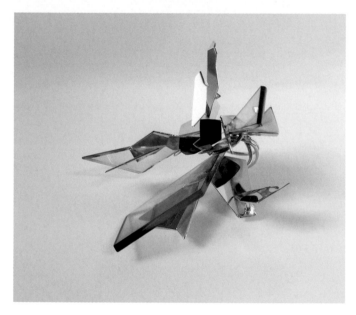

鄭 元 怡 Yuan-Yi, Cheng

1. 《夜鶯之歌》《The song of the nightingale》
120×62×62mm
925 銀、玻璃、環氧樹脂石、榴石
Sterling silver, glass, epoxy, garnet
2007

2. 《無法實現的舞會》《The impossible dance》
90×60×54mm
925 銀、電鍍、立方氧化鋯、環氧樹脂
Sterling silver, electroplating, cz, epoxy
2007

3. 《關於愛情》《About love》
100×95×80mm
925 銀、電鍍、壓克力
Sterling silver, electroplating, acrylic
2007

1	2
3	

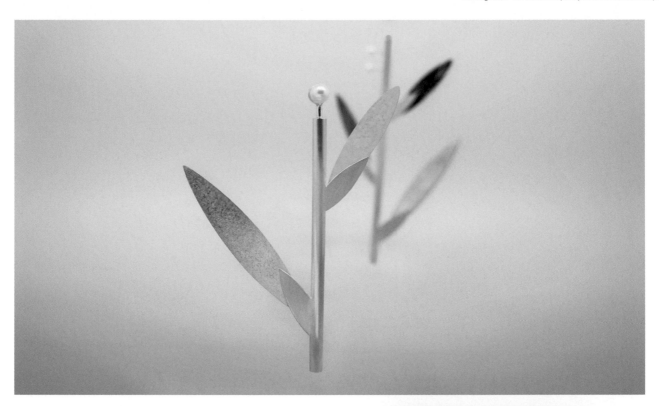

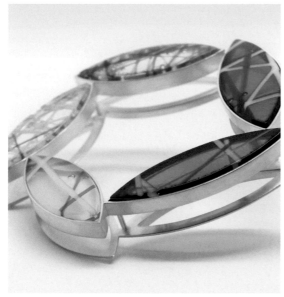

江怡瑩 I-Ying, Chiang

1.《靜好系列》《Tranquility》
80×60×10mm
925 銀、琺瑯、淡水珠
Sterling, enamel, freshwater pearl
2020

2.《旋進系列》《Precession》
120×120×35mm
925 銀、琉璃
Sterling, glass
2015

3.《俯拾系列》《Picking》
70×40×35mm
925 銀、矽膠
Sterling, silicon
2015

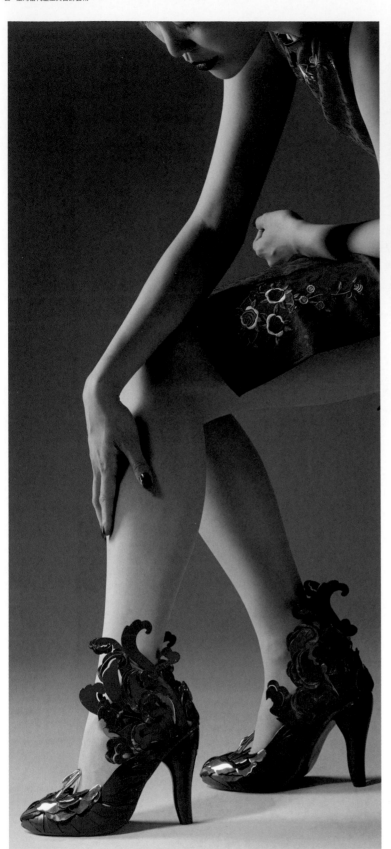

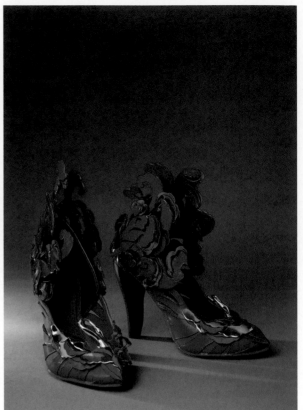

江曼荷　Man-Her, Chiang

《春花囍 - 鳳求凰》《Twined flower wedding high-heeled shoes》
250×160×240mm
金屬、皮革、纏花、絲綢、漆器
Metal, leather, twined flowers, silk, lacquer
2014

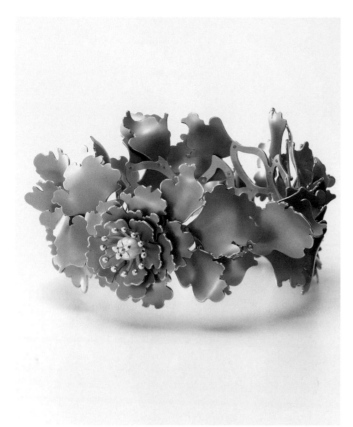

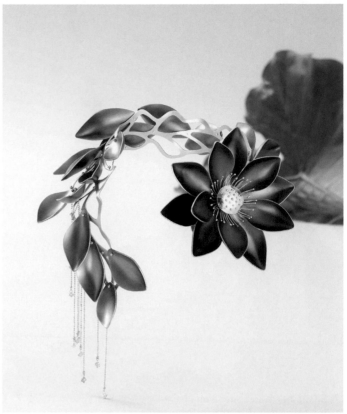

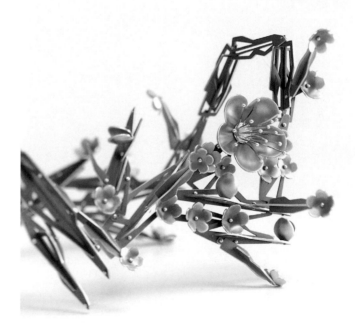

簡嬿庭 Yen-Ting, Chien

1.《微風。牡丹》《The breeze . peony》
150×150×85mm
鋁、925 銀
Aluminum, s925
2009

2.《流動。荷花》《The flow . lotus》
210×190×100mm
鋁、925 銀
Aluminum, s925
2009

3.《梅花》《The plum blossom》
300×200×150
鋁、925 銀
Aluminum, s925
2009

1	2
3	

127

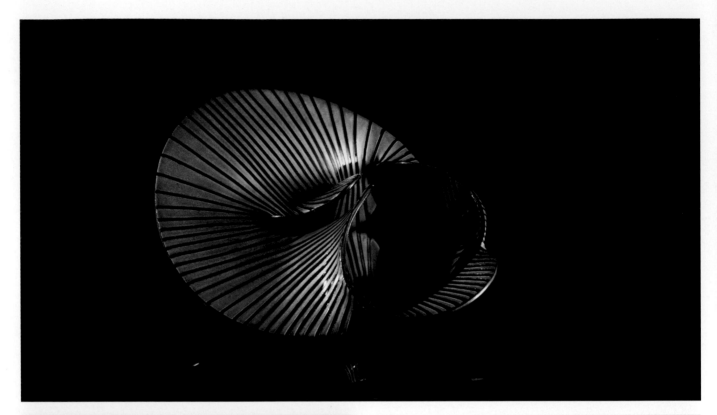

周 仕 敏 Shih-Min, Chou

1.《無限循環 I》《Infinity I》
100×100×20mm
樹脂、天然漆、金箔
Polyster resin, lacquer, gold foil
2009

2.《生命之旅 V》《Journey V》
210×175×100mm
複合媒材 (黃銅、腰果漆、珍珠粉、樹脂、彈性纖維)
Mixed media
2009

3.《內外之間 I》《Between I》
40×45×25mm
紅銅、天然漆、金箔
Copper, lacquer, gold foil
2009

1.《是結束也是開始》《It is the end, also the beginning》 2.《選一個喜歡的，帶走吧！》《Pick one that you like and take it!》 3.《生活窺視》《Peeping at life》

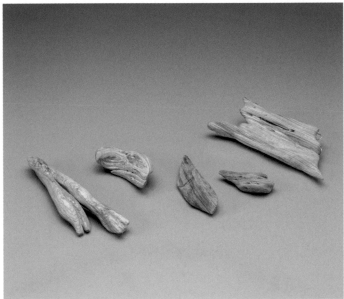

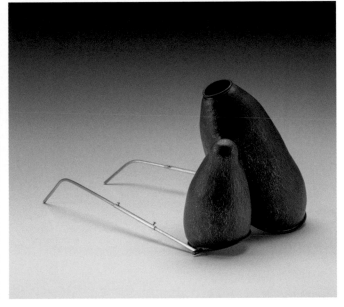

周育慈 Yu-Tzu, Chou

1.《是結束也是開始》《It is the end, also the beginning》
160×60×40、90×32×25、65×25×25、80×35×40、
165×40×25mm
報紙、銀、黃銅、不鏽鋼
Newspaper, silver, brass, stainless steel
2020

2.《選一個喜歡的，帶走吧！》《Pick one that you like and take it!》
100×60×50、50×40×30、50×4×35、80×60×35mm
報紙、黃銅
Newspaper, brass
2020

3.《生活窺視》《Peeping at life》
300×200×200mm
紅銅
Copper
2018

| | 2 | |
| 1 | | 3 |

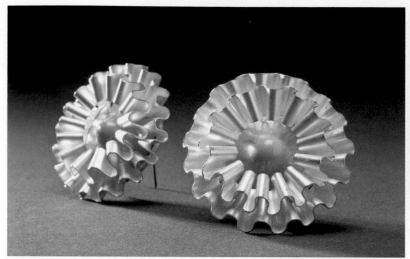

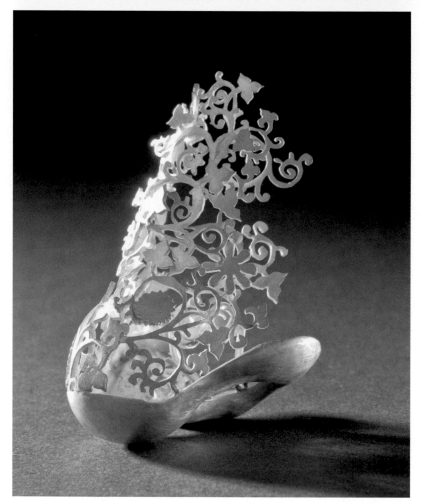

莊 舒 凱 Su-Kai, Chuang

1.《矯正器 I》《Corrector I》
60×60×20mm
925 銀、紅銅、琺瑯
Sterling silver, cooper, enamel
2009

2.《矯正器 IV》《Corrector IV》
50×30×30mm
925 銀
Sterling silver
2009

3.《矯正器 V》《Corrector V》
50×30×30mm
925 銀
Sterling silver
2009

1	3
2	

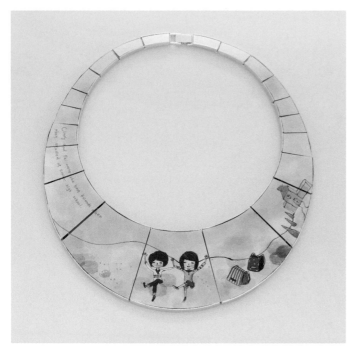

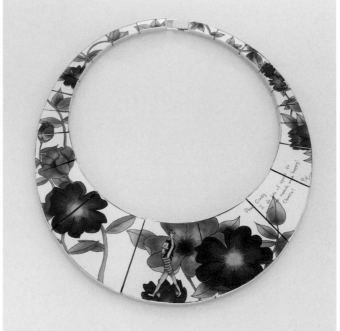

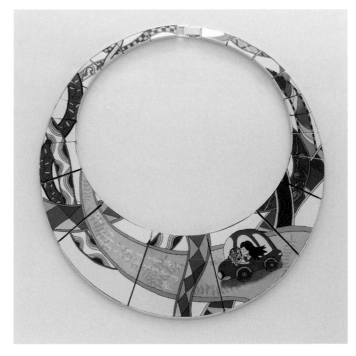

鍾欣瑜 Hsin-Yu, Chung

1.《信福時光》《Best friend series》
200×200mm
鋁合金、銅鍍白K、鋁染
Anodizing of aluminum
2012

2.《Pei 的瑜珈課》《Pei's yoga class》
200×200mm
鋁合金、銅鍍白K、鋁染
Anodizing of aluminum
2012

3.《一切都會變好的》《Everything will be ok》
200×200mm
鋁合金、銅鍍白K、鋁染
Anodizing of aluminum
2012

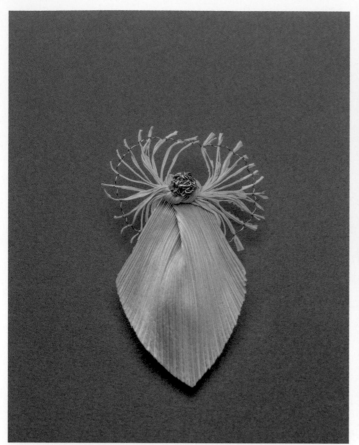

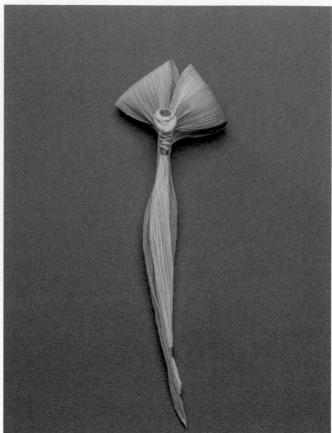

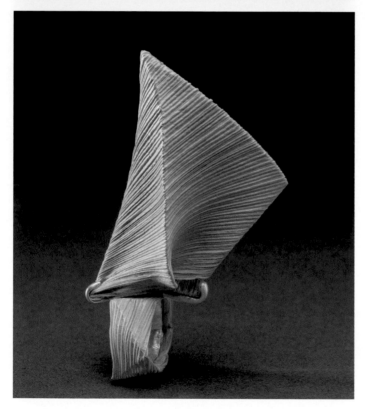

柯啟慧　Shirley Ke, Geiger

1.《渢》《Floating》
80×50×20mm
玉米殼、銅、銀
Corn husks, copper, silver
2022

2.《升》《Ascent》
170×55×35mm
玉米殼、銅、銀
Corn husks, copper, silver
2022

3.《側風》《Cross wind》
100×50×35mm
玉米殼、銀
Corn husks, silver
2022

| 1 | 2 |
| 3 |

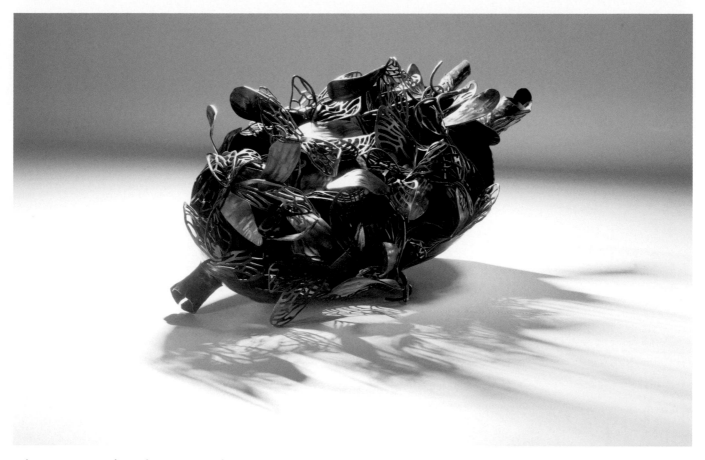

何家穎 Chia-Ying, Ho

1.《心之塚》《The grave of the heart》
270×190×140mm
紅銅、化學染色
Copper, patination
2014

2.《記憶的載體 II》《Medium of memories II》
80×110×15、110×115×15、95×105×15mm
紅銅、黃銅、銀合金、玻璃影像、鋼索、化學染色
Copper, brass, silver, glass, wire, patination
2020

3.《生長》《Grow up》
85×60×50、45×40×60mm
銀合金、紅銅、黃銅、鋯石
Silver, copper, brass, zircon
2021

1	
2	3

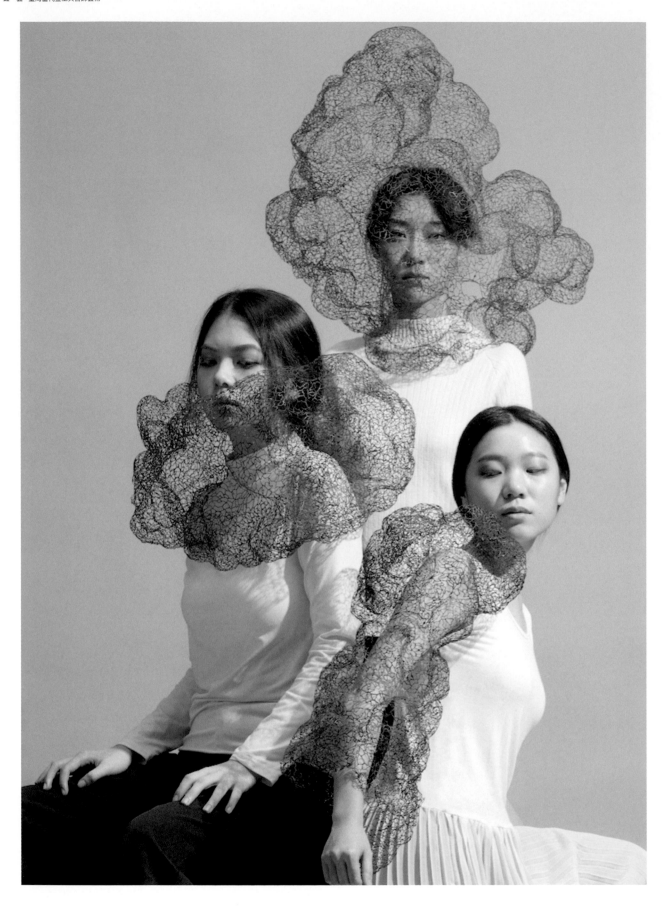

何紹慈 / 蔡宜潔 / 陳筱婷 Shao-Tzu, Ho / Yi-Jie, Tsai / Xiao-Ting, Chen

1.《懸案之枷項》《Who is murderer? - pillory》
500×420×270mm
紅銅
Copper
2019

2.《懸案之束縛》《Who is murderer? - restrain》
520×420×530mm
紅銅
Copper
2019

3.《懸案之桎梏》《Who is murderer? - shackles》
270×190×540mm
紅銅
Copper
2019

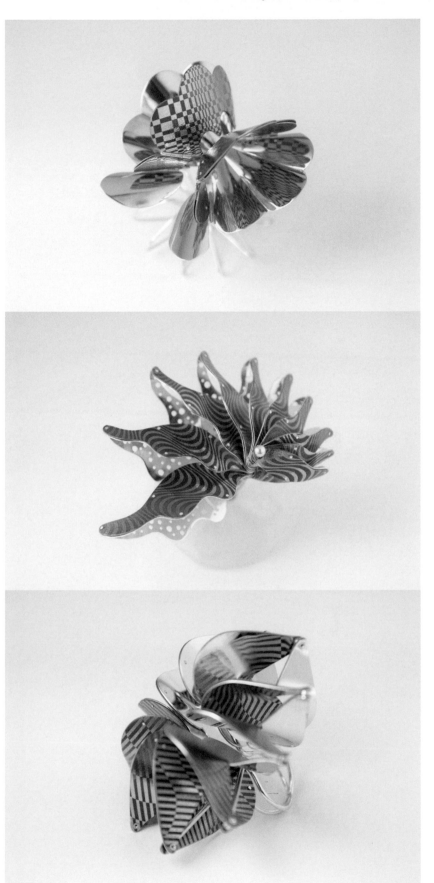

侯其伶 Chi-Ling, Hou

1.《蝶嬉 #6》《Butterfly #6》
70×60×60mm
銀、鈦、銅
Silver, titanium, copper
2005

2.《花舞 #9》《Blossom #9》
95×76×56mm
鈦、銅、壓克力
Titanium, copper, acrylic
2005

3.《花嬉 #11》《Blossom #11》
75×50×48mm
銀、鈦、銅
Silver, titanium, copper
2005

1
2
3

侯 千珈　Angela Chien-Chia, Hou

1.《眼淚生態 - 針雨》
《Tear ecology - needle rain》
45×1.8×1mm
不銹鋼針
Stainless steel, made needle
2018

2.《眼淚生態 - 柔軟如葉》
《Tear ecology - as soft as tender leaves》
100×8×12、50×6×10、30×5×5mm
925 銀、樹幹
Sterling silver, tree trunk
2018

3.《眼淚生態 - 患斯德哥爾摩症候群的珍珠》
《Tear ecology - pearl with stockholm syndrome》
200×30×15mm
貝殼、珍珠、硫化黑銀鍊、魚鉤、磁鐵
Shell, pearl, oxidised silver chain, fishhook and magnet
2018

1
2

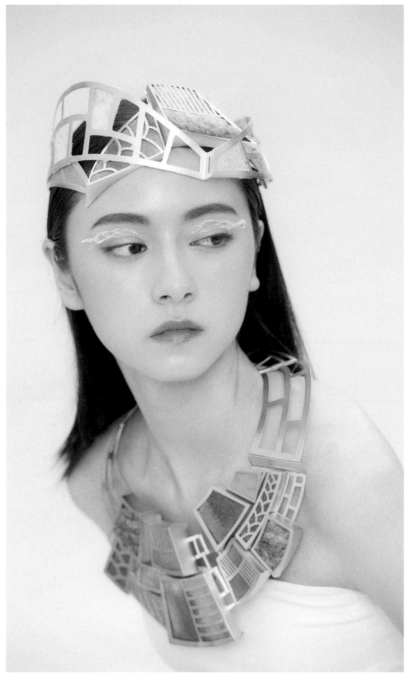

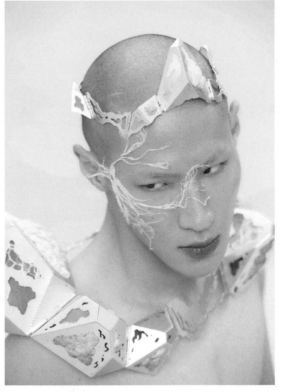

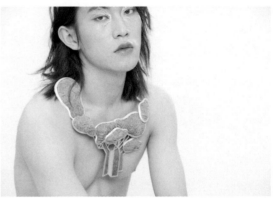

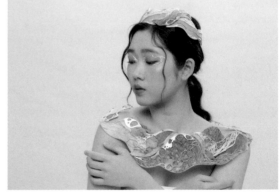

侯 靖 / 邱家榆 / 黃俞熏 / 楊旻馨　Ching, Hou / Chai-Yu, Chiu / Yu-Xun, Huang / Min-Hsin, Yang

1. 《菁生 _ 平原 _ 套鍊 & 頭飾》
《Nature rebuild project_enar_necklace & crown》
270×235×70、160×165×115mm
銅、構樹皮
Copper, papermulberry bark
2022

2. 《菁生 _ 山 _ 套鍊 & 頭飾》
《Nature rebuild project_lutuk_shoulder & crown》
360×250×130、200×170×95mm
鋁、構樹皮
Aluminum, papermulberry bark
2022

3. 《菁生 _ 森林 _ 套鍊》
《Nature rebuild project_kilakilangan_necklace》
270×355×40mm
鋁、構樹皮
Aluminum, papermulberry bark
2022

4. 《菁生 _ 海洋 _ 套鍊 & 頭飾》
《Nature rebuild project_liyal_necklace & crown》
360×250×130、200×170×950mm
鋁、構樹皮
Aluminum, papermulberry bark
2022

1	2
	3
	4

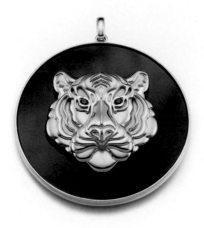

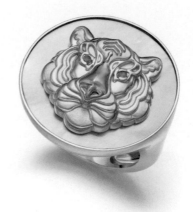

謝宜庭　I-Ting, Hsieh

1.《氣度》《Magnanimity》
45×38×11mm
18K 金、黑瑪瑙、藍寶石
18k gold, onyx, blue sapphire
2022

2.《無所畏懼》《Fearless》
23.5×23.5×27mm
18K 金、珍珠母貝、沙佛萊石
18k gold, mother of pearl, tsavorite
2022

3.《生命之美》《The beauty of life》
21.5×20.8×22.5mm
18k 玫瑰金、翡翠硬玉
18k rose gold, jadeite
2022

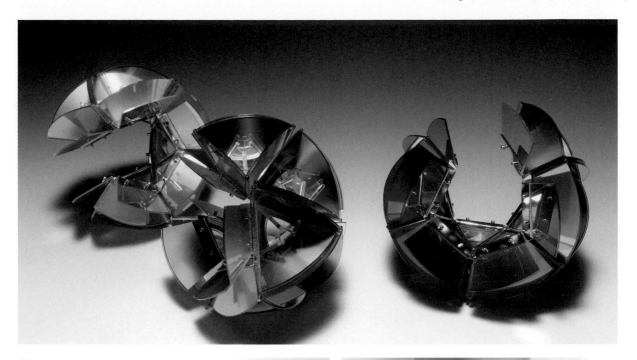

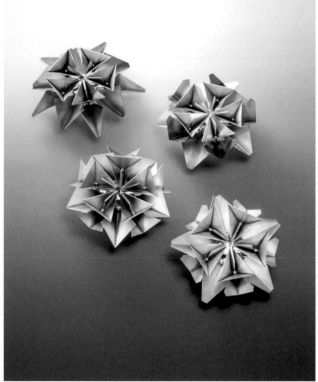

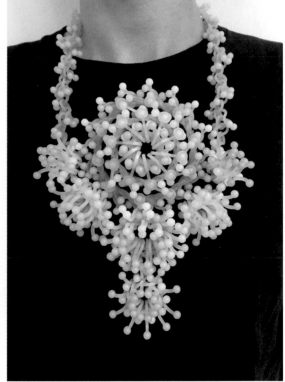

謝侑勳 Yi-Shun, Hsieh

1. 《光的元素》《The elements of light》
120×120×90mm
黃銅、光碟片、螺絲、壓克力
Brass, compact disc, screw, plastics
2010

2. 《繁光》《The complexity of light》
110×110×40mm
鋁、黃銅、白銅、螺絲
Aluminum, brass, nickel silver, screw
2014

3. 《表象》《Appearance》
160×340×40mm
塑料、銀、黃銅
Plastics, silver, brass
2020

許舒瑗 Su-Yuan, Hsu

1.《龍韻 頸飾》《New dragon necklace》
220×250×80mm
925 銀、合成寶石
Silver, synthetic gems
2006

2.《龍韻 肩飾》《New dragon shoulder-wear》
200×140×230mm
紅銅、合成寶石
Copper, synthetic gems
2006

3.《龍韻 手鍊》《New dragon bracelet》
450×85×85mm
925 銀、環氧樹脂
Silver, expocy
2006

許元馨　Yuan-Hsin, Hsu

1.《台灣蝴蝶戲珠花》《Tomentose japanese snowbell》
套鍊 300×200×50、耳環 70×30×10mm
紅銅、電鍍銀、絲線、鐵絲、紙片、珍珠、UV 膠
Copper, silver plating, silk thread, iron wire, paper, pearl, UV resin
2021

2.《玉山薄雪草》《Small leaf edelweiss》
套鍊 250×250×50、胸針 150×50×20、耳環
40×40×20mm
黃銅、電鍍銀、絲線、紙片、漆包線、羊毛、瑪瑙、UV 膠
Brass, silver plating, silk thread, paper, magnet wire, wool,
agate, UV resin
2021

3.《台灣火刺木》《Taitung firethorn》
胸針 200×60×30、耳環 100×30×20mm
黃銅、電鍍銀、絲線、紙片、漆包線、金箔、紅榴石、塑膠
線、UV 膠
Brass, silver plating, silk thread, paper, magnet wire,
gold foil, garnet, plastic wire, UV resin
2021

1	
3	2

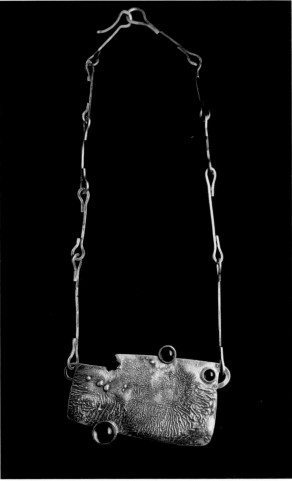

黃薰慧 Hsun-Hui, Huang

1.《星際旅行》《Space traveling》
120×70×10mm
800 銀、925 銀、黃水晶、紫水晶、茶晶
800 silver, 925 silver, lemon crystal, amethyst, smoky quartz
2016

2.《窗景》《Window》
240×140×70mm
800 銀、925 銀、茶晶、髮晶
800 silver, 925 silver, smoky quartz, tourmalinated quartz
2016

3.《歲月》《Time passing by》
200×180×15mm
800 銀、925 銀、青金石、月光石、紫水晶、石榴石、海水藍寶
800 silver, 925 silver, lazurite, moonstone, amethyst, garnet, aquamarine
2017

| 3 |
| 2 | 1 |

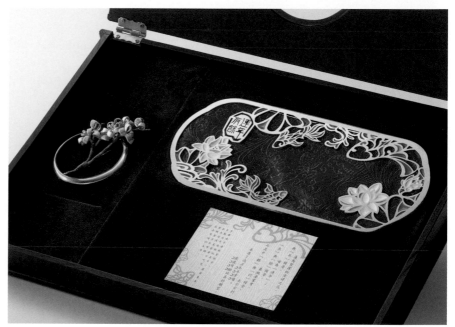

黃亦捷　I-Chieh, Huang

1.《心禮 - 鳳凰于飛》
《Hearty gift - always be in love》
380×265×35mm
不鏽鋼、環氧樹脂、紙、鐵絲、包邊線、銀
Stainless steel, epoxy, paper, iron wire, thread, silver
2012

2.《心禮 - 連年有餘》
《Hearty gift - surplus every year》
380×265×35mm
不鏽鋼、環氧樹脂、紙、鐵絲、包邊線、銀
Stainless steel, epoxy, paper, iron wire, thread, silver
2012

3.《心禮 - 九如之頌》
《Hearty gift - blessing on longevity》
380×265×35mm
不鏽鋼、環氧樹脂、紙、鐵絲、包邊線、銀
Stainless steel, epoxy, paper, iron wire, thread, silver
2012

1	3
2	

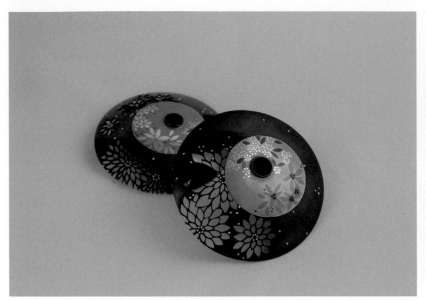

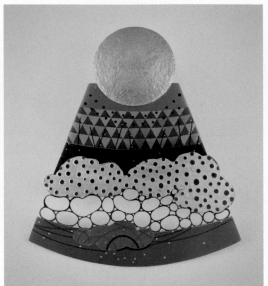

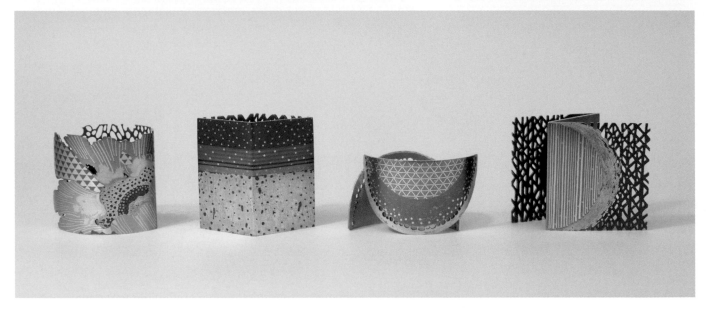

黃照津　Jaw-Jin, Huang

1.《蓋置「暗香」「深深」「月光」「月之森」》
《Lid rest - hidden fragrance, deep snow, moonlight, moon forest》
70×40×60、60×40×70、60×40×50、75×50×60mm
金、銀、銅、四分一、赤銅
Gold, silver, copper, shibuichi, shakudo
2016

2.《花器「月」》
《Single flower vase - moon》
140×50×160mm
金、銀、銅、四分一、赤銅
Gold, silver, copper, shibuichi, shakudo
2017

3.《象嵌筆座「百花」》
《Pen holder - blooming》
103×103×42mm
金、銀、銅、黃銅
Gold, silver, copper, brass
2019

|3|2|
|1|

黃琳真 Ling-Chen, Huang

1.《湖光瀲灩》《Leaf over the sparkling lake》
120×60×40mm
琺瑯、紅銅
Enamel, copper
2020

2.《採集記憶》《Collection of memories》
30×50×40mm
紅銅、琺瑯、不鏽鋼
Enamel, copper, stainless steel
2020

3.《掠影》《Sparkling shadow》
50×40×60mm
925 銀、999 銀、琺瑯
Sterling silver, fine silver, enamel
2014

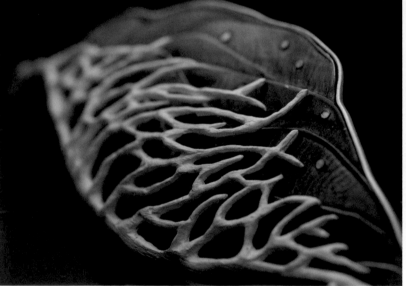

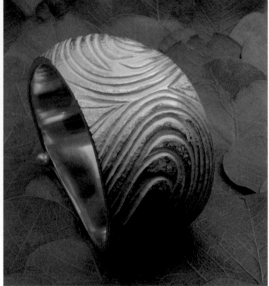

黃淑萍 Shu-Ping, Huang

1. 《微風景》《The scenery》
100×50×5mm
925、820 銀銅合金
Silver copper alloy, sterling
2010

2. 《韶光流轉》《Flow》
70×70×50mm
銀
Silver
2011

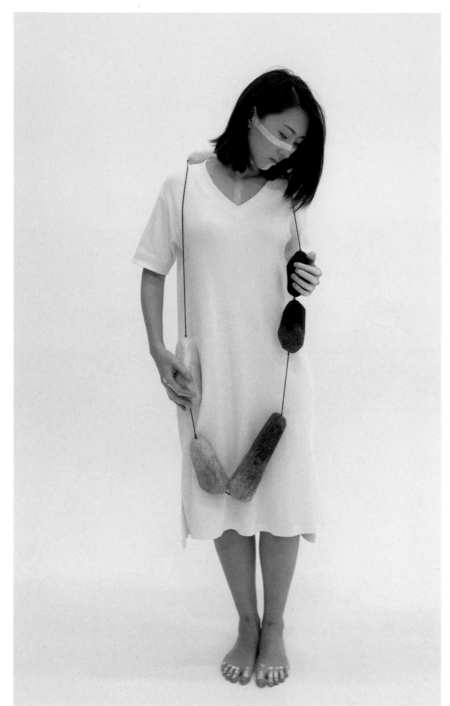

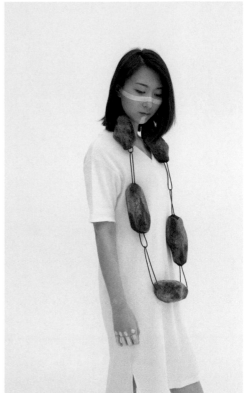

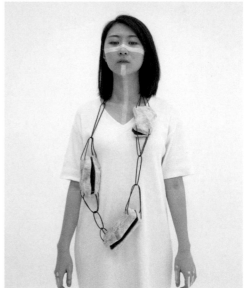

黃以筑 Yi-Jhu, Huang

1.《反差 - 1》《Contrast - 1》
1100×150×50mm
羊毛、橡膠條、黃銅
Wool, rubber cord, brass
2017

2.《反差 - 2》《Contrast - 2》
700×120×50mm
羊毛、橡膠條、黃銅
Wool, rubber cord, brass
2017

3.《反差 - 3》《Contrast - 3》
400×120×40mm
羊毛、橡膠條、黃銅
Wool, rubber cord, brass
2017

1	2
3	

洪慈君　Tzu-Chun, Hung

1. 《記憶殘骸 - 66》 《Remnants of memory #66》
55×75×27mm
琺瑯、紅銅、黃銅、現成物
Enamel, copper, brass, ready-made
2018-2019

2. 《記憶殘骸 - 70》 《Remnants of memory #70》
55×97×35mm
琺瑯、紅銅、黃銅、現成物
Enamel, copper, brass, ready-made
2018-2019

3. 《記憶殘骸 - 55》 《Remnants of memory #55》
62×100×25mm
琺瑯、紅銅、黃銅、現成物
Enamel, copper, brass, ready-made
2018-2019

3	1
	2

洪子筠 Tzu-Yun, Hung

1.《身份認同 02》《Identity 02》
74×74×35mm
頁岩、糯米、生漆、925 銀、不鏽鋼
Slate, rice glue, urushi lacquer, silver, stainless steel
2020

2.《身份認同 05》《Identity 05》
700×740×355mm
頁岩、糯米、生漆、紙
Slate, rice glue, urushi lacquer, paper
2020

3.《身份認同 06》《Identity 06》
100×95×15mm
頁岩、糯米、生漆
Slate, rice glue, urushi lacquer
2021

1	
2	3

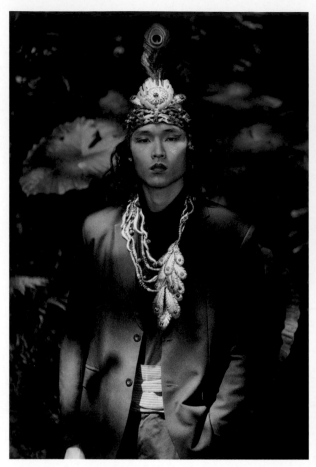

洪雅芬 / 鍾潔妮　　Ya-Fen, Hung / Chieh-Ni, Chung

《Zemadrezadrezadr- 如光一般的愛》《Zemadrezadrezadr-love that shine as light》

1. 250×250×320、450×250×450mm
琉璃、羽毛、銅電鍍銀
Glazed, feather, copper electroplating silver
2022

2. 150×150×100、 50×200×30mm
琉璃、玻璃、銅電鍍銀
Glaze, glass, copper electroplating silver
2022

張皓涵 Hao-Han, Jhang

1.《Hoe we dei I, II》
(I)250×250×150、(II)400×400×200mm
廢棄漁網、銀
Abandoned fishing net, silver
2020

2.《C3H6N6》
40×35×20mm
紅銅、黃銅、水干
Copper, brass, mineral powder
2017

3.《C2Cl4 V》
320×250×110mm
紅銅、黃銅、水干
Copper, brass, mineral powder
2017

1
2

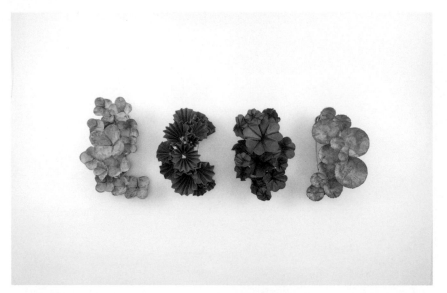

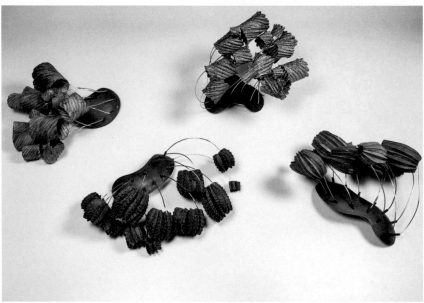

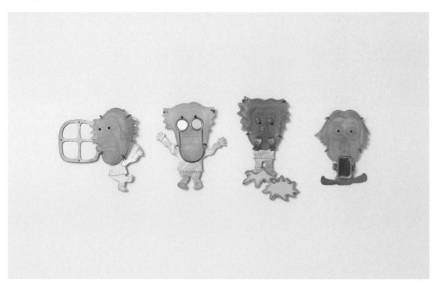

柯婷婷　Ting-Ting, Ko

1.《澀・摺》《The faded youth》
99×70×25、92×62×33、87×65×41、95×61×31mm
紅銅、黃銅、不鏽鋼、化學藥劑
Copper, brass, stainless steel, chemical agent
2017

2.《堆漬》《Deposition of the time》
114×96×56、105×130×55、115×90×87、118×105×70mm
紅銅、黃銅、不鏽鋼線、矽膠管
Copper, brass, stainless steelv, silicone tube
2019

3.《視 XI XII XIII XIV》《Sight XI XII XIII XIV》
70×68×17、67×45×17、72×58×13、84×53×10mm
瑪瑙、黃銅、不鏽鋼線、壓克力
Agate, brass, stainless steel, acrylic
2019

| 1 |
| 2 |
| 3 |

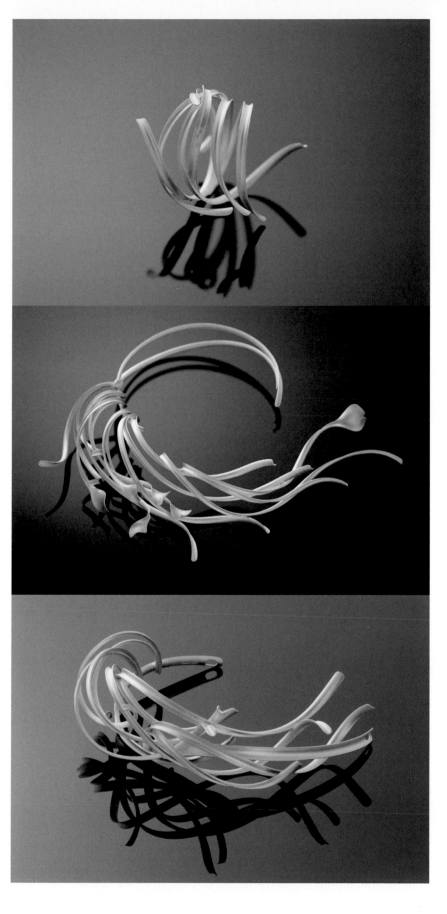

郭昭賢 Chao-Hsien, Kuo

1.《銀色的風，陽光 / 手環》
《Silver wind, sunshine / bracelet》
110×90×80mm
925 銀、24K 金箔
925 silver, 24k gold foil
2019

2.《銀色的風，金心 / 項飾》
《Silver wind with golden hearts / neckpiece》
320×260×57mm
925 銀、24K 金箔
925 silver, 24k gold foil
2018

3.《銀色的風 / 頭飾 No.2》
《Silver wind / tiara no.2》
190×160×53mm
925 銀
925 silver
2018

1
2
3

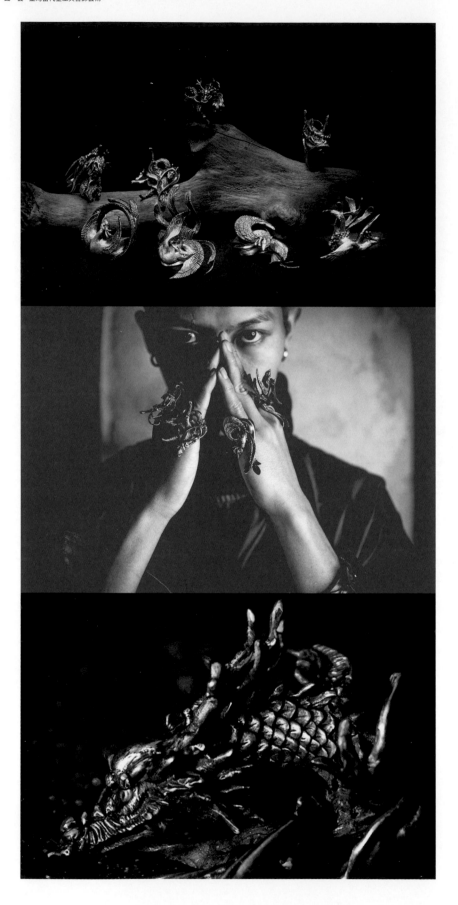

郭胤誥 Yin-Gao, Kuo

1. 《龍鳳》《Dragon and phoenixes》
50×30×40mm
925 銀
Silver 925
2018

2. 《龍鳳》《Dragon and phoenixes》
40×30×30mm
925 銀
Silver 925
2018

3. 《龍鳳》《Dragon and phoenixes》
40×30×30mm
925 銀
Silver 925
2018

| 1 |
| 2 |
| 3 |

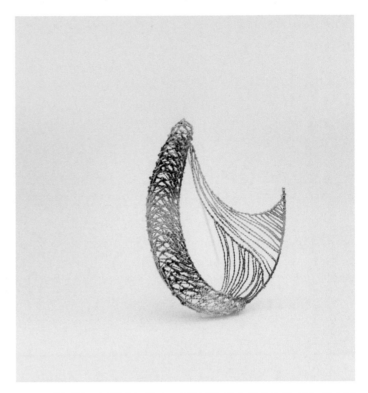

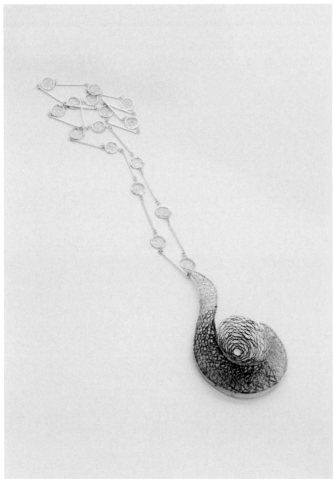

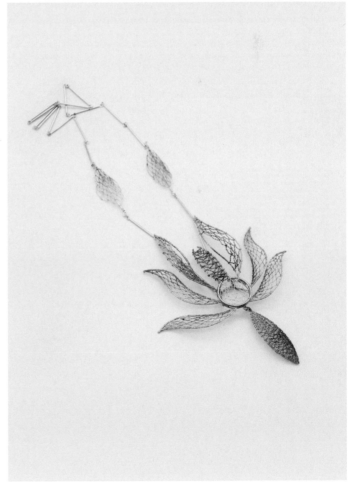

賴佳慧 Chia-Hui, Lai

1.《淌 IV》《Dripping IV》
100×70×30mm
黃銅、925 銀、999 銀、琺瑯
Brass, 925 silver, 999 silver, enamel
2020

2.《容納 I》《Accommodating I》
400×70×40mm
黃銅、925 銀、999 銀、琺瑯
Brass, 925 silver, 999 silver, enamel
2020

3.《賦予 III》《Endowing III》
360×100×10mm
黃銅、925 銀、999 銀、琺瑯
Brass, 925 silver, 999 silver, enamel
2020

1	
2	3

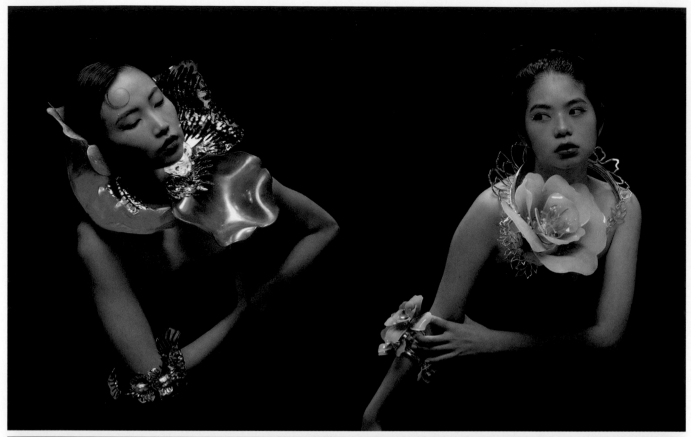

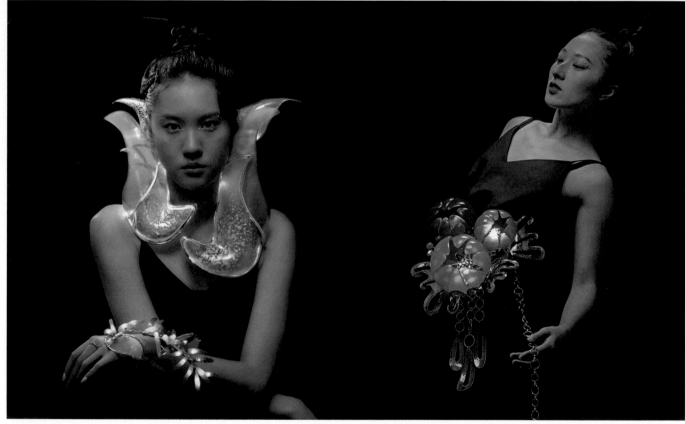

賴得詒 / 陳奕含 / 蔡宜庭 / 蔡昕珆 Te-Yi, Lai / Yi-Han, Chen / I-Ting, Tsai / Hsin-Yi, Tsai

1. 《TO - NIGHT - 崑山夜光》
《To - night - peony》
400×280×130mm
環氧樹脂、金屬、LED 燈
Epoxy, metal, led
2021-2022

2. 《TO - NIGHT - 夜皇后》
《To - night - queen of the night》
500×400×400mm
環氧樹脂、金屬、LED 燈
Epoxy, metal, led
2021-2022

3. 《TO - NIGHT - 路燈草》
《To - night - juncus》
350×280×80mm
環氧樹脂、金屬、LED 燈
Epoxy, metal, led
2021-2022

4. 《TO - NIGHT - 不夜城》
《To - night - aloe perfoliate》
500×400×400mm
環氧樹脂、金屬、LED 燈
Epoxy, metal, led
2021-2022

2	1
4	3

李 恒　Heng, Lee

1.《樹葉裡有光之一》《Light enter through leaves I》
300×85×20mm
白銅鍍白 K、繡線、烏干紗
Nickel silver plated with platinum, oxidized, thread, silk organza
2021

2.《樹葉裡有光之二》《Light enter through leaves II》
120×95×25mm
白銅鍍白 K、琉化處裡、繡線、烏干紗
Nickel silver plated with platinum, oxidized, thread, silk organza
2021

3.《樹葉裡有光之二》《Light enter through leaves II》
120×95×25mm
白銅鍍白 K、琉化處裡、 繡線、烏干紗
Nickel silver plated with platinum, oxidized, thread, silk organza
2021

1	2
3	

1. 《容納系列 - 契合 #2》
《Inclusion series - agree #2》

2. 《破曉系列 - 分解 #1》
《Dawning series - disintegration #1》

3. 《疊加系列 - 滲透 #5》
《Superimposition series - penetration #5》

李冠儀　Kuan-Yi, Lee

1. 《容納系列 - 契合 #2》
《Inclusion series - agree #2》
70×46×40mm
999 純銀、PP 塑料輸出影像
Starling silver, transparency
2021

2. 《破曉系列 - 分解 #1》
《Dawning series - disintegration #1》
25×25×331 - 445mm
999 純銀、PP 塑料輸出影像
Starling silver, transparency
2021

3. 《疊加系列 - 滲透 #5》
《Superimposition series - penetration #5》
130-340×130 - 275×57- 28mm
999 純銀、PP 塑料輸出影像
Starling silver, transparency
2021

| 1 |
| 2 |
| 3 |

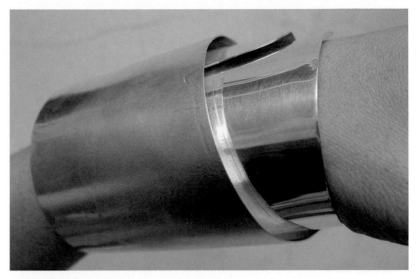

李梅華　Mei, Lee

1.《原礦》《Raw ore》
20×20×30mm
18 黃 K 金
18k yellow gold
1999

2.《張力》《Tension》
180×240×90mm
18 黃 K 金、紫水晶
18k yellow gold, amethyst
2006

3.《裡外》《Inside and outside》
80×90×70mm
925 銀
925 silver
2014

3
2
1

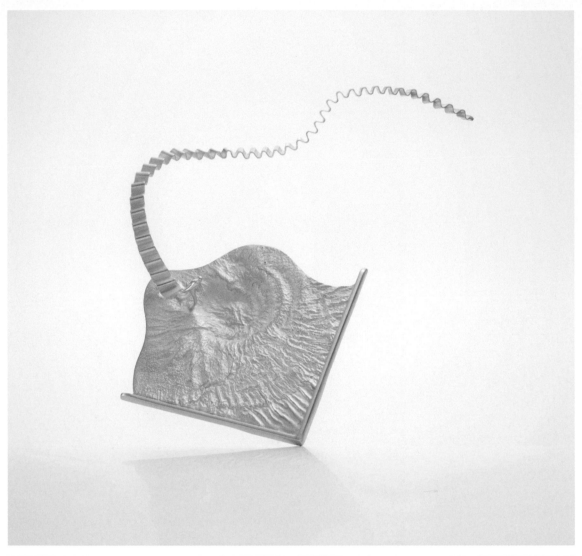

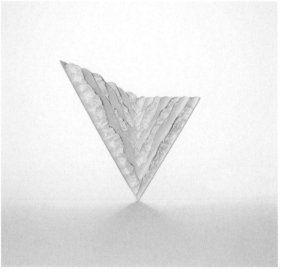

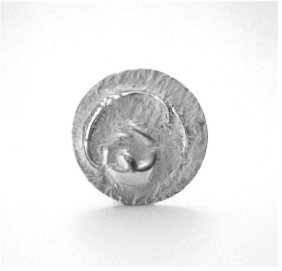

李玫儒　Mei-Ju, Lee

1.《生命的盡頭是進入新的開始》
《The next section of death》

30×78×73mm
銀、820 銀銅合金
Silver, silver copper alloy
2017

2.《智慧的結晶就在累世的輪迴中》
《Wisdom converge the wheel of karma》

56×66×70mm
銀、820 銀銅合金
Silver, silver copper alloy
2017

3.《記憶在下一次輪迴前流逝》
《Momeries will fade away before the next reincarnation》

110×110×15mm
銀、820 銀銅合金、鋯石
Silver, silver copper alloy, zircon
2018

1	
2	3

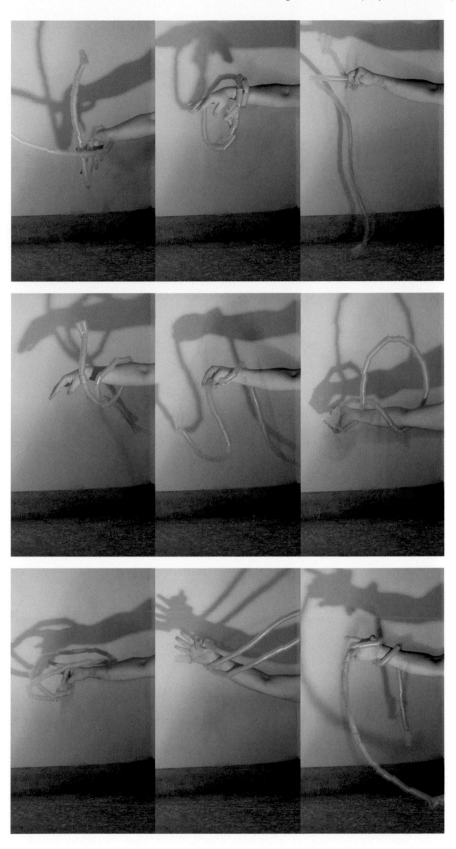

李奕芃　Yi-Peng, Lee

1.《水管珠寶 1》《Water pipe jewellery 1》
600×600×600mm
水管、彈力繩、束帶
Water pipe, elastic rope, cable tie
2022

2.《水管珠寶 2》《Water pipe jewellery 2》
600×600×600mm
水管、彈力繩、束帶
Water pipe, elastic rope, cable tie
2022

3.《水管珠寶 3》《Water pipe jewellery 3》
600×600×600mm
水管、彈力繩、束帶
Water pipe, elastic rope, cable tie
2022

| 1 |
| 2 |
| 3 |

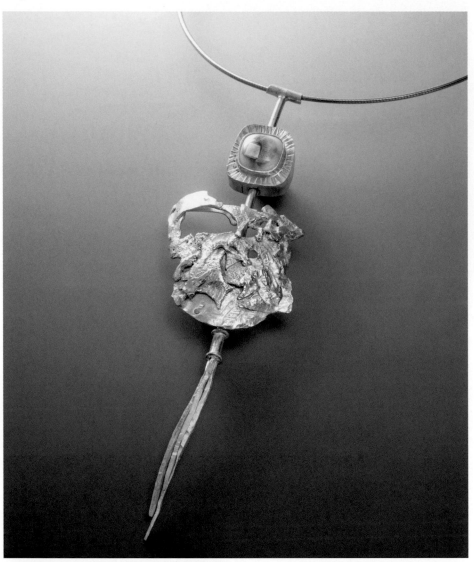

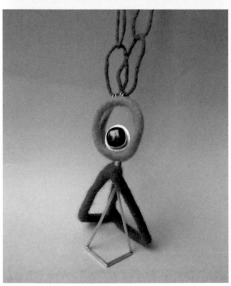
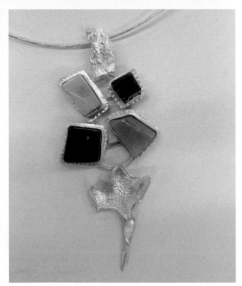

李豫芬 Yu-Fen, Lee

1.《時間的痕跡》《Trace of time》
48×110×8mm
925 銀、青金石、黃玉髓、樹皮實物鑄造 925 銀
925 silver, lapis lazuli, chalcedony, tree bark casting 925 silver
2019

2.《優雅女士》《Elegant lady》
160×45×15mm
96 玻璃、琉璃寶石、銀用琺瑯、925 銀
96 glass, dichroic glass, enamel, sterling silver
2017

3.《外星人》《ET》
100×30×25mm
925 銀、琉璃寶石、羊毛
925 silver, 96 glass, dichroic glass, wool
2018

2
3 1

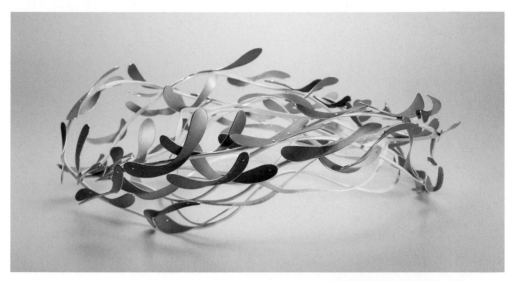

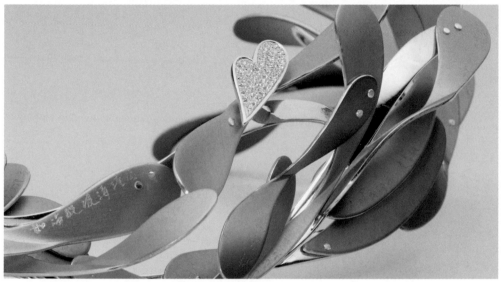

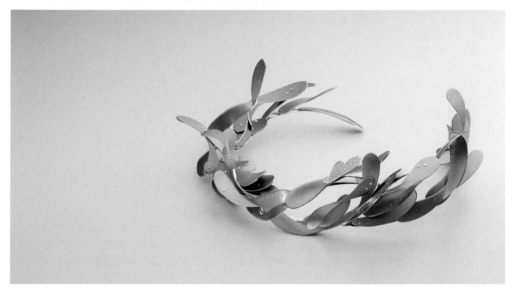

李岱容 Dai-Rong, Li

1.《情說書愛》《Written in love》
320×290×120mm
鋁、黃銅、925 銀
Aluminum, brass, 925 silver
2017

2.《情說書愛》《Written in love》
195×165×55mm
鋁、黃銅、925 銀、鋯石
Aluminum, brass, 925 silver, zircon
2017

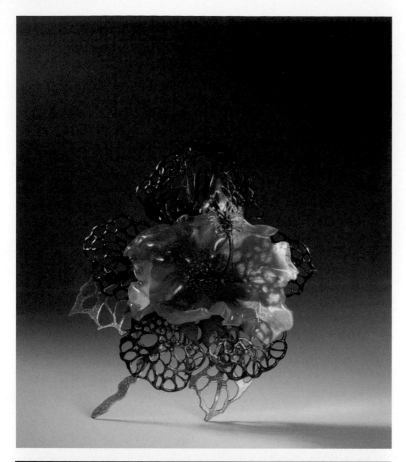

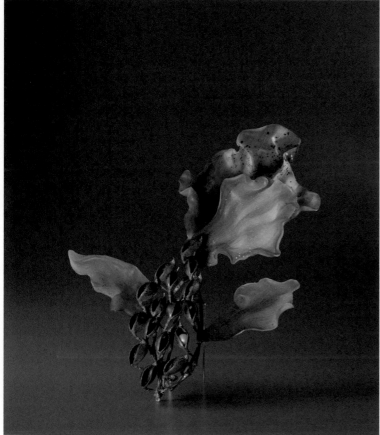

梁 淑 堯 Shu-Yao, Liang

1. 《繁花叢中 III》 《Blossom III》
150×150×50mm
紅銅、琺瑯燒製、樹脂、複合媒材
Copper, enamel, epoxy, mixed media
2019

2. 《凝聚體》 《Scene in the city》
130×160×40mm
黃銅、複合媒材、珍珠
Brass, mixed media, pearl
2019

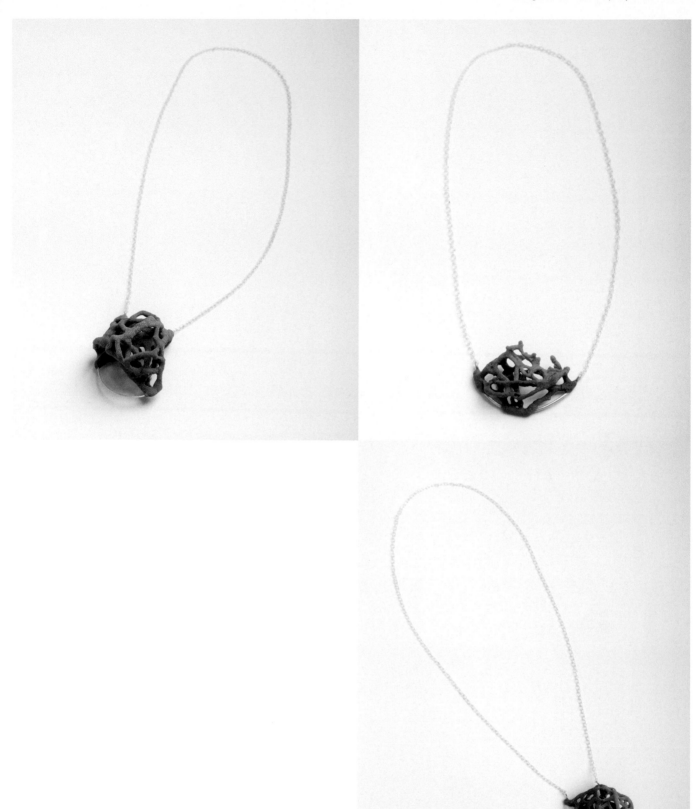

梁紫祺 Zih-Ci, Liang

1. 《思絮 I》《Fiber of thoughts I》
50×50×40mm
925 銀、無胎體琺瑯、日本塑鏈
925 silver, enamel without metal formation, japanese plastic chain
2020

2. 《思絮 II》《Fiber of thoughts II》
50×30×30mm
925 銀、無胎體琺瑯、日本塑鏈
925 silver, enamel without metal formation, japanese plastic chain
2020

3. 《思絮 III》《Fiber of thoughts III》
50×40×40mm
925 銀、無胎體琺瑯、日本塑鏈
925 silver, enamel without metal formation, japanese plastic chain
2020

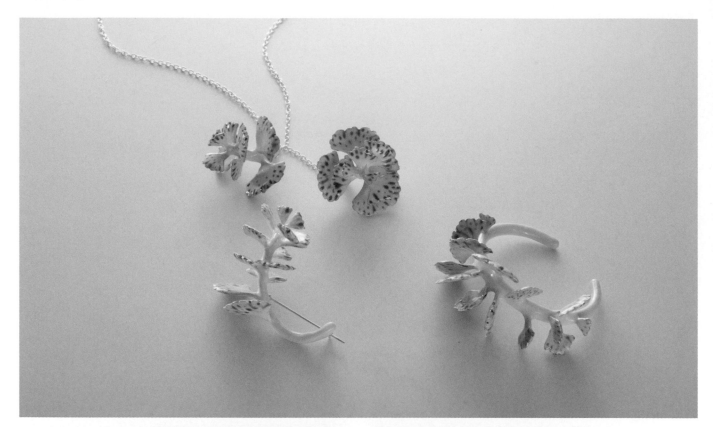

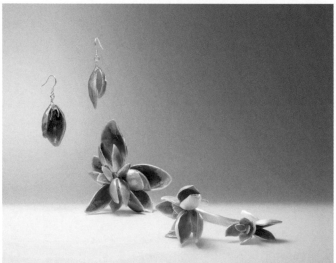 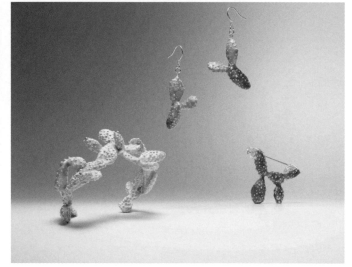

廖珮君 Pei-Jun, Liao

1.《荒漠花園 - 成長》《Desert garden - grow》
30×40×20、20×20×10、20×40×10mm
銀、琺瑯、釉彩
Silver, enamel, glaze
2022

2.《荒漠花園 - 茁壯》《Desert garden - thrive》
50×50×30、20×20×10mm
銀、琺瑯、油性色鉛筆、日本金油
Silver, enamel, oil-based colored pencils, japanese gold oil
2022

3.《荒漠花園 - 綻放》《Desert garden - bloom》
55×60×30、80×70×30、70×40×30mm
銀、樹脂、日本金油
Silver, resin, japanese gold oil
2022

3
2

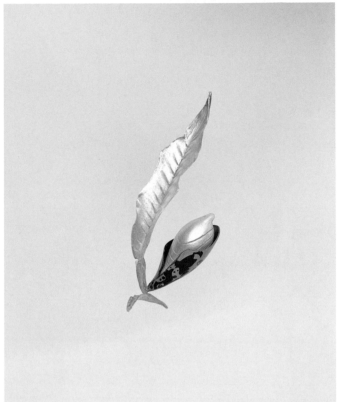

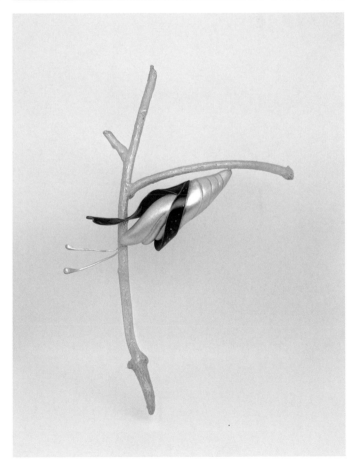

廖珮婷　Pei-Ting, Liao

1.《展翅之前 I》《Before blooming I》
80×80×25mm
銀、銅、天然漆、金箔
925 silver, copper, lacquer, gold leaf
2020

2.《展翅之前 II》《Before blooming II》
90×35×20mm
銀、銅、天然漆
925 silver, copper, lacquer
2020

3.《展翅之前 III》《Before blooming III》
150×100×20mm
銀、銅、天然漆、螺鈿
925 silver, copper, lacquer, shell
2020

1	2
3	

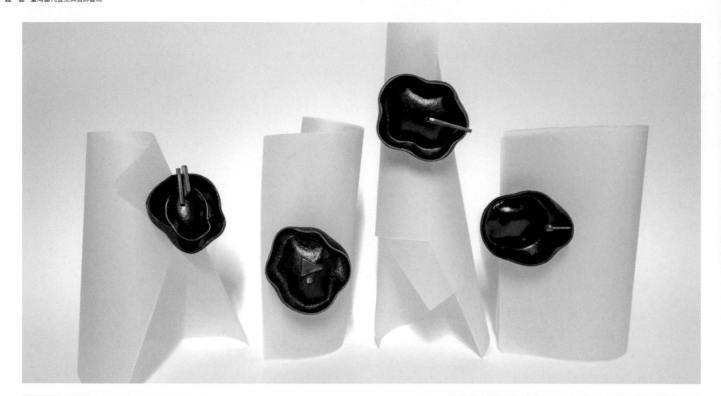

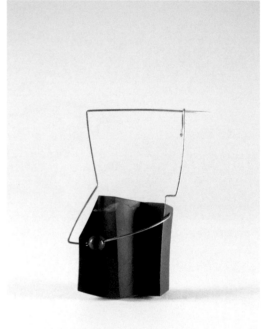

廖偉忖 Wei-Tsun, Liao

1.《新生》《New born》
80×80×30mm
漆、玉石、黃銅
Lacquer, jade, brass
2017

2.《摺玉》《Folding》
30×40×15mm
寶玉石
Gemstone
2018

3.《日常景色》《Daily scenery》
60×80×15mm
漆、寶玉石、黃銅
Lacquer, gemstone, brass
2019

連若均 / 李雅媛 / 程蘭淇　　Ruo-Chun, Lien / Ya-Yuan, Li / Lan-Chi, Cheng

1.《織竹》《Weaving nature》
(套鍊)310×250×250、(臂環)105×80×120mm
紅銅、黃銅、天然漆、竹子、金箔
copper, brass, lacquer, bamboo, gold foil
2018

2.《織竹》《Weaving nature》
(套鍊)260×190×200、(臂環)120×100×110mm
紅銅、黃銅、天然漆、竹子、金箔
copper, brass, lacquer, bamboo, gold foil
2018

3.《織竹》《Weaving nature》
(套鍊)370×250×200、(手環)110×65×80mm
紅銅、黃銅、天然漆、竹子、金箔
copper, brass, lacquer, bamboo, gold foil
2018

1	2
	3

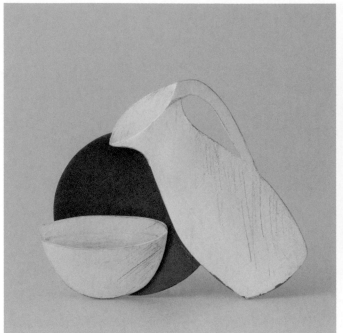

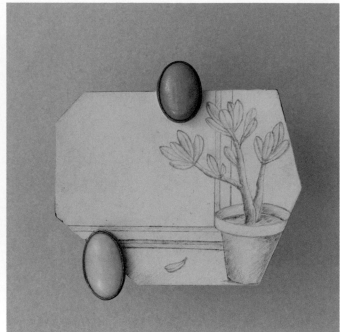

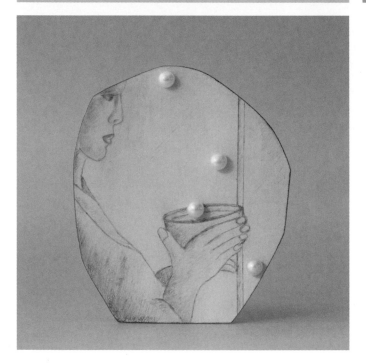

連時維　Shih-Wei, Lien

1.《倒水》《Pour clean water into a bowl》
57×48×7mm
925 銀、顏料
Sterling silver, gesso
2020

2.《植栽與石》《A plant and two stones》
58×57×13mm
925 銀、亞馬遜、顏料
Sterling silver, amazonite, gesso
2020

3.《供水》《Offering clean water》
46×55×7mm
925 銀、珍珠、顏料
Sterling silver, pearl, gesso
2020

1	2
3	

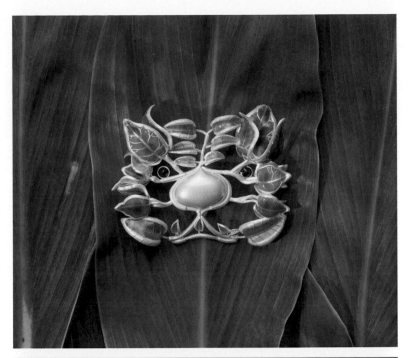

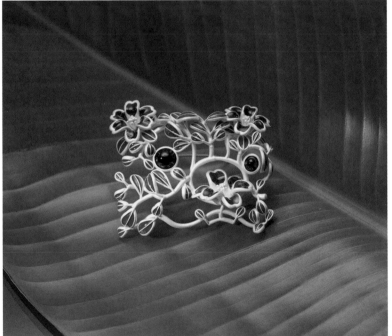

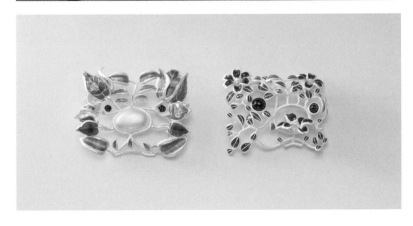

林貝郁 Rita Bey Yu, Lin

1.《夏時瑞虎》《Summer guardian tiger》
66×56×20mm
925 銀、琺瑯
Silver, enamel
2020

2.《冬時瑞虎》《Winter guardian tiger》
65×52×20mm
925 銀、琺瑯
Silver, enamel
2020

3.《夏時與冬時瑞虎》《Summer and winter guardian tigers》
66×56×20、66×52×20mm
925 銀、琺瑯
Silver, enamel
2020

| 1 |
| 2 |
| 3 |

林佳靜　Chia-Ching, Lin

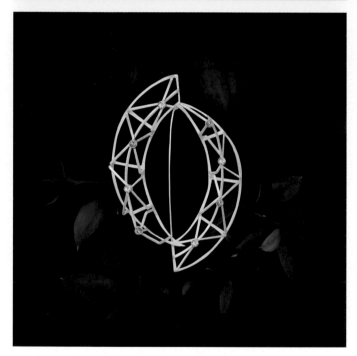

1.《自然析數一》《Nature and architecture 1》
100×60×60mm
金工建構
Metal construction
2018

2.《自然析數二》《Nature and architecture 2》
80×60×80mm
金工建構
Metal construction
2018

3.《自然析數三》《Nature and architecture 3》
90×6.5×20mm
金工建構
Metal construction
2018

1	2
3	

林秀蘋 Hsiu-Ping, Lin

1.《未曾擁抱，那黑 | 漩之黑》
《Darkness un-embraced | brooch series | the spiral of black》
70×60×120mm
沉水黑檀木、999 純銀、不鏽鋼線
Ebony wood, 999 silver wire, SS wire
2016

2.《未曾擁抱，那黑 | 看見那黑》
《Darkness un-embarced | brooch series | the glimpse of black》
50×50×10mm
沉水黑檀木、999 純銀、不鏽鋼線
Ebony wood, 999 silver wire, SS wire
2016

3.《未曾擁抱，那黑 | 光影》
《Darkness un-embarced | brooch series | light and shadow》
45×45×8mm
沉水黑檀木、金箔、腰果漆、純銀
Ebony wood, gold leaf, cashew lacquer wear
2016

2	3
1	

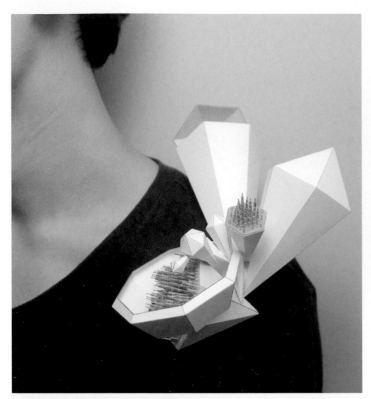

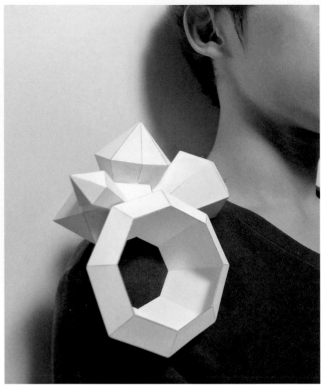

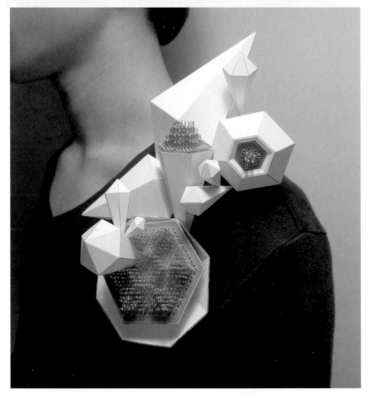

林蒼玄 Tsang-Hsuan, Lin

1. 《位移 I》 《Shifting I》
200×150×100mm
蒙耐合金、電子材料、塑料、不鏽鋼、噴漆、色鉛筆
Monel, electronic components, plastic, stainless steel, spray paint,
prismacolor
2016

2. 《位移 II》 《Shifting II》
230×180×100mm
蒙耐合金、電子材料、塑料、不鏽鋼、噴漆、色鉛筆
Monel, electronic components, plastic, stainless steel, spray paint,
prismacolor
2016

3. 《位移 III》 《Shifting III》
250×100×180mm
蒙耐合金、電子材料、塑料、不鏽鋼、噴漆、色鉛筆
Monel, electronic components, plastic, stainless steel, spray paint,
prismacolor
2016

2	1
3	

林 奕彣 Yi-Wen, Lin

1. 《以花會友 - 濱菊》
《Best friend rings for 2 - shasta daisy》
50×40×40mm
925 銀、鋯石、磁鐵
925 silver, zircon, magnet
2015

2. 《以花會友 - 黃色鬱金香》
《Best friend rings for 3 - yellow tulips》
50×40×40mm
925 銀、腰果漆、樹脂染料上色、鋯石
925 silver, cashew lacquer, resin, zircon
2015

3. 《以花會友 - 虞美人》
《Best friend rings for 4 - corn poppy》
50×40×40mm
925 銀、樹脂燃料上色、磁鐵
925 silver, resin, magnet
2015

1	2
3	

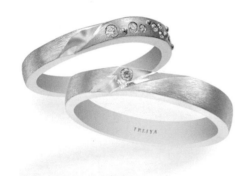

林盈君 Ying-Chun, Ling

1.《瞬間的永恆 結婚對戒》
《Sunrise & sunset》
18×18×35mm
（女戒）18K 白金、18K 玫瑰金、0.10ct 白鑽（男戒）18K 白金、0.02ct 黃鑽
(Woman ring)18k white & rose gold, 0.10 white diamond
(Man ring)18k white gold, 0.02ct yellow diamond
2021

2.《宇宙遨遊 求婚戒》
《Fly into universe》
20×18×65mm
18K 白金、1.003ct 白鑽
18k white gold, 1.003ct white diamond
2022

3.《國王先生與皇后小姐的海上探險》
《Mr. king & Mrs. queen wedding rings》
18×18×50mm
（女戒）18K 白 & 黃金、0.22ct 白鑽（男戒）18K 白 & 黑金、0.09ct 白鑽
(Woman ring)18k white & yellow gold, 0.22 white diamond
(Man ring)18k white & black gold, 0.09 white diamond
2021

2	3
1	

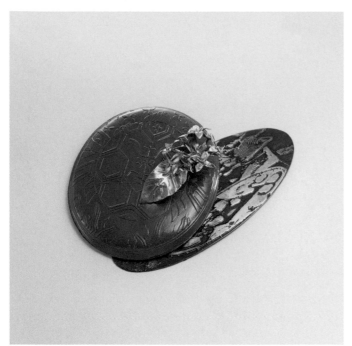

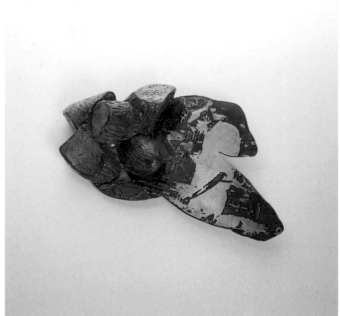

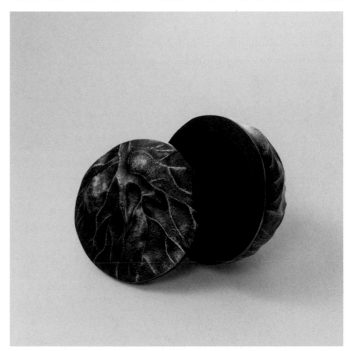

劉 芳 慈 Fang-Tzu, Liu

1.《新丁粄》《Rice cakes for newborns》
120×100×10mm
紅銅、腰果漆、黃銅
Red copper, cashew paint, brass
2018

2.《炒茄子》《Basil eggplant》
150×70×25mm
紅銅、腰果漆、黃銅
Red copper, cashew paint, brass
2018

3.《高麗菜封》《Stuffed cabbage》
80×75×65mm
紅銅
Red copper
2020

| 1 | 2 |
| 3 | |

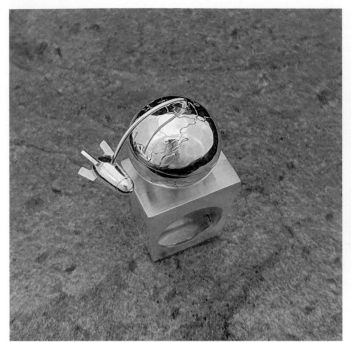

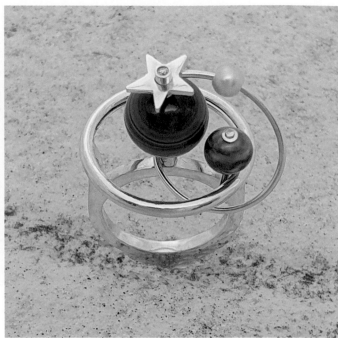

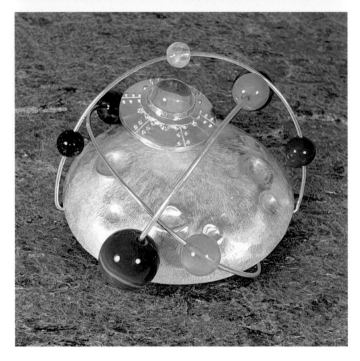

劉淑玲　Noelle, Liu

1.《出發》《Departure》
33×22×50mm
925 銀
925 silver
2020

2.《星空一隅》《Scene of outer space》
23×20×37mm
925 銀、鑽石、孔雀石、硃砂、迷你珍珠
925 silver, diamond, malachite, cinnabar, mini pearl
2021

3.《即將⋯到達》《Almost ⋯achieved》
50×50×37mm
925 銀、玻璃、尖晶石、紅瑪瑙、虎眼石、月光石、海水藍寶、黃玉髓、青金石、孔雀石、紅碧玉
925 silver, glass, spinel, agate, tiger eyes, moonstone, aquamarine, topaz, lapis, malachite, jasper
2021

1	2
3	

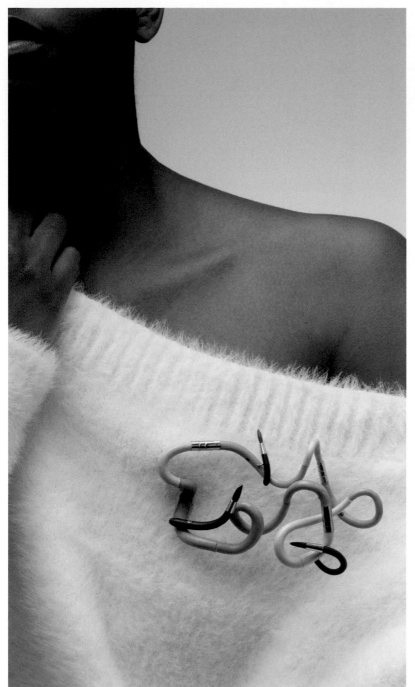

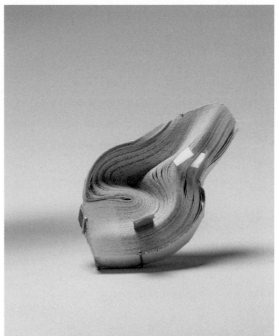

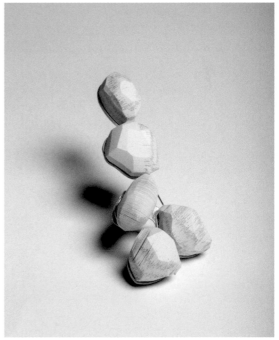

劉子幼　Tzu-Yu, Liu

1.《雀躍》《Cheer》
120×70×45mm
黃銅、畫筆
Brass, brush
2018

2.《喜悅》《Joy》
120×75×40mm
黃銅、書本、便利貼
Brass, book, sticky note
2018

3.《寶藏》《Treasure》
120×47×27mm
黃銅、書本
Brass, book
2018

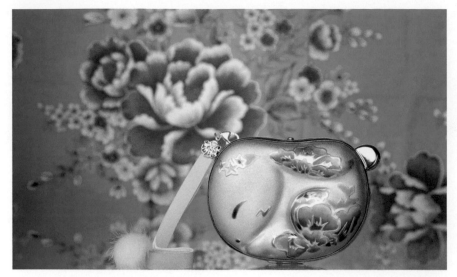

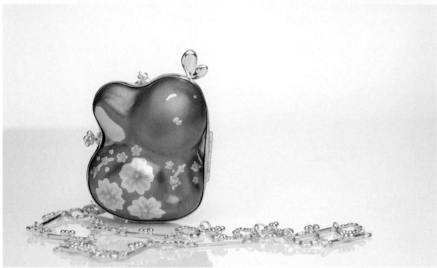

劉瑋珊 Wei-Shan, Liu

1.《妳好 · 自在 - 包包掛飾》《Sunny days - bag hanging》
110×85×27mm
鋁
Aluminum
2011

2.《妳好 · 自在 - 項鍊》《Sunny days - necklace》
85×65×30mm
鋁
Aluminum
2011

3.《妳好 · 自在 - 手環》《Sunny days - bangle》
85×65×30mm
鋁
Aluminum
2011

| 1 |
| 2 |
| 3 |

呂佳靜　Chia-Ching, Lu

1.《痕跡》《Trace》
82×31×8mm
羊毛氈、黃銅
Felt, brass
2017

2.《靈肉對立》《Spirit wander》
1200×450×300mm
羊毛氈、黃銅
Felt, brass
2019

3.《有好事會發生》《Soft shield》
60×650×380mm
羊毛、黃銅、鐵、蠟、纖維
Wool, brass, steel, cotton thread, candle
2019

3	1
	2

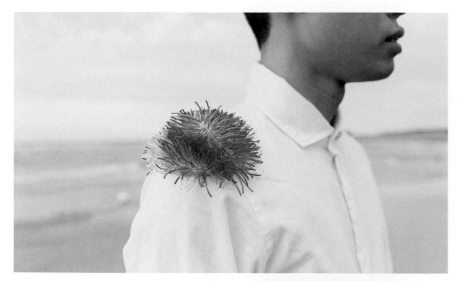

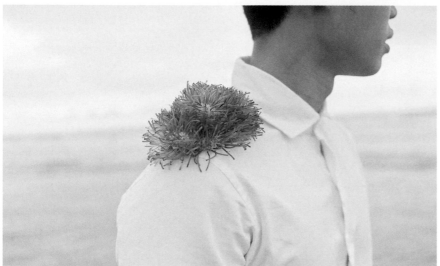

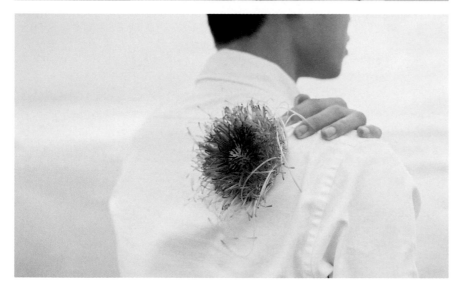

羅硯澤 Yan-Ze, Luo

1.《共生 - 漫 I》《Mutualism - wave I》
130×80×70mm
聚氯乙烯、壓克力、黃銅、不鏽鋼
PVC, acrylic, brass, stainless steel
2013

2.《共生 - 漫 II》《Mutualism - wave II》
150×80×70mm
聚氯乙烯、壓克力、黃銅、不鏽鋼
PVC, acrylic, brass, stainless steel
2014

3.《共生 - 漫 III》《Mutualism - wave III》
250×250×70mm
聚氯乙烯、壓克力、黃銅、不鏽鋼
PVC, acrylic, brass, stainless steel
2014

| 1 |
| 2 |
| 3 |

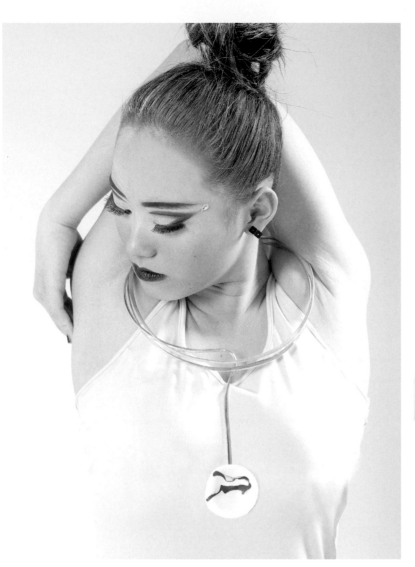

兵春滿 Chin-Man, Ping

1. 《境 - 泮汗系列 項鍊》
《Real / place - boundless necklace》
550×180×30mm
銅、電鍍、樹脂土
Copper, electroplating, resin soil
2015

2. 《境 - 泮汗系列 手環》
《Real / place - boundless bracelet》
120×80×90mm
銅、電鍍、樹脂土
Copper, electroplating, resin soil
2015

3. 《境 - 泮汗系列 戒指》
《Real / place - boundless ring》
60×60×50mm
銅、電鍍、樹脂土
Copper, electroplating, resin soil
2015

1	2
	3

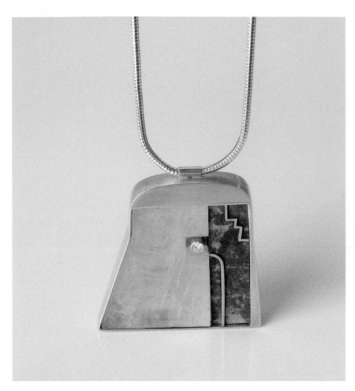

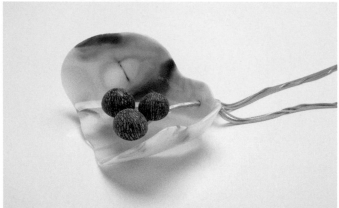

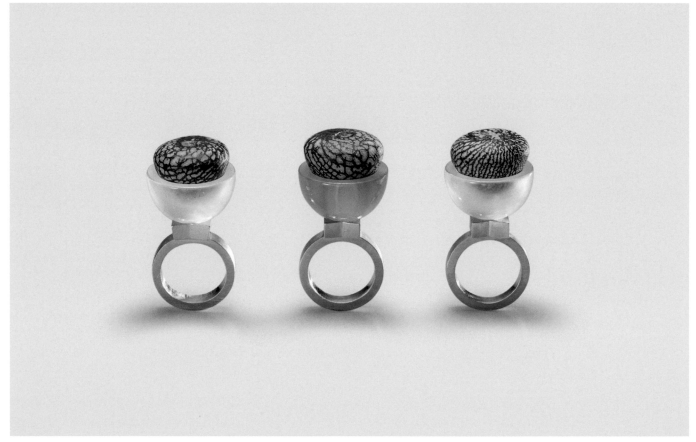

阮文盟　Weng-Mong, Ruan

1.《人形》《People in movement》
42×41×9mm
925 銀、750K 金、粉晶、青金石、鑽石
Silver 925, yellowgold 750, rose krystal, lapis lazuli, brilliant
2008

2.《熱帶迴響》《Tropic echo》
25×25×5mm
925 銀、瑪瑙、水晶、檳榔子
Silver 925, agate, crystal, betelnuts
2019

3.《檳榔神靈》《Spirit of betelnuts》
420×130×65mm
瑪瑙、檳榔子、925 銀
Agate, betelnuts, silver 925
2022

1	3
	2

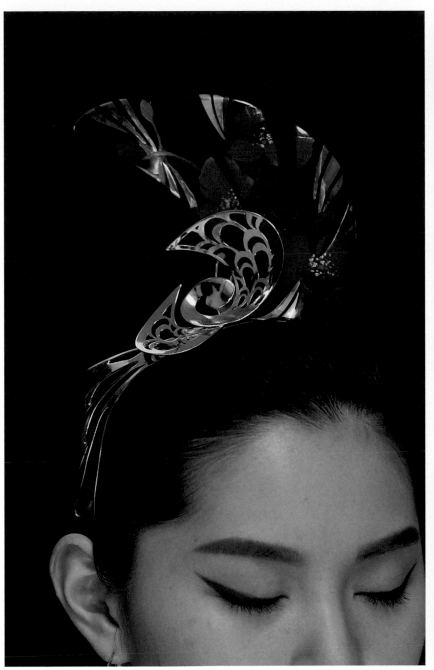
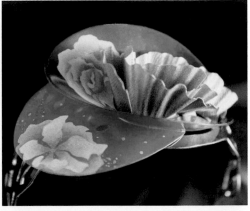

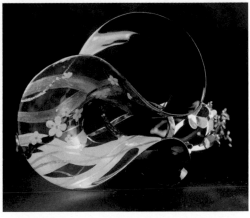

沙之芊 / 方芊文 / 王祈玉 / 鍾嬡　　Chih-Chien, Sha / Chien-Wen, Fang / Chi-Yu, Wang / Ai, Chung

1.《金蒔紅樓 薛寶釵》《The dream of the red chamber - Bao Chai Xue》
150×150×110mm
漆器、黃銅、鋁
Lacquerware, brass, aluminum
2020

2.《金蒔紅樓 林黛玉》《The dream of the red chamber - Dai Yu Lin》
150×150×110mm
漆器、黃銅、鋁
Lacquerware, brass, aluminum
2020

3.《金蒔紅樓 王熙鳳》《The dream of the red chamber - Shi Fung Wang》
150×150×110mm
漆器、鋁、黃銅
Lacquerware, brass, aluminum
2020

4、《金蒔紅樓 賈迎春》《The dream of the red chamber - Ying Chun Jia》
150×150×110mm
漆器、鋁、黃銅
Lacquerware, brass, aluminum
2020

3	2
1	
4	

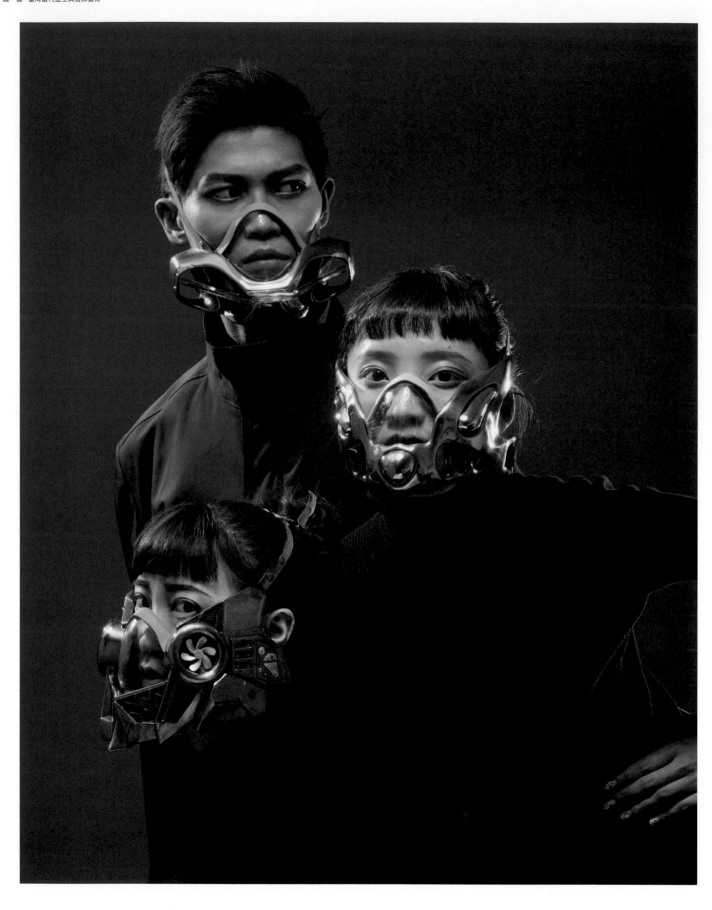

蘇宸緯 / 陳重楠 / 鮑亨艾　　Chen-Wei, Su / Chung-Nan, Chen/ Heng-Ai, Pao

《餘生 2050》《Cyrvive2050》
200×140×150mm
SLA、壓克力
SLA, acrylic
2019

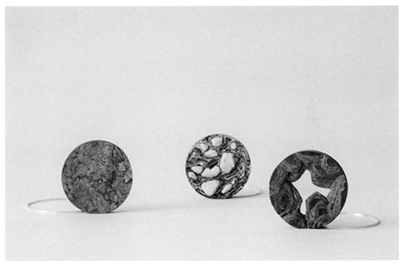

蘇健霖 Chien-Lin, Su

1.《揭墨之捌》《Uncovering ink VIII》
60×50×18mm
汽車補土、宣紙、925 銀、醫療級不銹鋼線
Car poly putty, xuen paper, 925 silver, medical grade stainless steel wire
2014

2.《揭墨 - 山岩、薄霧、浮冰》《Uncovering ink-mountain rock, mist, floating ice》
60×60×9mm
汽車補土、宣紙、925 銀
Car poly putty, xuen paper, 925 silver
2014

3.《揭墨 - 雙生》《Uncovering ink-twins》
90×35×20mm
汽車補土、宣紙、925 銀、醫療級不銹鋼線
Car poly putty, xuen paper, 925 silver, medical grade stainless Steel Wire
2015

1
3

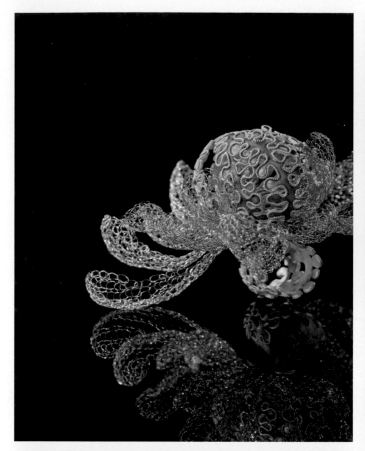

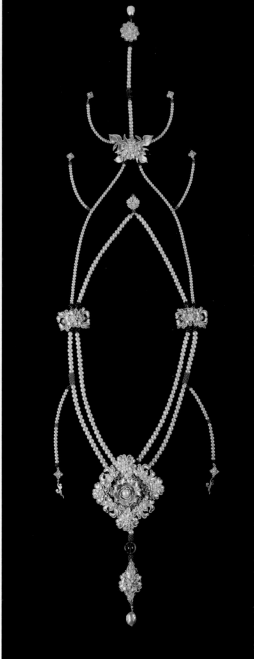

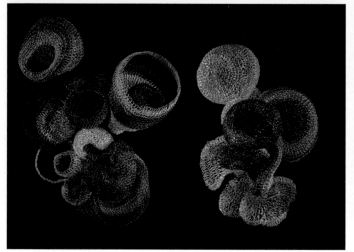

蘇 小 夢　Hsiao-Meng, Su

1.《包容》《Capacity》
120×150×100mm
不銹鋼、925 銀、琺瑯
Stainless steel wire, sterling silver, enamel
2018

2.《瓔珞 - 1》《Yingluo necklace - 1》
1100×250×50mm
925 銀、珍珠、珊瑚、碧璽、水晶、玉石
Sterling silver, pearl, coral, tourmaline, crystal, jade
2020

3.《時間型態》《Time form》
1200×2200×370mm
鋁
Aluminum
2021

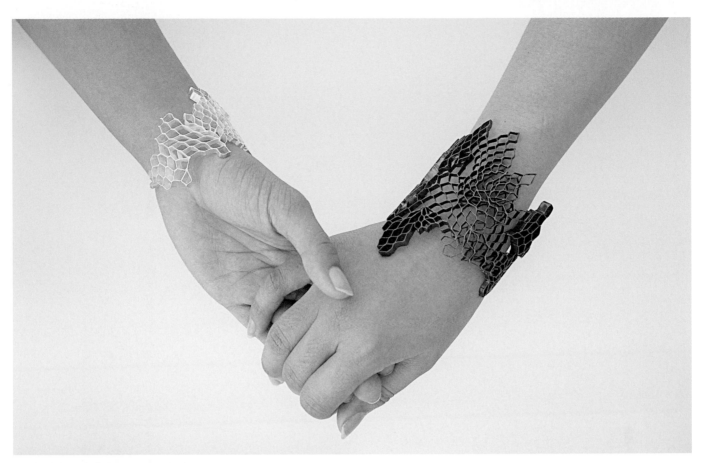

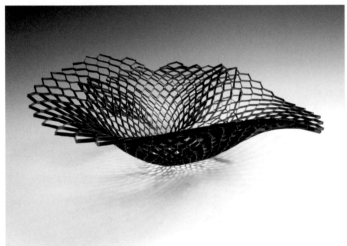

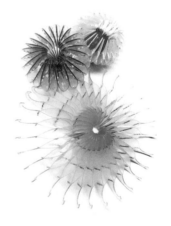

蘇筱婷 Hsiao-Ting, Su

1.《轉化 I》《Transformation I》
80×70×60、50×60×60mm
紅銅、烤漆、紅銅鍍銀
Copper, car paint, silver plated copper
2011

2.《轉化 II》《Transformation II》
350×370×140mm
紅銅、烤漆
Copper, car paint
2011

3.《轉化 III》《Transformation III》
120×80×60mm
塑膠片、銀
Plastic, silver
2019

1
2

蔡沛珍 Pie-Chen, Tsai

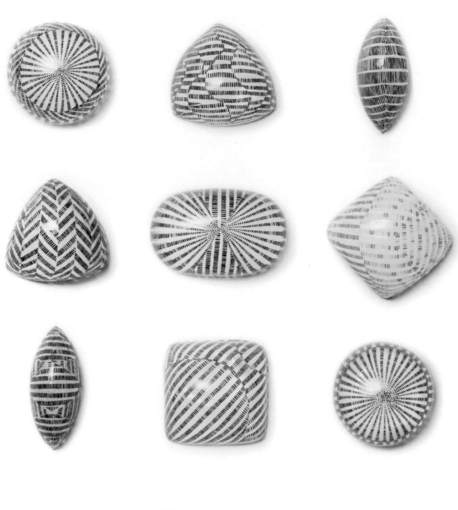

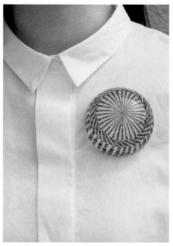

蔡沛珍 Pie-Chen, Tsai

1.《視・知覺 I》《The perception by seeing I》
95×55×30mm
矽膠、繡線、925 銀、不銹鋼
Silicone rubber, cotton threads, sterling silver, stainless steel
2014

2.《視・知覺 II》《The perception by seeing II》
70×70×30mm
矽膠、繡線、925 銀、不銹鋼
Silicone rubber, cotton threads, sterling silver, stainless steel
2014

3.《視・知覺 III》《The perception by seeing III》
70×70×30mm
矽膠、繡線、925 銀、不銹鋼
Silicone rubber, cotton threads, sterling silver, stainless steel
2014

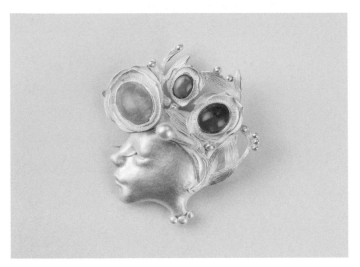

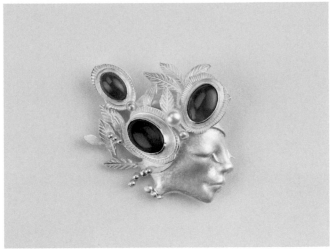

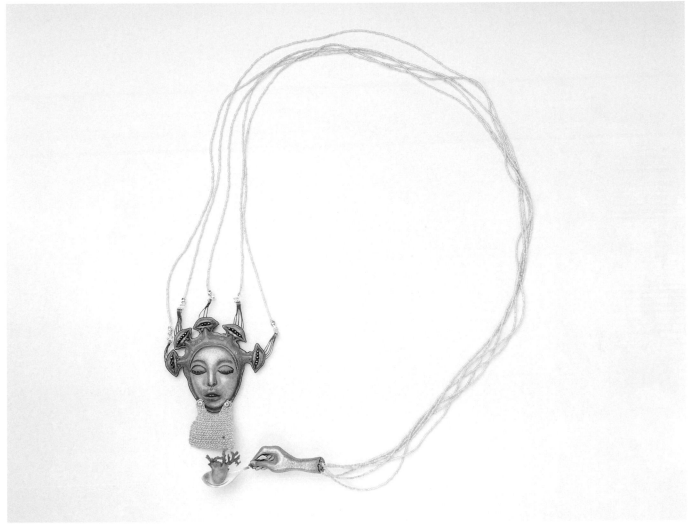

蔡 依 珊 Yi-Shan, Tsai

1.《芳蹤精靈 1(瑟西亞)》《Flower genius 1》
60×60×10mm
銀、寶石、珍珠
Silver, coral, pearl, gemstone
2014

2.《芳蹤精靈 2(迪米亞)》《Flower genius 2》
60×60×15mm
銀、珍珠、寶石
Silver, pearl, gemstone
2014

3.《食心人》《Someone who eat heart》
340×250×20mm
銀、珠子、珊瑚、蠟、纖維
Silver, beads, coral, wax, fiber
2008

1	2
3	

曾 敬 之 Ching-Chih, Tseng

1.《Zazazoo》

(人型)20×50、(場景)150×100mm
銅、琺瑯
Copper, enameling
2005

2.《永痕對戒》《Scratch / wedding bands》

6×22×22、3×19×19mm
18K 金、白鑽、黑鑽
18k gold, white diamond, black diamond
2016

3.《穗對戒》《Tassel / wedding bands》

4.5×22×22、2.5×18×18mm
18K 金、白鑽
18k gold, white diamond
2019

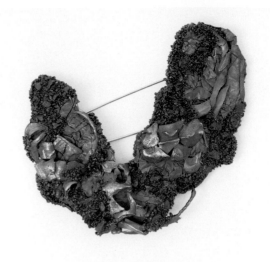

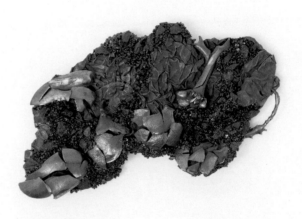

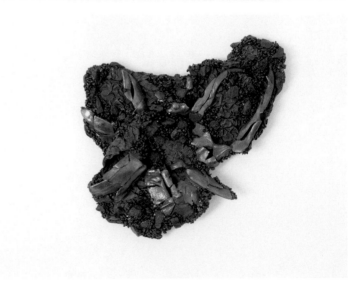

曾翊捷 Yi-Jie, Tseng

1.《修復》《Repair》
112×68×17mm
999 銀、黃銅、紅銅、不銹鋼、瀝青混凝土
999 silver, brass, copper, stainless steel, asphalt concrete
2022

2.《修復》《Repair》
87×115×17mm
999 銀、黃銅、紅銅、不銹鋼、瀝青混凝土
999 silver, brass, copper, stainless steel, asphalt concrete
2022

3.《修復》《Repair》
90×85×17mm
999 銀、黃銅、紅銅、不銹鋼、瀝青混凝土
999 silver, brass, copper, stainless steel, asphalt concrete
2022

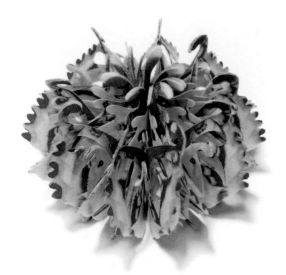

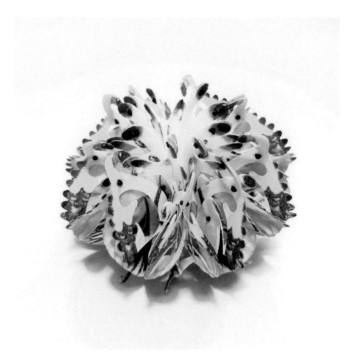

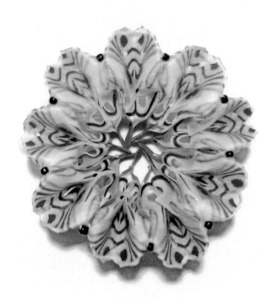

林 玉 萍 Yu-Ping, Lin(Rainey Walsh)

1.《萬花朵記之 2》《The journey of dazzle 2》
45×65×65mm
尼龍布、複合媒材、不銹鋼線材
Nylon, mixed media, stainless steel wire
2014

2.《萬花朵記之 10》《The journey of dazzle 10》
45×65×65mm
尼龍布、複合媒材、不銹鋼線材
Nylon, mixed media, stainless steel wire
2016

3.《萬花朵記之 6》《The journey of dazzle 6》
45×65×65mm
尼龍布、複合媒材、不銹鋼線材
Nylon, mixed media, stainless steel wire
2014

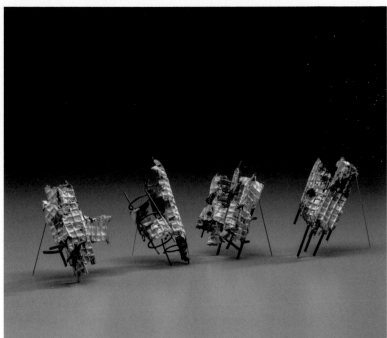

王奕傑 Yi-Chieh, Wang

1.《漸》《Gradually》

8.5×5.5×2mm
銀合金、紅銅、黃銅、不鏽鋼
Silver alloy, red copper, silver, stainless steel
2020

2.《構》《Structure》

8×4.5×5mm
銀、紅銅、黃銅、不鏽鋼
Silver, copper, brass, stainess steel
2020

3.《消失的存在》《Disappearing from existence》

8.5×5.5×2mm
銀、紅銅、黃銅、不鏽鋼
Silver, copper, brass, stainess steel
2020

|1|2|
|3|

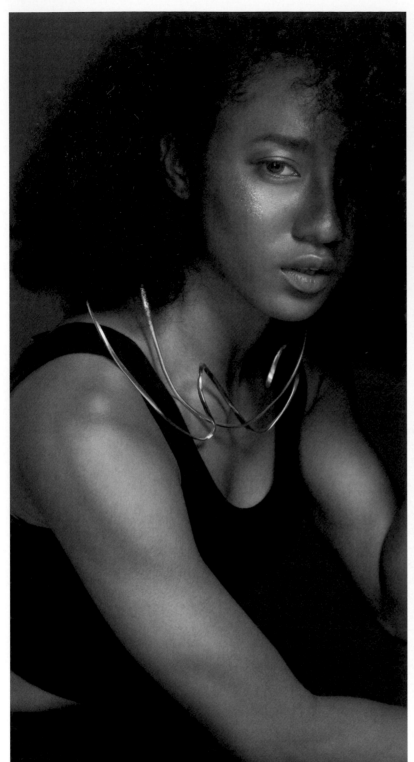

王御茗 Yu-Ming, Wang

1	2
3	

1.《Householic 頸飾》《Householic neckwear》
240×130×100mm
銀
Silver
2018

2.《Householic 耳飾》《Householic earcuff》
80×80×20mm
銀
Silver
2018

3.《Householic 耳飾》《The eye and mind》
90×50×25mm
銀
Silver
2018

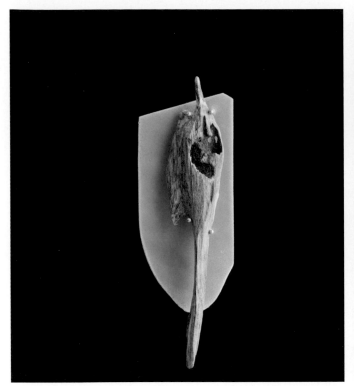

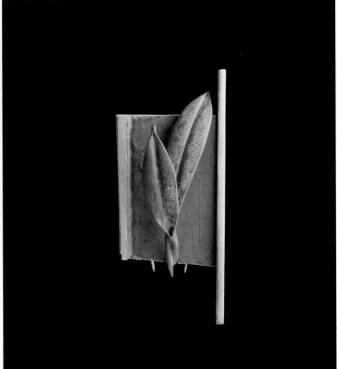

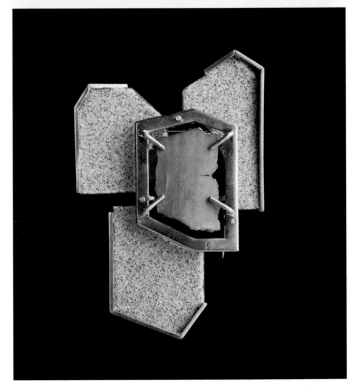

溫 政 傑 Cheng-Chieh, Wen

1.《沈懿》《Shen yi》
70×24×14mm
純銀、沈香、琺瑯、不鏽鋼針
Sterling silver, agarwood, enamel, stainless steel needle
2020

2.《循環生機 II》《Circulation #2》
82×26×18mm
白銅、紅檜、紅銅、黃銅、不鏽鋼針
White copper, red cypress, red copper, brass, stainless steel needle
2020

3.《旅程。記憶》《Journey memory》
68×45×17mm
銅、木質柱漆皮、埃及的砂、琺瑯、不鏽鋼針
Bronze, wooden column patent leather, Egyptian sand, enamel,
stainless steel needle
2021

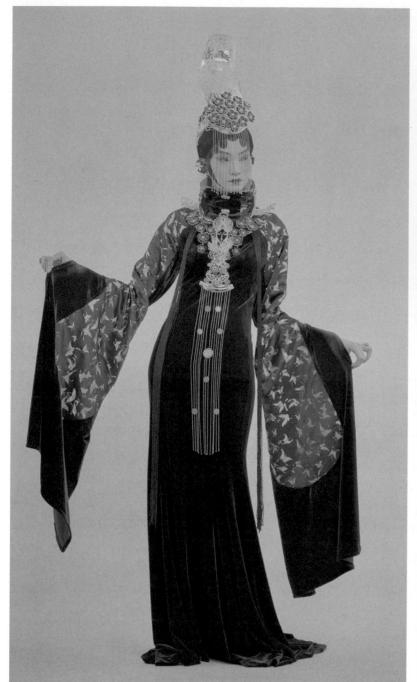

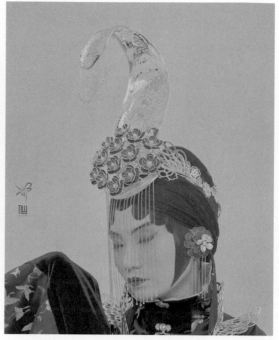

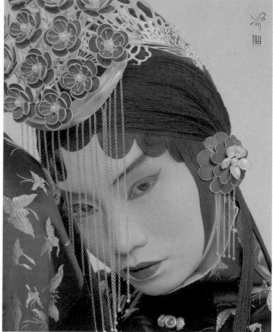

翁子軒 Tzu-Hsuan, Wong

1.《花間夢‧鳳冠》
《The phoenix coronet of dreaming in the flowers》
350×170×350mm
銀、銅、珍珠、羽毛
Sliver, copper, brass, pearl, feather
2016

2.《花間夢‧霞帔》
《The xiapei of dreaming in the flowers》
950×320×120mm
銀、銅、珍珠、羽毛
Sliver, copper, brass, pearl, feather
2016

3.《花間夢‧耳環》
《The earings of dreaming in the flowers》
140×60×50mm
銀、銅、珍珠、羽毛
Sliver, copper, brass, pearl, feather
2016

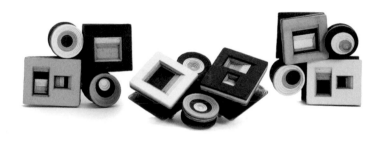

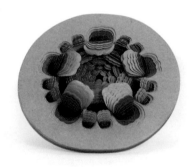

吳 禮 竹　Li-Chu, Wu

1.《山景系列》《Mountain collection》
80×100×15mm
紙、紅銅、不鏽鋼線
Paper, copper, stainless steel wire
2012

2.《城市系列 I》《City I》
60×50×20mm
紙、紅銅、冷琺瑯、不鏽鋼線
Paper, copper, cold enamel, stainless steel wire
2014

3.《植之生 II - 作品 1》《Plants life II - work 1》
100×100×20mm
紙、紅銅、冷琺瑯、不鏽鋼線
Paper, copper, cold enamel, stainless steel wire
2014

<div style="text-align:right">

1	
2	3

</div>

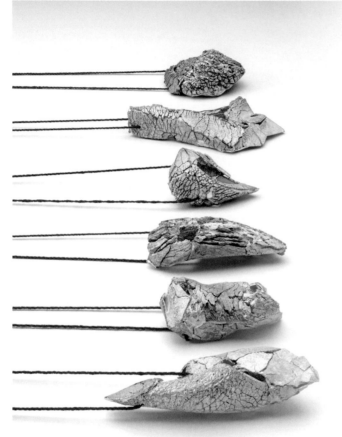

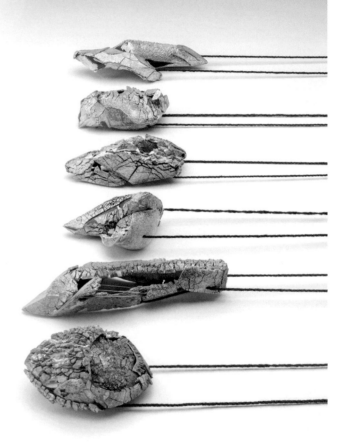

吳孟儒 Meng-Ju, Wu

1.《重生》《Rebirth》
140×60×15mm
琥珀、自製合金、銀、蠟繩
Amber, self-developed metal alloy, silver, wax rope
2020

2.《現代遺物》《Modern relics》
140×75×20mm
自製合金、繩
Self-developed metal alloy, rope
2020

3.《精神遺跡》《Spiritual relic》
44-55×25-50×70-135mm
自製合金、銀、棉繩
Self-developed metal alloy, silver, cotton rope
2020

1	2
3	

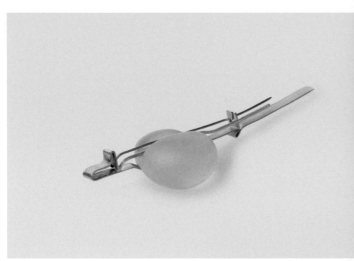
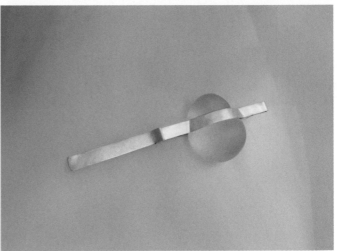

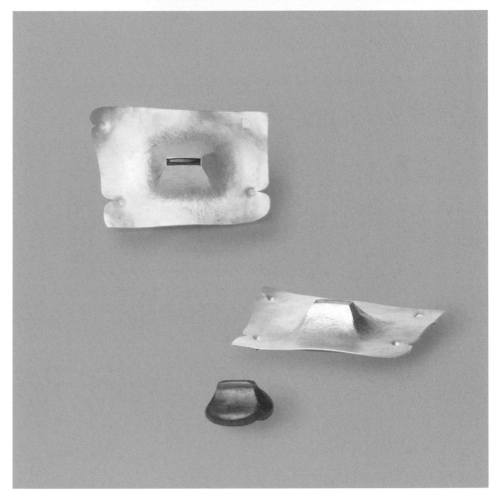

吳沛　Pei, Wu

1.《孝》《Xiao》
120×30×25mm
粉水晶、14k 黃金
Rose quartz, 14ct gold
2020

2.《我是壞小孩嗎？》《Am I bad kid?》
60×55×25mm
菱錳礦、銀、鋼線
Rhodochrosite, silver, steel wire
2020

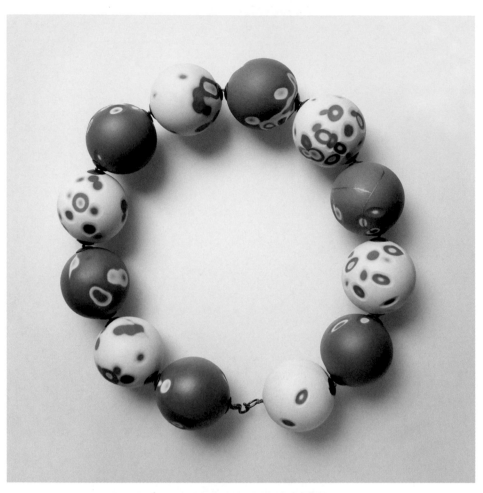

吳淑麟　Shu-Lin, Wu

1.《Re - 木目 #1》《Re - mokume #1》
250×250×49mm
瓷、銀、尼龍、生漆、金粉
Porcelain, silver, nylon, urushi, gold(with kintsugi technique)
2021

2.《季節的回憶 - 橄欖》《Seasonal memory - olive》
250×250×37mm
瓷、銀、鋼線、橡膠
Porcelain, silver, steel wire, rubber
2011

3.《穿戴陶 GCC #1》《GCC #1》
280×280×20mm
陶、銀、尼龍線
Ceramic, silver, nylon
2014

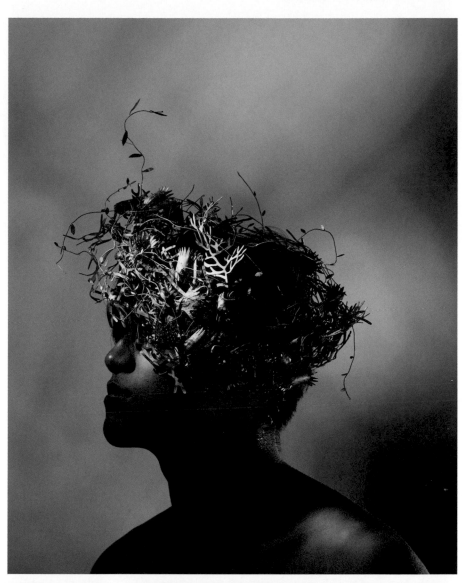

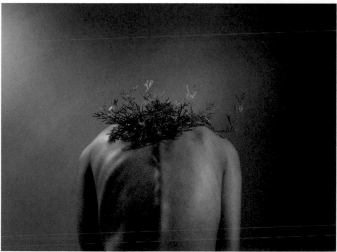

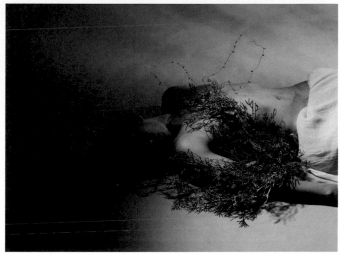

許淳瑜 Ivy, Xu

1.《蔓延 II》《Spread II》
370×240×85mm
廢棄紅銅、黃銅、銅染綠、漆、壓克力顏料、繡線
Copper, brass, patina, lacquer, acrylic paint, embroidery yarn
2017-2020

2.《覆蓋》《Covering》
300×330×110mm
廢棄紅銅、黃銅、銅染綠、漆、壓克力顏料、繡線
Copper, brass, patina, lacquer, acrylic paint, embroidery yarn
2017-2020

3.《簇擁 II》《Crowd II》
930×630×440mm
廢棄紅銅、黃銅、銅染綠、漆、壓克力顏料、繡線
Copper, brass, patina, lacquer, acrylic paint, embroidery yarn
2017-2020

2
1

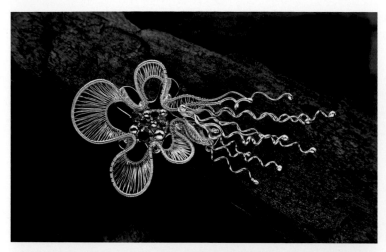

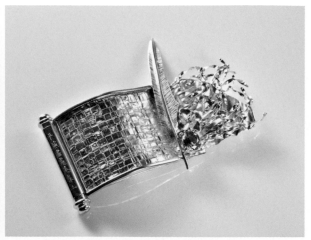

楊彩玲 Tsai-Lin, Yang

1.《木 - 蕪盡》《Wood - barren》
80×35×10mm
925 銀、鍍白 K
Sterling silver, white plated k
2021

2.《土 - 菱花》《Earth - rhombus flower》
150×55×10mm
925 銀、黃玉髓、鋯石、鍍白 K
Sterling silver, topaz, zircon, white plated k
2021

3.《火 - 未爐》《Fire - unburnt》
75×35×10mm
925 銀、天然紅寶、鍍白 K
Sterling silver, natural ruby, white plated k
2021

3	1
2	

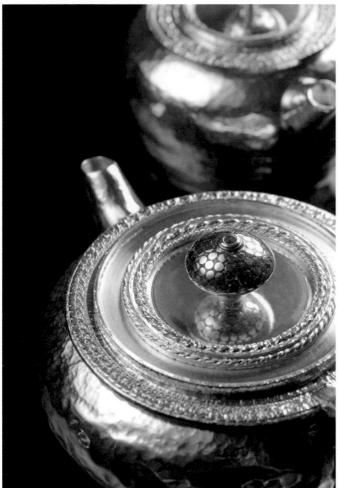

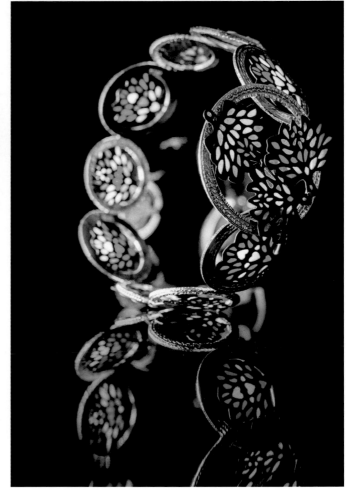

楊炘彪　Xin-Biao, Yang

1.《宇宙之秩序》《Cosmos》
500×400×200mm
950 銀、18K 金、天然樹漆
950 silver, 18k gold, natural tree lacquer
2014

2.《寰宇》《Universe》
150×120×120mm
黃金、天然樹漆、950 銀、天然梨子地樹漆
Gold, natural tree lacquer, 950 silver, nashiji
2016

3.《世界》《The world》
300×300×100mm
950 銀、鍍金、琺瑯、空窗琺瑯
950 silver, planting gold, enamel, plique-`a-jour
2018

1
2

205

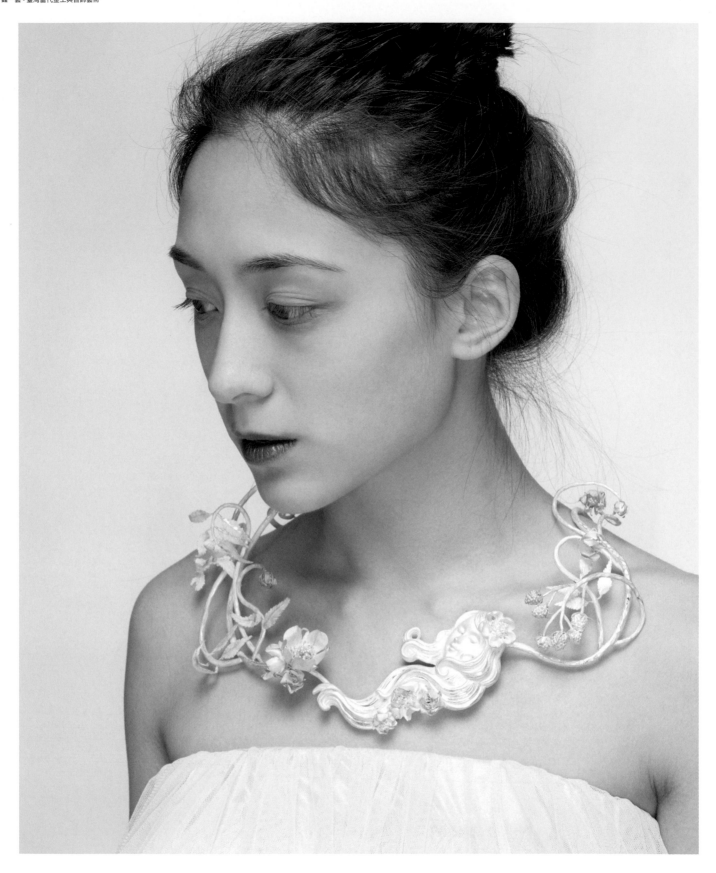

楊 雅 如 Yu-Ju, Yang

《末路青春 系列一》《Last blossom #1》
270×225×126mm
銀
Silver
2015

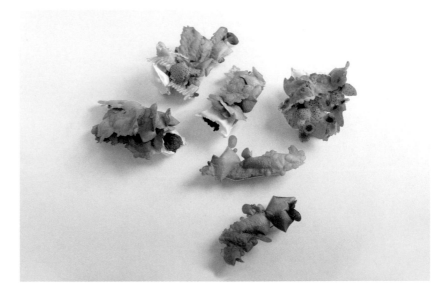

葉方瑾　Fang-Jin, Yeh

1.《浸泡在海裡的家鄉印象》《Homeward impressions pickled in the sea》
155×60×30mm
銀、紙
Silver, paper
2017

2.《閑靜的海》《The sea》
120×85×45mm
銀、紙
Silver, paper
2020

3.《藏》《Hide and seek》
120×75×40mm
銀、紙
Silver, paper
2020

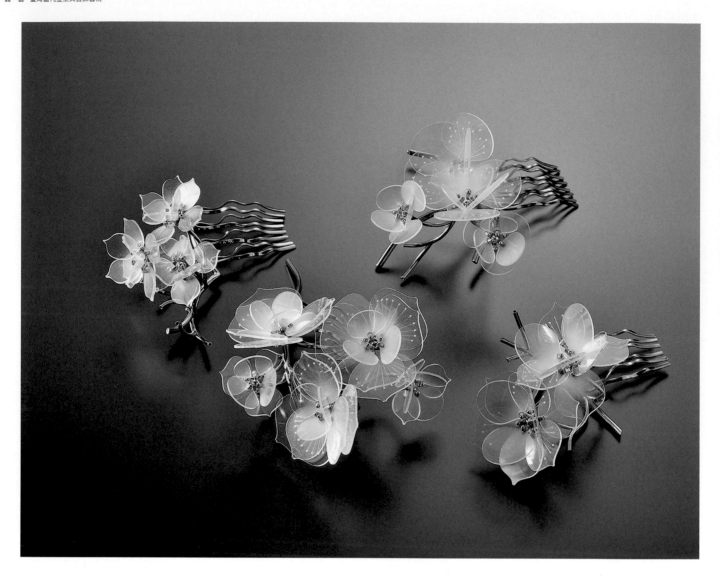

葉璇　Hsuan, Yeh

《花非花 - 髮飾系列 I、II、III、IV》《Flower in the haze - hairpin series I, II, III, IV》
105×105×65、95×105×65、70×100×60、90×120×80mm
壓克力、白銅、黃銅、925 銀、不鏽鋼、透明線
Plexiglas, nickel sliver, brass, sterling sliver, stainless steel, transparent thread
2015-2017

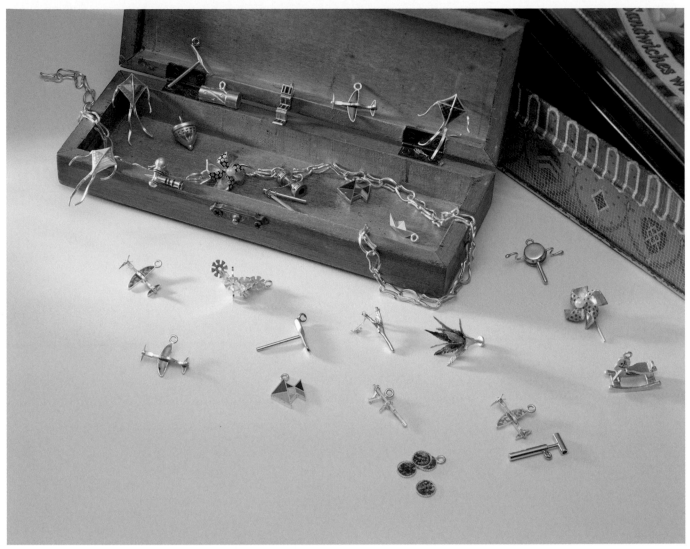

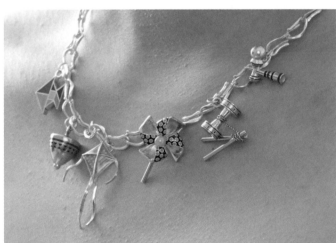

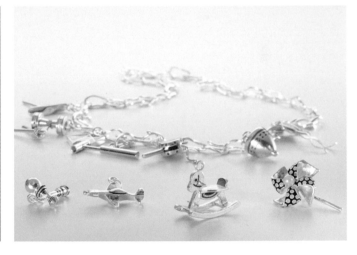

葉旻宣　Min-Hsuan, Yeh

《袖珍記憶》《Pocket memories》
10×10×10mm
925 銀、999 銀、琺瑯
925 silver, 999 silver, enamel
2005

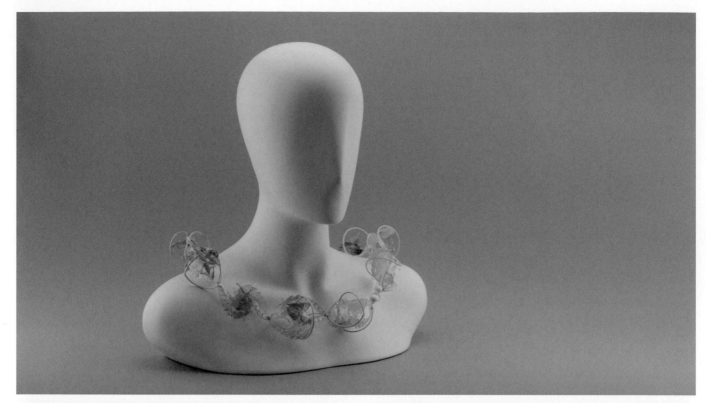

葉玟妙　Wen-Miao, Yeh

1.《空間盒子系列 - 生生不息》《The space - circle of life》
890mm
塑膠、壓克力顏料、黃銅、木頭、環氧樹脂
Plastic, paint, brass, wood, resin
2018

2.《空間盒子》《The space》
60×80×60mm
塑膠、壓克力顏料、黃銅、環氧樹脂
Plastic, paint, brass, resin
2018

3.《空間盒子》《The space》
70×70×68mm
塑膠、壓克力顏料、黃銅、環氧樹脂
Plastic, paint, brass, resin
2018

1	
2	3

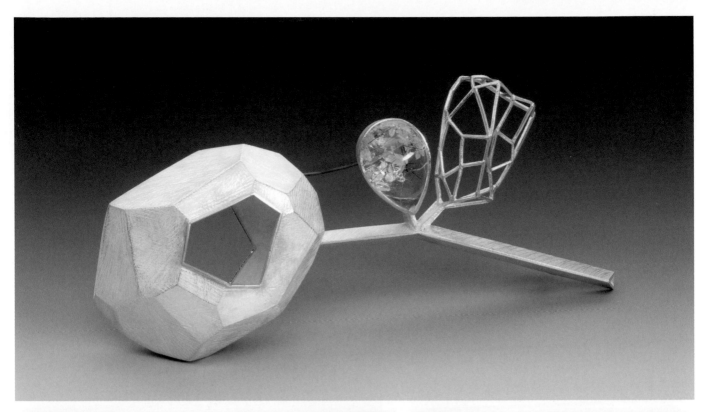

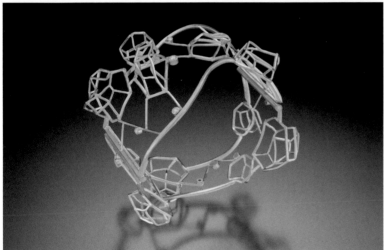

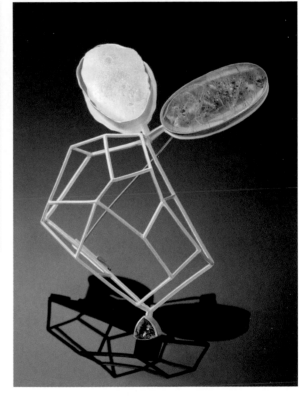

顏亮中 Liaung - Chung, Yen

1.《漫步在石頭路上 - 手環》
《Stone pathway I - bracelet》

70×85×50mm
18K 黃金、鑽石
18k yellow gold, diamonds
2010

2.《悸動 - 胸針》
《In the mood for love - brooch》

135×60×27mm
22K & 18K 黃金、925 銀、水晶、銅針
22k & 18k yellow gold, sterling silver, phantom quartz
2014

3.《兔子般的關係 / 美麗的關係 - 胸針》
《Bunny(bonnie)kind of relationship - brooch》

110×90×30mm
22K & 18K 黃金、925 銀、水晶、黃水晶、銅針
Sterling brooch, 22k and 18k yellow gold, lopedocrocite quartz, citrine
2019

2
1

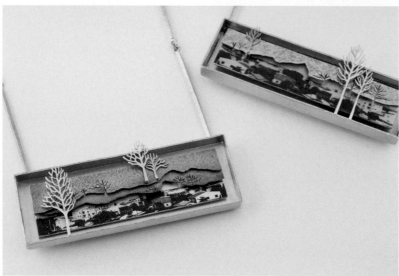

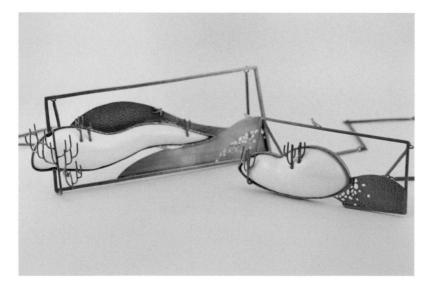

余純緣 Chun-Yuan, Yu

1.《山水墨 #1 - #3》《Films of landscapes #1 - #3》
150×200×40mm
紅銅、白銅、銀
Copper, nickel silver, silver
2013

2.《日常風景》《Daily scenery》
30×90×15、40×90×15mm
黃銅、紅銅、白銅、鋁
Brass, copper, nickel silver, aluminum
2013

3.《飄渺》《Ethereal》
50×80×20、50×150×30mm
紅銅、黃銅、白銅、琺瑯
Copper, brass, nickel silver, enamel
2014

1
2
3

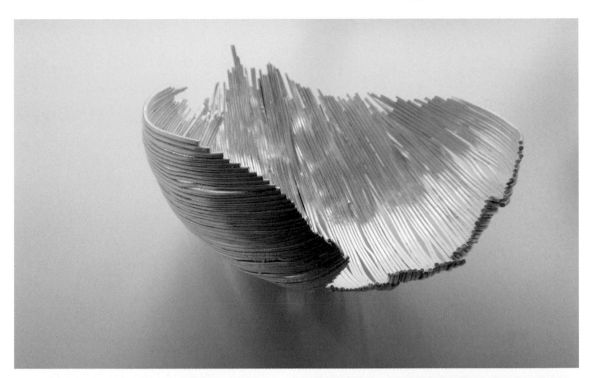

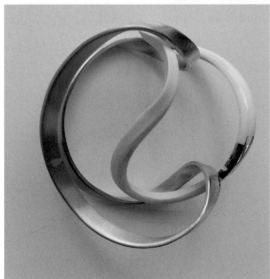

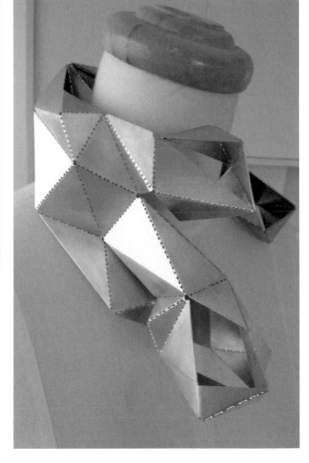

2

3 1

余啟菁 Mimi, Yu

1.《光》《Light》
280×230×130mm
紅銅、黃銅
Copper, brass
2013

2.《齊心》《Hand in hand》
310×150×150mm
銀
Silver
2015

3.《太極》《Tai chi》
85×75×43mm
紅銅、白瓷
Copper, porcelain
2016

2

3 1

俞溫馨 / 楊修　Wen-Shin, Yu / Shiu, Yang

1.《烏托邦項鍊頸飾 / 胸針》《Utopia neckwear / brooch》
(Neckwear)550×350×350、(Brooch)120×120×50mm
黃銅、鎳、銀
Brass, nickel, silver
2017

2.《烏托邦項鍊》《Utopia necklace》
300×250×500mm
黃銅、鎳、銀、水干顏料
Brass, nickel, silver, glue painting
2017

1	1
	2